HOW TO READ
GREEK VASES

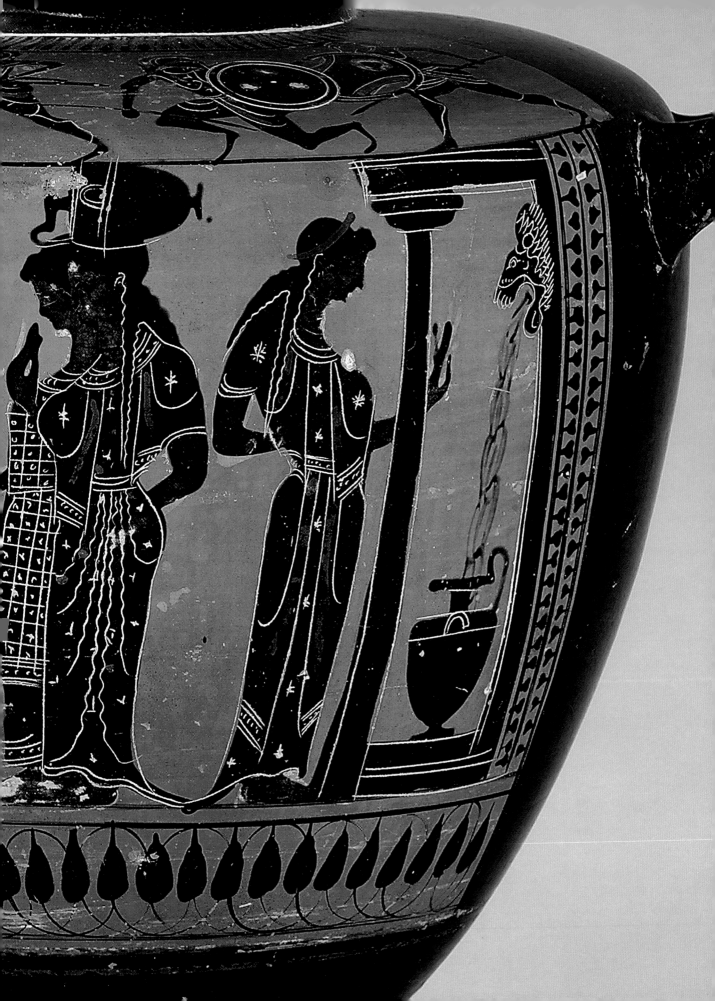

HOW TO READ
GREEK VASES

Joan R. Mertens

The Metropolitan Museum of Art, New York
Yale University Press, New Haven and London

AMICIS OPTIMIS

This publication is made possible in part by
The BIN Charitable Foundation, Inc.

Published by The Metropolitan Museum of Art, New York

Gwen Roginsky, General Manager of Publications
Peter Antony, Chief Production Manager
Barbara Cavaliere, Editor
Rita Jules, Miko McGinty Inc., Designer
Robert Weisberg, Assistant Managing Editor
Bonnie Laessig, Assistant Production Manager

Unless otherwise indicated in the accompanying caption, all the
works of art illustrated in this publication are in the collection of
The Metropolitan Museum of Art.

Photographs of works in the Metropolitan Museum's collection
are by the Photograph Studio, The Metropolitan Museum of Art.
Additional photograph credits appear in the individual captions.

Separations by Professional Graphics, Inc., Rockford, Illinois
Printed by Brizzolis, arte en gráficas, Madrid
Bound by Encuadernación Ramos, S.A., Madrid
Printing and binding coordinated by Ediciones El Viso, S.A., Madrid
Cover illustration: Detail, No. 23
Frontispiece: Detail, No. 18

Library of Congress Cataloging-in-Publication Data

Metropolitan Museum of Art (New York, N.Y.)
 How to read Greek vases / Joan R. Mertens.
 p. cm.
 Includes bibliographical references and index.
 ISBN 978-1-58839-404-0 (pbk: the metropolitan museum of
art) — ISBN 978-0-300-15523-5 (pbk: yale university press) 1. Vases,
Greek—Catalogs. 2. Vase-painting, Greek—Catalogs. 3. Vases—
New York (State)—New York—Catalogs. 4. Metropolitan Museum
of Art (New York, N.Y.)—Catalogs. I. Mertens, Joan R. II. Title.
 NK4645.M475 2010
 738.3'820938—dc22
 2010037224

CONTENTS

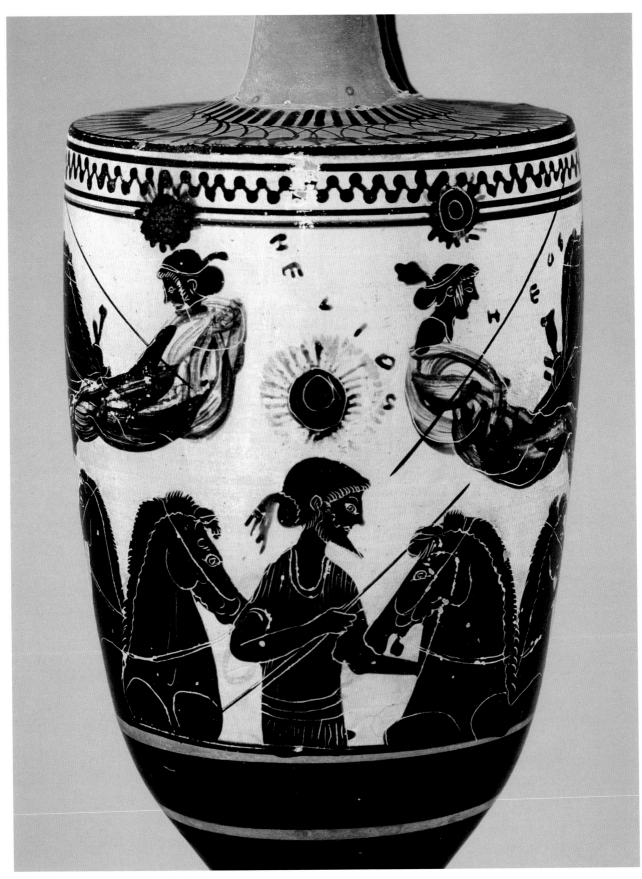

Detail, No. 19

DIRECTOR'S FOREWORD

How to Read Greek Vases is the second in a series of generously illustrated books intended to introduce a wide audience to groups of related works of art from all areas of the Metropolitan Museum's collections. The choice of the word *read* in the title serves as a metaphor for concentrated looking, but it also underlines the role of written texts in many works of art.

The series began with *How to Read Chinese Paintings* (2008) by Maxwell K. Hearn, Douglas Dillon Curator in the Department of Asian Art. It is a pleasure to add the present volume, which highlights another of the Metropolitan's world-renowned holdings. Joan R. Mertens, Curator in the Department of Greek and Roman Art, has chosen thirty-five works—some masterpieces, some not, but all originally utilitarian; they were used by ancient men and women in their daily lives.

The selections discussed here are representative of ancient Greek vase-painting, but especially, they provide a means of entering a world that, on the one hand, seems long ago and far away but, on the other, lives on all around us, in architecture, in concepts such as the superhero, and in all sorts of trivia in our daily lives, down to the takeout coffee cup with the meander pattern. Objects are eloquent intermediaries, and the images on ancient Greek vases are particularly accessible because their focus is on human beings—their gods, their myths, their daily lives—and the relation between the representations and the underlying shapes is dynamic and strong. Greek vase-painting is an art of great discipline and also of great diversity. Once we enter its world, we become familiar with a large part of our own.

We are grateful to The BIN Charitable Foundation, Inc., for its support in helping to make this book possible.

THOMAS P. CAMPBELL

DIRECTOR
THE METROPOLITAN MUSEUM OF ART

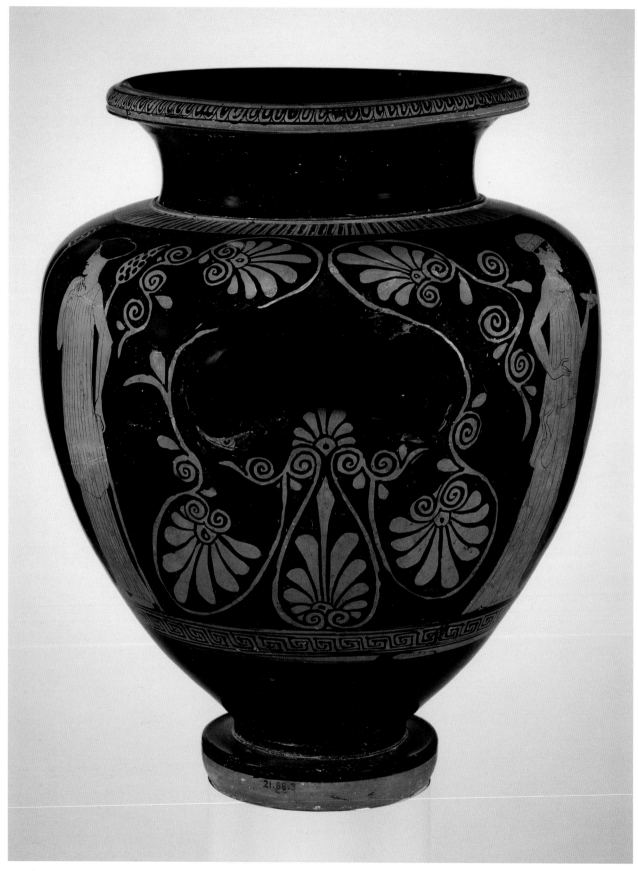

Detail, Fig. 13

ACKNOWLEDGMENTS

My first thanks are to Thomas P. Campbell, Director, Philippe de Montebello, Director Emeritus, and Carlos A. Picón, Curator in Charge of the Greek and Roman Department, all in The Metropolitan Museum of Art, for accepting Greek vases into the Museum's How to Read series. I am indebted to The BIN Charitable Foundation, Inc., and its principals as well as to Sandra Brue for their generous support.

For help in obtaining photographs, I thank Daniel Berger, Rita Cosentino, Alicja Egbert, Katarina Horst-Mehlhorn, Nikolaos Kaltsas, Joan Knudsen, Martin Maischberger, Helen Morati, Katerina Rhomiopoulou, Aletta Seiffert, Christina Vlassopoulou, and Angeliki Voskaki. I thank Georg Nicolaus Knauer for philological help, Mary B. Moore for her attentive proofreading, and Maya B. Muratov for research assistance. Within the Museum, I thank the Photograph Studio, specifically Barbara Bridgers and Paul Lachenauer, the photographer responsible for most of the illustrations. In the Image Library, Julie Zeftel and Neal Stimler have willingly tracked down pictures. I am indebted to the members of the Greek and Roman Department, particularly John F. Morariu Jr. and Jennifer Slocum Soupios.

I wish to express special appreciation to the Editorial Department beginning with Gwen Roginsky and Peter Antony for their consummate professionalism, to Barbara Cavaliere for her care in editing, to Bonnie Laessig for help with production, to Jayne Kuchna for her bibliographic expertise, to Mary Jo Mace for dealing with outside photography, and to Susan G. Burke for the index. Pamlyn Smith created the fine maps. With great sensitivity and flair, Miko McGinty and Rita Jules created a design that allows the attractions of a three-dimensional Greek vase to resonate from a book page.

John P. O'Neill, the late Publisher and Editor in Chief of the Museum, invited me to write this book. His interest and encouragement made the process even more rewarding. The late Elfriede (Kezia) Knauer applied her formidable acuity to the entire manuscript and improved it significantly.

JOAN R. MERTENS

CURATOR, DEPARTMENT OF GREEK AND ROMAN ART
THE METROPOLITAN MUSEUM OF ART

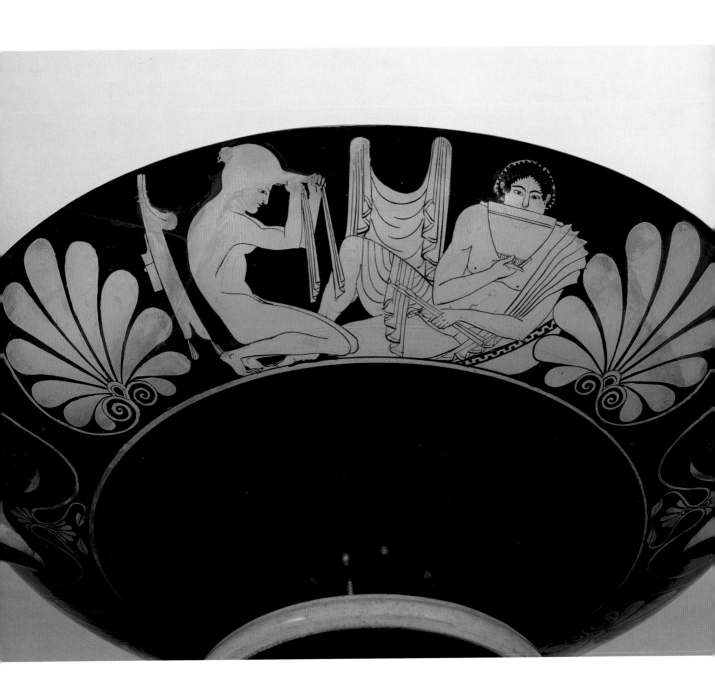

INTRODUCTION

Looking at Greek vases is a contemplative pursuit (Fig. 1), comparable perhaps to fishing or gardening. It generously repays a viewer who is keenly attentive to detail, who is willing to linger over the wiry lines that define a palmette or pleated drapery or to consider the effect of the placement of a handle. This is not to say that the perusal of vases is all about minutiae, low-key and esoteric. Within the limited range of shapes, the basically orange and black color scheme, and a fundamentally unrealistic manner of representation, Greek vases depict the full gamut of human experience and emotion. There is no lack of dramatic effect, surprise, pathos or play.

The intention of this book is to provide an introduction into looking at Greek vases, using The Metropolitan Museum of Art's superlative collection. This is neither a history of vase-painting nor a compilation of masterpieces. While essential features such as shape, technique, ornament, and subject necessarily appear, I would liken the presentation here to an extended gallery talk. The selection of objects is quite personal. I wish to provide information on what to look for. And I hope that the cumulative effect of the discussion will convey the complexity of the objects as well as the excitement of examining them closely.

"Greek vases" is a term conventionally applied to pottery made in ancient Greece between about 900 B.C. and about 300 B.C. Pottery was produced in enormous quantities and served all basic needs in daily life because good clay was plentiful and craftsmen everywhere had the skills for forming and firing vessels. Designed for specific functions from fetching water to holding toilet articles, the most utilitarian household vases were plain and undecorated. There was also a parallel production of finer, painted vases—these are our focus. We shall highlight examples from Athens, where painted vases began to appear in the late tenth century B.C. and flourished from the sixth through the fourth century B.C. Athens does not represent the whole story, however (see Figs. 2, 4, 5). In our ceramic peregrination, a few works will illustrate the accomplishments of prehistoric potters and painters (Nos. 1–3). Other vases will represent non-Attic centers, notably Euboea (No. 4), Corinth (No. 8), Eastern

OPPOSITE: FIGURE 1. Kylix (drinking cup) with symposiast and flute player binding her hair. Greek, Attic, red-figure, ca. 500 B.C. Attributed to the Ashby Painter. Terracotta, diam. 12⅞ in. (32.7 cm). Purchase, Amalia Lacroze de Fortabat Gift and The Bothmer Purchase Fund, 1993 (1993.11.5)

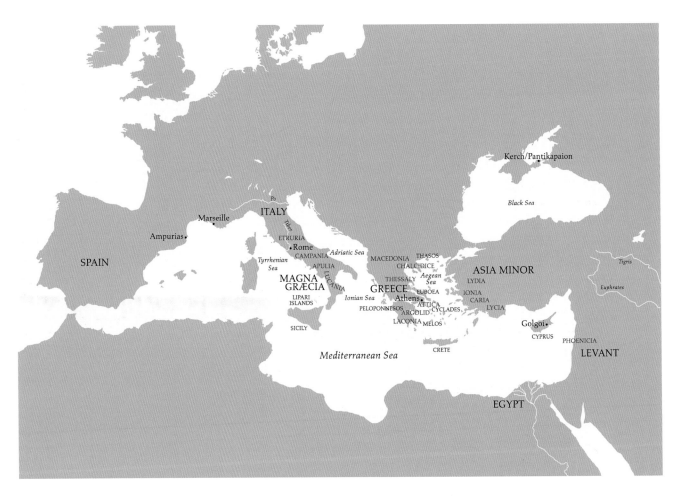

FIGURE 2. The Classical World

Greece (No. 15), and early workshops in Southern Italy (No. 17). Our considerations will end with later products of Southern Italy, where mainland artists immigrated during the second half of the fifth century B.C., establishing a regional tradition that flourished for over a century (Nos. 32–35).

Despite their ubiquity in ancient times, even the finest clay vases were not valued sufficiently to be celebrated, or even noted, in contemporary literature. There are no surviving texts as we have for buildings, sculpture, wall paintings or small precious objects that identify specific artists, impressive dedications in religious sanctuaries or otherwise outstanding pieces. On the other hand, considerable contemporary evidence comes from the works of art. The status and wealth attainable by a successful potter are documented by a marble relief dedicated on the Athenian Akropolis about 510 B.C. (Fig. 3). The seated craftsman holds two kylikes (drinking cups). The very fragmentary dedication preserves part of the name of the dedicator and part of the name of the sculptor of the relief; neither individual can be identified definitively. It does record the goddess Athena as the recipient of the dedication.

Individual potters and painters occasionally signed their wares with their names and the verb designating the maker (epoiesen) or the painter (egraphsen) (Nos. 10, 20, 23). Very rarely, an artist included his father's name, revealing an artistic lineage. For instance, the Museum's collections contain a fine kylix of the mid-fifth century B.C. inscribed "Tleson tou Nearchou," Tleson son of Nearchos (No. 13). In addition, we have two works inscribed by the father, Nearchos, a cup of the same shape as well as an extraordinary little aryballos (oil flask) (No. 9). It is laborious to eke out such connections, but they are tremendously

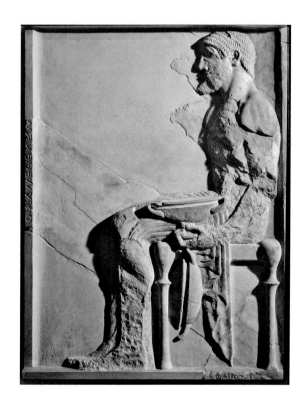

FIGURE 3. Votive relief to Athena showing a seated potter. Greek, ca. 510 B.C. Marble, h. 48 in. (121.9 cm). Athens, Akropolis Museum inv. 1332. Illustration courtesy of the 1st Ephorate of Prehistoric and Classical Antiquities; copyright © Hellenic Ministry of Culture and Tourism—Archaeological Receipts Fund

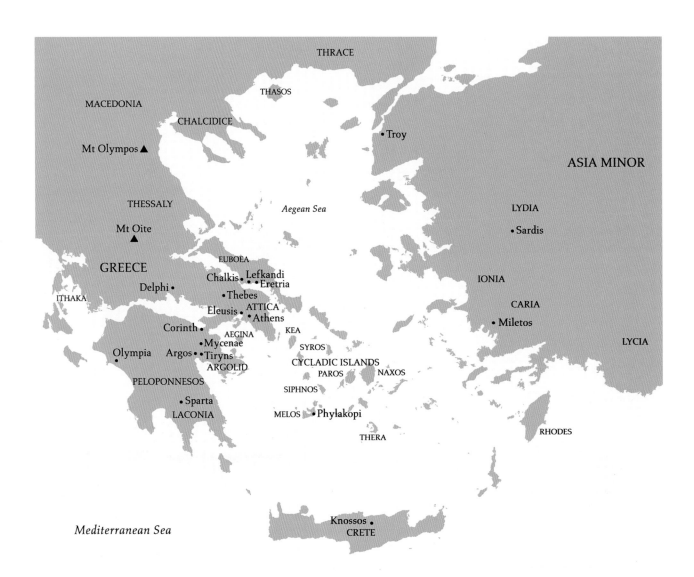

FIGURE 4. Greece

FIGURE 5. Italy

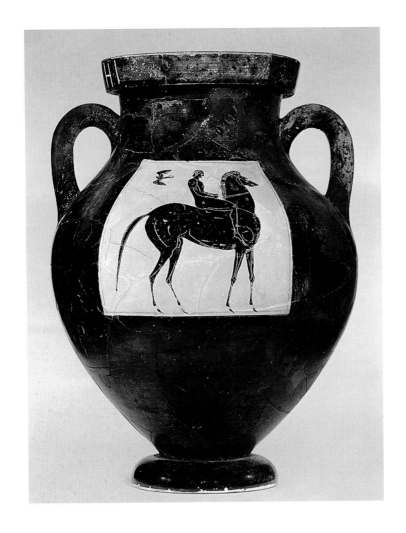

FIGURE 6. Amphora (jar) with horseman. Greek, Attic, black-figure, ca. 540 B.C. Attributed to the manner of Lydos. Terracotta, h. 21¹⁵/₁₆ in. (55.7 cm). Rogers Fund, 1951 (51.11.3)

informative. Since the great majority of vase painters are anonymous, if a group of works by one hand has been identified, the artist is given a conventional name based on an artistic peculiarity, the modern location of an important piece, or some other feature. This book contains works attributed, for instance, to the Amasis Painter, who worked with a potter who signed his name Amasis; to the Sappho Painter, whose name vase depicts the poetess Sappho, identified by an inscription; and to the Capodimonte Painter, whose name vase in the Museum's collection resided for a time in Capodimonte, site of the palace of the kings of Naples (Nos. 14, 19, 32).

Since Greek vases do not provide extensive surfaces for writing, most other types of inscriptions are equally laconic. For instance, they may record a dedication to a divinity. The lip of an amphora preserves four letters, of which two, HI, suggest a friendly greeting but may in fact be the beginning of the word for "sacred to" (Fig. 6). Even more terse is a single sign or a small group of signs that are typically painted or scratched into the underside of the foot of a vase. Known as mercantile inscriptions or trademarks, these signs—they may consist of letters—seem to have designated batches of pottery that were exported (Fig. 7). They occur particularly frequently on exports to

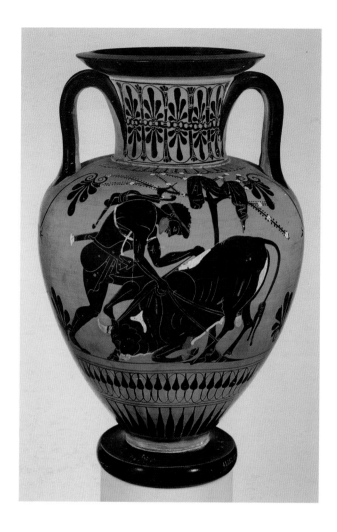

Italy. The exact meaning of the marks is not clear, whether they identify a trader, a destination or something else. However, the same mark may appear on vases attributed to the same artist and/or found at the same site. Trademarks are among the tantalizing clues to many aspects of pottery production and distribution for which virtually no tangible evidence survives. When exports reached their destinations, they might receive an additional inscription—once again scratched into the surface—identifying the owner or a dedication. On vases sent to Etruria, such inscriptions are written in Etruscan letters (Fig. 8). It is worth noting that, when not in use, drinking cups were often suspended by one handle, thus displaying the inscription beneath the foot. With their heartland situated between the Arno and the Tiber Rivers, the Etruscans were the dominant population in north central Italy before the Romans—and avid customers of Greek vases (see Fig. 5).

One further type of inscription deserves mention here. Athenian vases from the end of the sixth century B.C. into the fifth often bear an inscription praising the beauty of a youth. The reference might be general, ho pais kalos, "the youth is fair" (Fig. 9), or specific, such as Leagros kalos, "Leagros is fair." Young scions of the foremost Athenian families were evidently celebrated for a brief

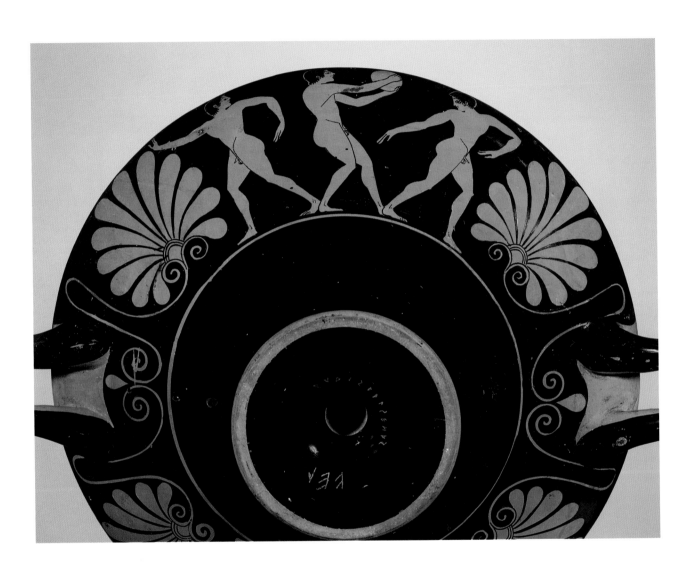

FIGURE 8. Kylix (drinking cup) with athletes.
Greek, Attic, red-figure, ca. 510 B.C. Attributed to
the Euergides Painter. Terracotta, diam. 13^{15}/$_{16}$ in.
(35.4 cm). Rogers Fund, 1909 (09.221.47)

Detail, Etruscan graffiti

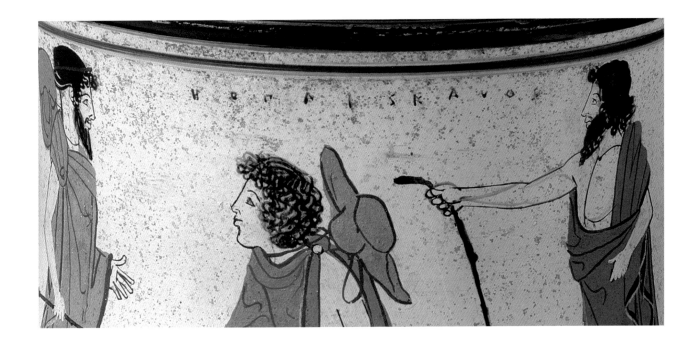

period. The inscriptions have been recognized by modern scholars as being of chronological value because those celebrating a particular youth must have been pretty much contemporary. Moreover, some of the individuals have historical identities. Leagros, who appears on a large number of vases during the last decade of the sixth century, can be identified from literary evidence as a member of a significant family and a general in a military campaign against Thasos; he died in 464 B.C.

While there are yet other kinds of information on Greek vases, it has seemed worthwhile to touch first on inscriptions because, in our day and age, we assume the existence of a written text that will tell us everything we want to know about a given subject. The writing on vases offers bits of information that need to be investigated

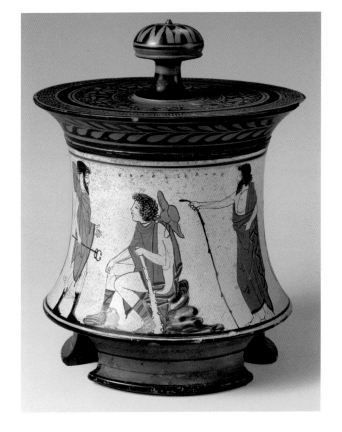

FIGURE 9. Pyxis (box) with the Judgment of Paris. Greek, Attic, white-ground and red-figure, ca. 465–460 B.C. Attributed to the Penthesilea Painter. Terracotta, h. 4¾ in. (12.1 cm). Rogers Fund, 1907 (07.286.36)

Detail, inscription

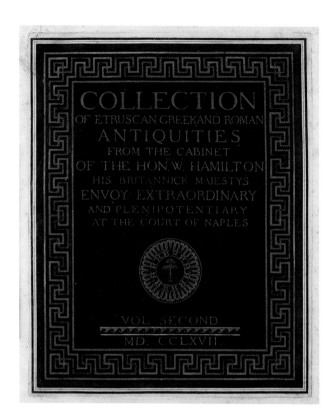

FIGURE 10. *Collection of Etruscan, Greek, and Roman Antiquities from the Cabinet of the Hon. W. Hamilton His Britannick Majesty's Envoy Extraordinary and Plenipotentiary at the Court of Naples, volume 2.* William Hamilton and Pierre d'Hancarville, publisher, Naples, 1767. Hand-colored etching, sheet 19 $^{11}/_{16}$ x 14 $^{15}/_{16}$ in. (50 x 38 cm). Thomas J. Watson Library, Gift of Christian A. Zabriskie, 1954 (579.2 H186 F)

before they yield information. There are many other features of a vase that can tell us a lot more and have been the focus of scholarship for over three centuries.

The understanding of ancient vases by the modern world required two preconditions—the recognition that the objects were made by Greeks and the availability of a large quantity of material for study. Finds from Italy fulfilled both of these preconditions (see Fig. 5). During the eighteenth century, the discovery and collecting of vases were centered in Campania, the area around Naples. The best-known enthusiast was Sir William Hamilton, who had been appointed British envoy to the Kingdom of the Two Sicilies in 1764. Hamilton formed two collections, one in the 1760s, the other in the 1780s, both of which he published in handsome editions that circulated widely and exerted a considerable influence, notably on the decorative arts and paintings of the day (Fig. 10). The Hamilton collections included both Attic imports and South

Italian works. The prevailing interpretation of their origin was that they were created on Italian soil, leading to their designation as "Etruscan." The key to the correct identification lay in associating the Greek inscriptions with the place of production. The antiquarian and biblical scholar A. S. Mazochius achieved this breakthrough in a publication of 1754, and even though his insight was not immediately accepted, the growing interest and study of ancient vases through the eighteenth century increasingly corroborated it. Worth noting also is the publication ten years later of Johann Joachim Winckelmann's *Geschichte der Kunst des Altertums*, in which a first differentiation between Greek and Roman sculpture was attempted on stylistic grounds. The immediate and profound effect of Winckelmann's work further contributed to the definition of a Greek art.

The event that decisively advanced every aspect of the study of Greek vases occurred in 1828. Lucien

Bonaparte, prince de Canino and brother of Napoleon Bonaparte, owned considerable property at Vulci, northwest of Rome. The chance discovery of some ancient pottery led him to organize excavations on his land, which proved to be the site of an extraordinarily rich ancient Etruscan cemetery. The first campaign, in 1828–29, yielded well over two thousand vases; most were Attic, and 235 were inscribed. They include a large number of undisputed masterpieces by the greatest Greek potters and painters. For his time, Bonaparte imposed some discipline on his activity. He subdivided the area into ten zones and recorded the finding place and date of discovery, most particularly of the inscribed works. In addition to the figured material, there were plain wares in the black Etruscan fabric known as bucchero as well as bronzes, scarabs, and items of gold. The finds generated enormous interest. Bonaparte exhibited them in Rome beginning in 1829, and in that year, he also published a selection of major pieces. The sheer quantity and variety of pottery motivated one of the landmarks in vase scholarship, Eduard Gerhard's "Rapporto volcente" of 1831, 218 pages in the *Annali dell'Instituto di Corrispondenza Archeologica*, the periodical of what was to become the German Archaeological Institute in Rome. While Bonaparte continued to excavate, he also very rapidly sold his finds. Through auctions and individual dealers, Canino vases reached London, Paris, Berlin, Munich, and St. Petersburg, to name only the major European capitals. There are also examples in the Metropolitan Museum. The catalogue *Museum Etrusque de Lucien Bonaparte Prince de Canino, fouilles de 1828 à 1829, vases peints avec inscriptions* (Viterbo, 1829) records where our Fig. 7 came to light in November 1829, and No. 22 was found in April 1829.

Gerhard's "Rapporto volcente" exemplifies the seriousness and breadth of contemporary vase studies. Through its methodical discussion of the major topics—style, subject, inscriptions, function, date, and place of origin—the article pulled together what was known about vases from all sources and integrated the observations that Gerhard had made about the new finds at Vulci. Gerhard studied the material firsthand, going to Bonaparte's excavation in March and June 1829, and again in May 1830 and 1831. His publication identified the vase shapes in the terms that are commonly accepted; he was aware of differences between regional styles, although he named them differently than we are able to do now, and thanks to the large number of inscriptions, he commented at length on the subjects depicted as well as the artists who wrote their names on the pottery. In evaluating a publication like Gerhard's, it is useful to keep in mind that, certainly until the mid-eighteenth century, antiquarians knew more about Greece and Rome from ancient literary sources than from extensive exposure to original works of art. Moreover, it was only in 1830 that Greece gained independence from the Ottoman Empire and became a kingdom, initially under the rule of the royal house of Bavaria. This political development very quickly furthered archaeological investigation in a region that had been visited only by exceptionally stalwart travelers, quite unlike Italy.

As the nineteenth century advanced, the combination of archaeological excavation, collecting by private individuals as well as major museums, and increasingly specialized studies turned Greek vase-painting into a serious discipline dominated by German scholars. Probably the most illustrious among them was Adolf Furtwängler (father of the conductor Wilhelm Furtwängler). His

catalogue of the vase collection in Berlin, published in 1885, marks a watershed in several respects. First, it contains 4,221 works, each of which is numbered. The order is chronological, beginning with prehistoric vases and ending with the latest products of Southern Italy. The subdivisions are by technique, by region, and by shape. Stylistically similar vases tend to be in sequence. Each entry provides dimensions, place of discovery when known, and a full description. An important aspect of the bibliography was to provide references for published illustrations, which consisted of line drawings. Furtwängler's catalogue rationalized all the information that could be conveyed in words. As scholarship refined the distinctions between an ever greater number of features of a vase, especially with regard to fabric and style, the need for adequate visual evidence became ever more acute. Furtwängler addressed this need in 1900, planning a publication of 120 vases for which he would write the texts and Karl Reichhold, an accomplished draftsman, would furnish meticulously detailed drawings. The enterprise, *Griechische Vasenmalerei*, continued after Furtwängler's death in 1907, and although the quality of the renderings makes the work valuable even today, it was the popularization of photography that revolutionized vase studies.

The excavations at Vulci in the 1820s had yielded several hundred pieces with artist signatures that consist of a name followed by the verb epoiesen (made) or egraphsen (painted). Gerhard and his colleagues recognized that the individual who signed egraphsen was responsible for the decoration. The meaning of epoiesen is not entirely clear, even to this day, but the artist who signed with that verb was likely the potter and perhaps also the owner of the workshop. The groups of vases that could be formed around a specific painter allowed the definition of specific stylistic features that, in turn, led to the attribution of unsigned works with the same features. While the recognition of individual artistic personalities had occurred before, the incorporation of photographs into the study and publication of vases brought attribution to the forefront of attention in the early twentieth century (Fig. 11). It is worth noting that until the advent of this new reproductive medium, a person had never before been able to see all the surfaces of an ancient vase at the same time. Attribution requires close comparison of details on one object and among numerous objects. Edmond Pottier's publication of pottery in the Louvre in 1897 marked the first use of photography in the catalogue of a major collection. Very rapidly, it was recognized as providing the visual complement to all the verbal information about an object.

The acceptance of photography and the stylistic analysis that it allowed introduced another principle according to which vases could be organized—by artist. The development of this criterion is due chiefly to the Englishman Sir John Beazley. Beazley's extraordinary achievement was that he defined by attribution the personalities of hundreds of painters as well as numerous potters, their artistic interconnections, their preferences as to shapes and subjects, and often, the evolution of their careers. The distillate of his work is presented in a series of compendia listing the artists, more or less chronologically, and the vases attributed to each one. Because of their conciseness, these books are often compared with telephone directories. In fact, the absence of all superfluity combined with the rigor of Beazley's method and his unsuppressibly fine language distinguish the publications. His many articles amplify his observations.

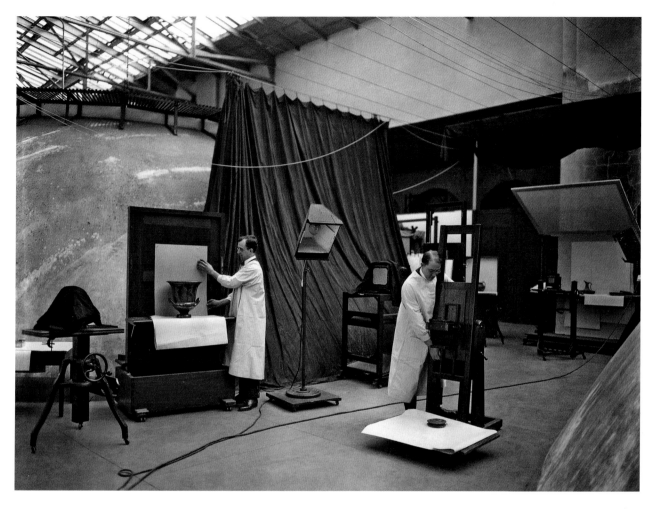

FIGURE 11. The Metropolitan Museum of Art Photograph Studio, 1924

The ramifications of Beazley's scholarship were immediate and considerable. To a degree that had never before been achieved, his method approached what we consider "scientific"; it could be reproduced. His organizing principle was by artist, with a structure for dealing with such variables as shape or the subject of the decoration. For the interested nonspecialist, it became possible to speak about artists like the Amasis Painter (No. 14) or the Achilles Painter (No. 28) as one did about Raphael or Ingres. A name allowed the definition of an artistic personality. This development also changed the nature of collecting. The acquisition of ancient pottery had already kindled considerable passion in the eighteenth century. Through the work of Beazley in particular, the appreciation of a vase became more like that for a painting or a drawing—an individual work of art. Though Beazley's focus was on artistic features, he looked beyond purely aesthetic considerations. He attributed great vases and hackwork; he recorded whatever finding places were known; he compiled all the known history of every piece that he dealt with, primarily through its history of publication; and he introduced many additional observations

from his deep and broad learning. The history of the study of Greek pottery shows the accumulation of knowledge in an additive progression. It can be said with some justification that, through his work on the individual artists, Beazley made the last major contribution to achieving a whole view of an ancient Greek vase as a work of art.

In our time, there remain many other possibilities to pursue. There is, for instance, the context—historical, cultural, economic, sociological—in which the objects were made, traded, used, and buried. Another field of inquiry concerns the technical dimension that continuing advances in science are elucidating. The exact sources of the clays, the identity of the pigments, the application of gilding, the construction of kilns—the questions are limitless. Their point of departure lies *in* the objects, while their focus is *on* the objects.

When we look at an ancient work today, there is a series of questions that we ask in order to place it properly within the very long continuum of vase production in the Greek world (see Figs. 2, 4). First of all, does it belong to one of the prehistoric cultures (Nos. 1–3)? Or was it made during the first millennium B.C., between about 900 and about 300 B.C.? Since we shall be most concerned with this era, it is helpful to place the piece within the appropriate art historical period. The Geometric Period, about 1000–700 B.C. (Nos. 4–7), is marked by the establishment of the fundamental Greek institutions after the collapse of the prehistoric centers of power and an ensuing time of dormancy and decline. The new millennium began with the emergence of the polis (city-state), the major sanctuaries such as those of Delphi and Olympia, and the pan-Hellenic athletic competitions such as those at Olympia and Athens. It saw the introduction of writing from Phoenicia and the composition of Homer's *Iliad* and *Odyssey*. By the early eighth century, the first Greek colonies were being founded in Southern Italy. The most creative ceramic center at this time was Athens, but significant production took place in Euboea (No. 4), the Cyclades, and Argos on the Peloponnesus.

The Archaic Period, about 700–480 B.C. (Nos. 8–23), which followed, is the great and colorful age when the Greek city-states were generally on a par with one another, continually at war yet coming together at sanctuaries and athletic competitions. The pottery of the time reflects the kaleidoscopic relation of the various regions; the fabric of each is distinct, but they share such features as an iconographical predilection for animals, both real and mythological. Creatures such as sphinxes, sirens, griffins, centaurs, and satyrs were introduced mainly from the Near East and Egypt. During the early part of the period, Corinth was the dominant center of pottery production. Its vases circulated throughout the Mediterranean world, probably as much for their contents—wine, oil, perfume—as for the containers. Corinth was also responsible for the introduction of black-figure, the earlier of the two predominant techniques for the decoration of vases (No. 8). The figure-work and any supplementary geometric or vegetal motifs were painted on the piece with a rather liquid clay preparation conventionally known as glaze. The forms were articulated with incised lines, an extremely cumbersome process, especially on convex surfaces, as well as with added red and white ceramic colors. At the end of a three-stage firing process, the forms depicted with glaze appeared black, while the plain, or reserved, background remained the orangey color of the clay.

The black-figure technique took hold in Attic workshops soon after 600 B.C. and found its most accomplished artistic application there. Until about 530 B.C., however, black-figure was used throughout the Greek world (No. 17). During the third quarter of the sixth century B.C. in Athens, a potter who signed with the name Andokides seems to have been responsible for introducing the red-figure technique (No. 20), in which the decoration remains the color of the clay and the surrounding surfaces are black. The new procedure freed the artist to draw both the contours of forms and the interior articulation. The glaze could be diluted and used almost as an additional color. Red-figure very quickly replaced black-figure for fine wares both in Athens and elsewhere in the Greek world.

The close of the Archaic Period and the beginning of the Classical (480–323 B.C.) are conventionally linked to the historically decisive defeat of the Persian Empire by Greece in the Persian Wars that ended in 479 B.C. The single greatest political result was that Athens became the dominant Greek state until the last quarter of the fifth century B.C. The artistic manifestation of this development is exemplified by the architectural reconstruction and embellishment of the city, most notably on the Akropolis. The Parthenon, created between 447 and 432 B.C., was dedicated to Athena, the patron goddess of Athens. In vase-painting, red-figure predominated, although about mid-century, the white-ground technique emerged from relatively secondary importance to considerable significance. White-ground vases received a light-colored slip over part or all the surface to be decorated. The change in background led to the increasing use of color in the scenes. At first, the pigments were applied before firing, but gradually they were added afterward, leading to the introduction of pinks, purples, greens, blues, and other tonalities that were incompatible with the character and technique of black-figure and red-figure. White-ground vases consisted chiefly of lekythoi, flasks containing scented oil for the dead (No. 28).

During the third quarter of the fifth century B.C., the production of red-figure vases began in Southern Italy, specifically in the area of Metapontum (see Fig. 5). We do not know precisely the circumstances surrounding this development. What is evident, however, is that the techniques of red-figure and black-figure, most of the shapes, and many of the subjects and subsidiary ornaments were transplanted from Attica to the West. Very quickly, the local artists introduced their own interpretations, at first very subtle, later quite pronounced. Their clients were predominantly the indigenous people of wealth and stature who often appear in the decoration (No. 33). The major differences between vases in the West and those on the mainland are that the South Italian works were primarily funerary and that this function significantly changed the meaning of both the shape and decoration. A correct interpretation of both elements is extremely difficult to reach without written evidence. In the art of mainland Greece, there is a more direct connection between the myths and other subjects depicted on vases; moreover, the tradition and quantity of scholarship are greater. On the pottery of Southern Italy, the iconography is refracted through a prism—a combination of local traditions and beliefs—that is understood much less completely. The transference of Greek vase-painting to the West did, however, serve to revitalize the art and result in another century of creative production. By about 300 B.C., it had run its course.

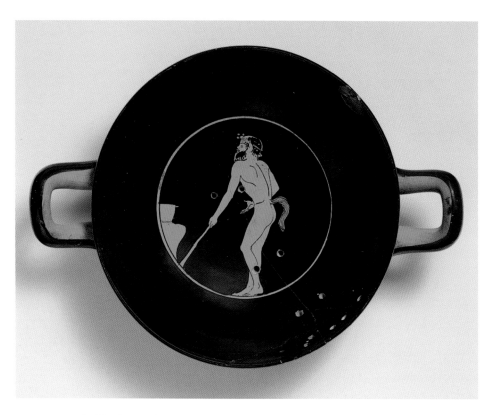

FIGURE 12. Kylix (drinking cup) with satyr cooking in a skyphos (deep drinking cup). Greek, Attic, red-figure, ca. 460–450 B.C. Attributed to the Euaion Painter. Terracotta, diam. 6⅞ in. (17.5 cm). Rogers Fund, 1906 (06.1021.177)

Wherever they may have been made, the finest Greek vases show a perfect melding of shape, technique, secondary ornament, and figural decoration. The pleasure and excitement of looking at them lie in recognizing the complexity of the component elements and their masterful integration. It is important to bear in mind that the objects we are considering here were all utilitarian. While they may now reside on shelves in display cases or embellish a private interior, originally they were used for transport, pouring, drinking, or storage. We find indications of their original functions in the marks left by a ladle on the rim of a krater, a piece that broke and was repaired or representations of vases in use (Figs. 12, 13). The range of shapes is limited, and the features of each shape are determined by its purpose. For instance, the hydria, a jar for water, is equipped with two horizontal handles at the sides for lifting and one vertical handle at the back for pouring (No. 18). The mouths of oinochoai (No. 8), jugs for pouring wine in particular, are articulated in various ways to control the flow of liquid. Vases for storage, like amphorae, neck-amphorae (No. 11), or stamnoi, have two handles for lifting, and they had lids, which are now generally lost.

A further aspect of each shape is that its painted embellishment tends to follow an established pattern. We use the word ornament for the geometric and vegetal motifs that articulate the various parts of the shape such as the mouth, the handle zone (see p. 8 and Fig. 14), and the point at which the body meets the foot (No. 11). It is

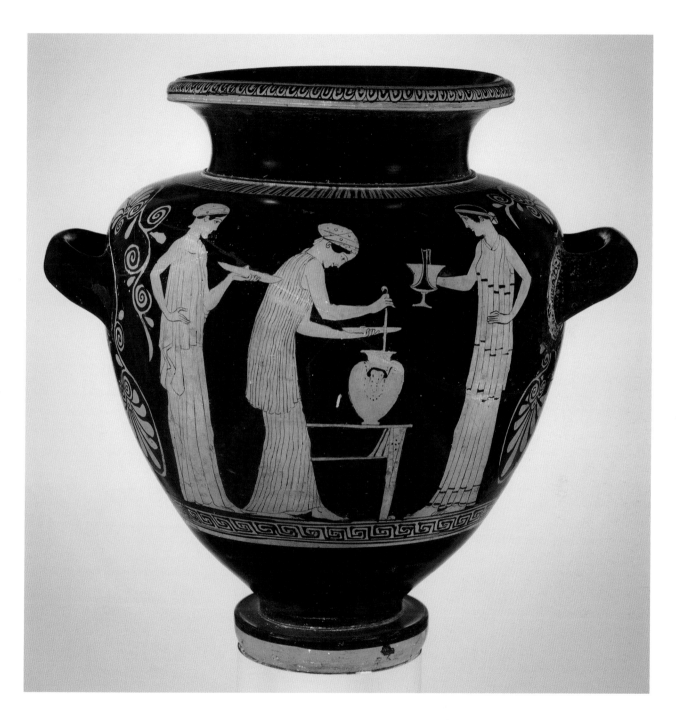

FIGURE 13. Stamnos (jar) with women preparing offerings of wine at a festival of Dionysos (the Lenaia). Greek, Attic, red-figure, ca. 450–440 B.C. Attributed to an artist recalling the Barclay and the Thomson Painters. Terracotta, h. 12 ¼ in. (31.1 cm). Rogers Fund, 1921 (21.88.3)

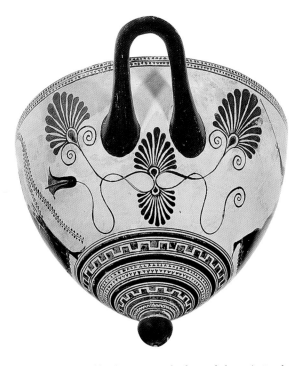

FIGURE 14. Mastos (drinking cup in the form of a breast). Greek, Attic, black-figure, ca. 520 B.C. Attributed to Psiax. Terracotta, h. 5¼ in. (13.4 cm). Purchase, The Abraham Foundation Inc. Gift, 1975 (1975.11.6)

transmit their contained energy to the motifs that grow and encircle them. Reciprocally, the ornaments emphasize the organic structure and proportions of the shape. There is vitality in every ingredient of a Greek vase.

The figural decoration draws together all the constituent elements. This point can be clearly illustrated with vases used for drinking. The symposium was an Attic institution conducted according to established principles. Men gathered to drink, converse, and enjoy the pleasures of music and sex. During the late sixth and early fifth centuries B.C., symposia were a favorite subject on Attic vases; we can visualize the participants and the necessary paraphernalia (No. 23). The wine, mixed with water, was

very probable that the potter who made the vase was also responsible for the ornament, just as he would have applied any special slips such as white-ground or coral red. The diversity of ornament tends to be greater on a black-figure vase than on a red-figure one because there is more light "background" to be structured and filled. For example, black-figure neck-amphorae of the latter part of the sixth century B.C. tend to show a rather standardized formula of palmette-lotus bands on the neck, a palmette composition under the handles, and a succession of geometric bands and glaze lines below the figural decoration and as far as the zone of rays at the very bottom of the body (No. 11). The many possible variations can be due to the inspiration of the artist, the region where the vase was produced, and the time. Careful attention to the interrelation of shape and ornament over many types of vase and over time makes clear the degree to which the two elements are mutually reinforcing. The volumes of the shape

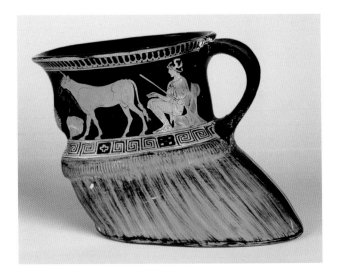

FIGURE 15. Drinking cup in the shape of a cow's hoof with cowherd. Greek, Attic, red-figure, ca. 470–460 B.C. Attributed to a painter recalling the Brygos Painter. Terracotta, h. 4¹/₁₆ in. (10.3 cm). Fletcher Fund, 1938 (38.11.2)

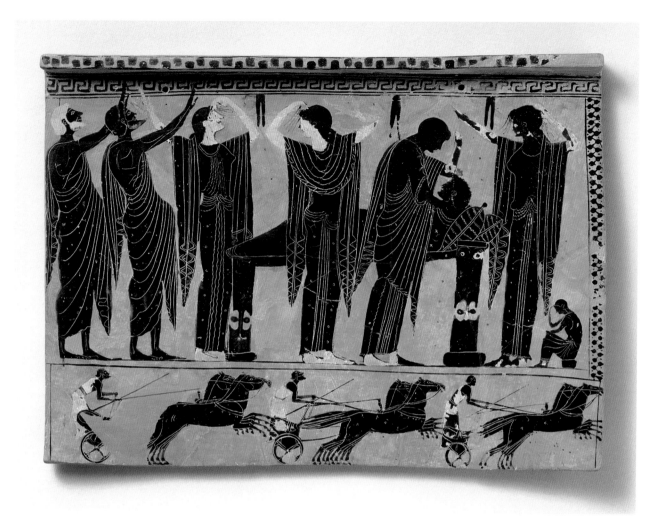

FIGURE 16. Funerary plaque with the laying out of the dead and chariot race. Greek, Attic, black-figure, ca. 520–510 B.C. Terracotta, h. 10¼ in. (26 cm). Rogers Fund, 1954 (54.11.5)

served from a krater. The krater might be filled from an amphora or an oinochoe. A ladle or a jug could be used to serve the wine, which was drunk from a kylix, occasionally a skyphos. Wine would have been chilled by filling a psykter, a mushroom-shaped vase specially designed for the purpose, and placing it within a krater containing cold water or snow. Symposia also had their playful aspects; there are all sorts of "trick vases" and novelties for the entertainment of the participants (Figs. 14, 15). The various shapes had their particular repertoire of ornament, but they tended also to be decorated with subjects connected with wine and drinking: Dionysos, the wine god,

and his followers, the satyrs and maenads; different aspects of the symposium; the consequences of revelry; and so forth (No. 16). There can be little doubt that providing the necessary pieces for the symposium was one of the Athenian potter's tasks.

The same might be said for pottery that was part of other rituals, such as funerals and weddings. From its first appearance in the late ninth to the early eighth century B.C., Greek pottery served a prominent funerary role. Objects of clay served as grave markers (Nos. 5, 6), offerings in the tomb, plaques affixed to funerary structures (Fig. 16), as well as containers for lustral water. All these works have appropriate subjects, notably the prothesis, or laying out of the dead. By the second quarter of the fifth century B.C., the lekythos, a flask for oil that was already a standard tomb offering, began to be decorated with a wide variety of funerary subjects ranging from the traditional prothesis and mourners at a tomb to scenes of Charon, whose task was to ferry men, women, and children who had died across the river Styx to the Underworld. The rendering of these subjects on a prepared white slip and with an unprecedented range of colors gives them special poignancy (No. 28).

Around the middle of the fifth century B.C., vases connected with wedding celebrations had increased in number. A specific shape, the lebes gamikos (Fig. 17), was used for the bridal bath and tends to be decorated with a bride receiving gifts. This subject and variants such as the bride accompanied by Eros and attendants also appear, for instance, on skyphoi (No. 29), pyxides (toilet boxes), and lekanides (shallow bowls with handles and a lid).

The wonder and power of Greek vases lie in the way the shape, the figural subject, and often also the technique and ornament contribute to the meaning of the work. Indeed, it would be more accurate to say the meanings. As we look at the selection that follows, we shall find the world of human experience in masterfully accomplished creations that served as integral parts of their owners' lives.

FIGURE 17. Lebes gamikos (bowl and stand used in weddings) with wedding preparations. Greek, Attic, red-figure, ca. 420 B.C. Attributed to the Naples Painter. Terracotta, h. 17^{1}/$_{8}$ in. (43.5 cm). Rogers Fund, 1906 (06.1021.298)

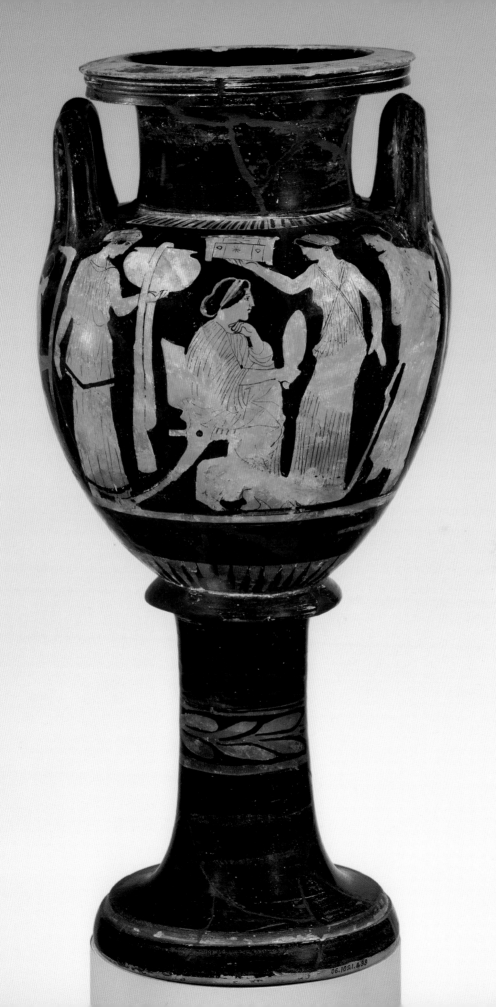

I

Kernos (offering vase)

Cycladic, Early Cycladic III–Middle Cycladic I, ca. 2300–2200 B.C.
Terracotta, h. 13⅝ in. (34.6 cm)
Purchase, The Annenberg Foundation Gift, 2004 (2004.363.1)

About 3000 B.C. in the Greek world, a series of cultures developed that culminated between 1600 and 1400 B.C. in the great palaces of Crete and mainland Greece, notably Mycenae. Although these centers had collapsed by the twelfth century B.C., their wealth and the exploits of their rulers lived on in the *Iliad* and *Odyssey* of Homer and in many Greek myths. The attainment of artists and architects of this prehistoric period was such that from the construction of vast multistoried palaces and domed tombs, from working bronze and precious metals to seal-engraving, from pottery production to wall-painting, there was no major technology that they had not mastered.

To open our consideration, I have chosen a virtuosic display of the potter's craft. The kernos was a well-established object in the Mediterranean world from Greece to the Levant. It contained multiple offerings, in this case perhaps seeds, flowers, fruit, and other products. In terracotta examples, the individual containers are often connected. Our piece is a particularly fine specimen of a group that seems to have been made at Phylakopi on Melos, one of the islands of the Cyclades. The kernos consists of a conical base, the top of which develops into nine separate "platforms," each of which merges with the base of a receptacle. The nine receptacles form an inner ring and provide the structure for the attachment of the bowl in the center and the outer ring of sixteen receptacles. Specifically, at the base of each of the nine receptacles are three sets of clay struts. One anchors the central bowl. A second set of struts attaches each receptacle to its neighbor in the inner ring. The third set consists of a double strut to hold the outer ring of sixteen receptacles that are, in effect, cantilevered over open space. Characteristic of

Greek creativity from the very beginning, the solution is as simple as it is bold.

By comparison with its bravura construction, the decoration is simple, but it emphasizes the component parts. The central support and the outside of the receptacles were covered with a light slip, a clay wash. The painted lines, however summarily executed, complement the areas to which they are applied.

The function served by kernoi assured the longevity of the type, albeit in different forms. They occur in some quantity on Cyprus, for instance (Fig. 18).

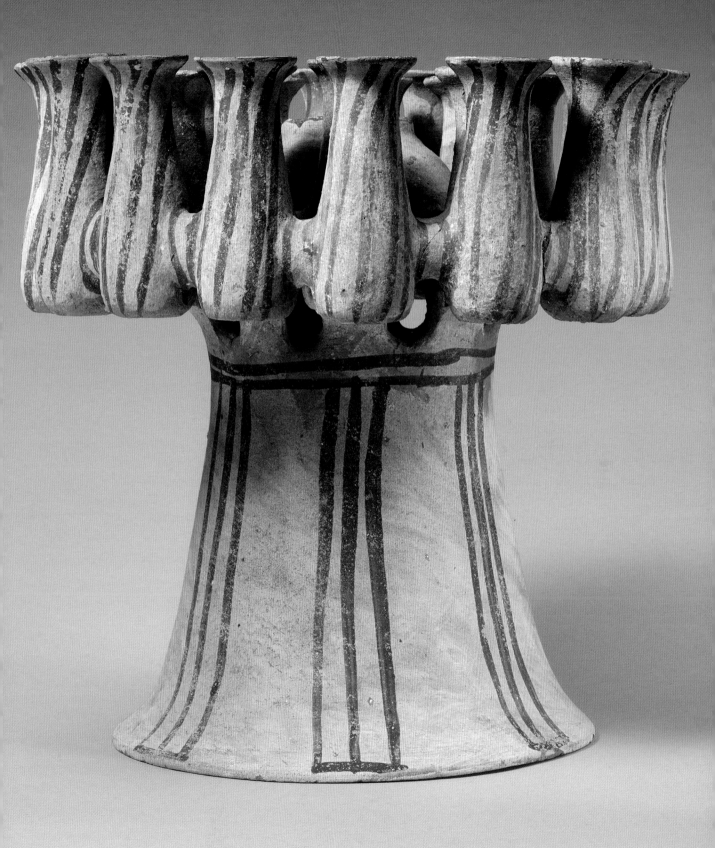

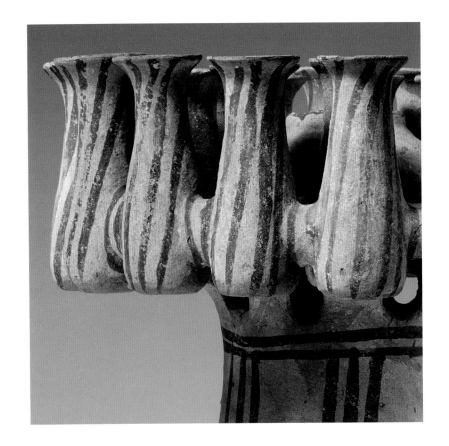

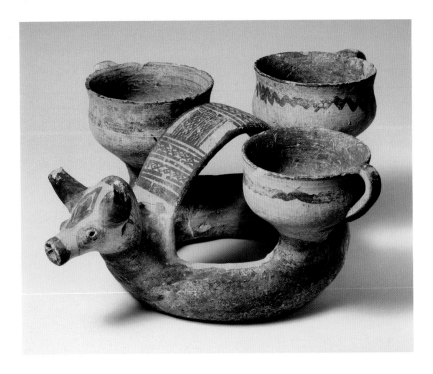

FIGURE 18. Ring-kernos (offering vase). Cypriot, Cypro-Geometric I, ca. 1050–950 B.C. Terracotta, h. 4 7/16 in. (11.3 cm). The Cesnola Collection, Purchased by subscription, 1874–76 (74.51.659)

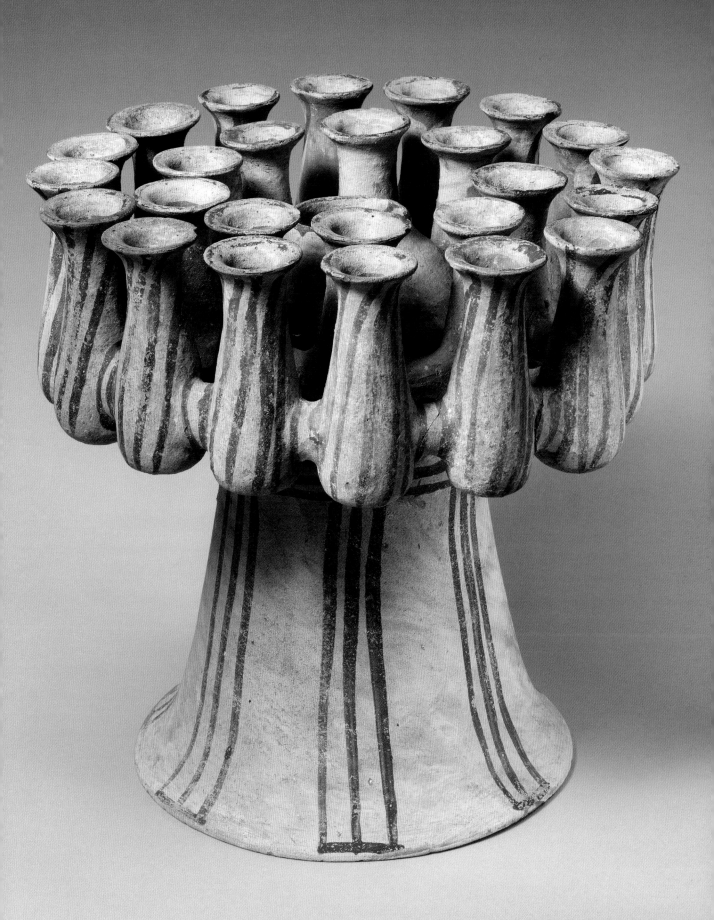

Jar with three vertical handles

Minoan, Late Minoan I, ca. 1600–1450 B.C.
Terracotta, h. 13½ in. (34.3 cm)
Rogers Fund, 1922 (22.139.76)

The fine wares of prehistoric Crete from the height of their production, between about 2000 and 1400 B.C. (spanning the Middle Minoan I through the Late Minoan II periods), are endlessly engaging because of their complexity. This jar would have served for storage and/or transport. The three handles on the shoulder allowed for the attachment of a lid. A number of such containers could be suspended from a sturdy pole and carried (see Fig. 19). The volume of the vase is conveyed not only by the placement of the greatest circumference high on the body but also by the connection in size and color between the foot and the neck. It is of particular note and import here that the various decorative motifs are not confined or organized within a panel or a part of the shape as is usual on Greek vases of the first millennium B.C. Rather, the elements are disposed more freely; around the two bands of assertive spirals, there are delicate fillers, perhaps flotsam and jetsam among powerful waves. The red spot, resulting from a problem in the firing, is fortuitously decorative. The finest examples of the Minoan aesthetic appear on vases with marine life or plants. With the advent of mainland Greeks on Crete during the fourteenth century B.C., this iconography became progressively more stylized and structured in its appearance on a vase.

FIGURE 19. Triangular prism, seal and impression. Minoan, Middle Minoan II, ca. 1900–1750 B.C. Steatite, l. ¹¹⁄₁₆ in. (1.75 cm). Bequest of Richard B. Seager, 1926 (26.31.134)

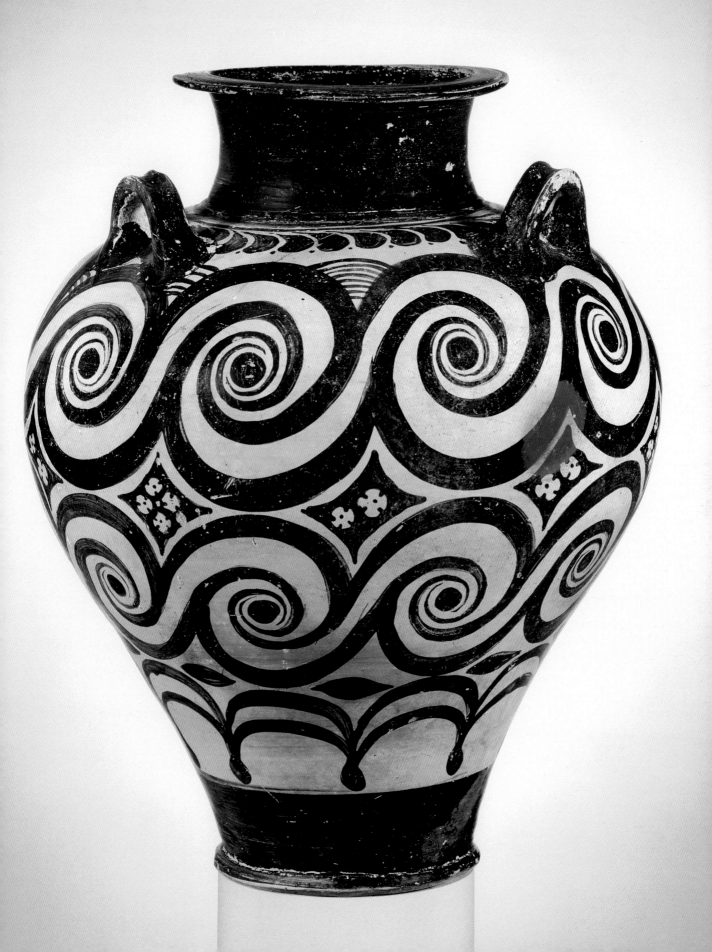

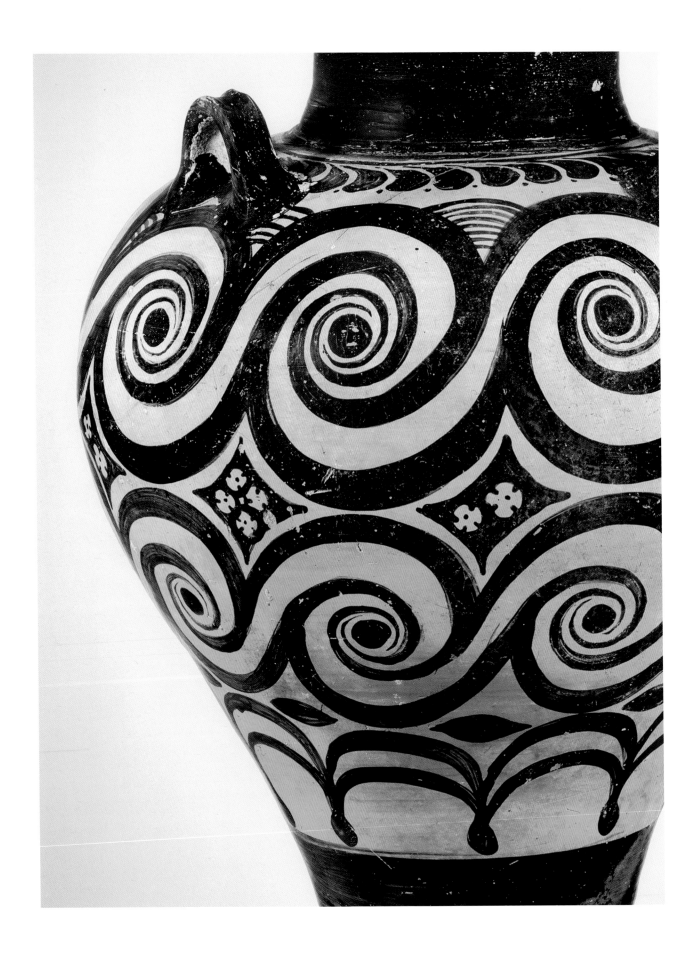

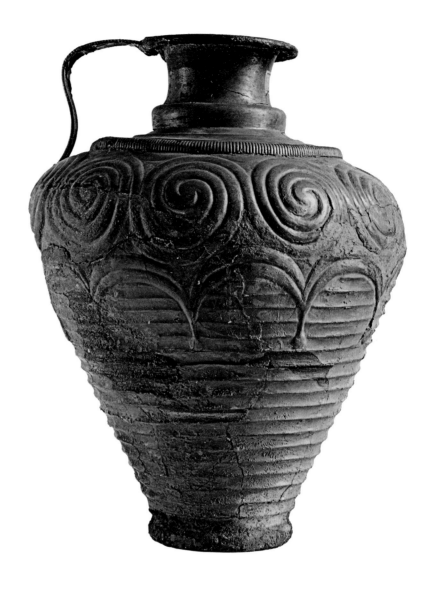

The jar interests us also because it raises a recurrent issue in the study of Greek pottery of all periods, the interrelation with counterparts in metal—bronze, rarely silver, exceptionally gold. Questions concerning the relation of clay to metal examples are vexing, first of all because clay is common and virtually indestructible when fired, while metal objects were melted down for other uses or are subject to deterioration when buried in the ground for long periods. In the case of the jar, the combination of spirals and an arcade pattern below is attested in a gold cup, a gilded silver jug, and other related material from near Knossos on Crete and from Mycenae on the Greek mainland (Fig. 20). Since the archaeological record is so incomplete, it is impossible to determine whether the metalware or the ceramic had primacy, although cheaper clay versions were derived from luxury items made in expensive materials. Even if this applies to our jar, there is no lack of creativity and refinement in its execution.

3

Chariot krater (deep two-handled vase)

Mycenaean, Late Helladic IIIB, ca. 1300–1230 B.C.
Terracotta, h. 16⅜ in. (41.6 cm)
The Cesnola Collection, Purchased by subscription, 1874–76 (74.51.966)

The pottery produced in Greece and the Aegean Islands during the prehistoric period is remarkable for the scarcity of decoration featuring human subjects and narrative scenes until the period of Mycenaean domination and the advent of the so-called pictorial style that flourished between about 1375 and 1200 B.C. One group of vases, known as chariot kraters, deserves our attention because of the circumstances of their production and their iconography. The example illustrated here has the characteristic shape, which is also attested in other media, for instance in the mouth and handles of what would have been an ambitious bronze krater as well as in a small-scale version of stone (Figs. 21, 22). On the ceramic vases, the ample, rather regularly shaped zone on the body typically depicts

one or several chariots with other figures or filling motifs. In the present case, behind the car, there appears a very tall female figure with breasts emphasized, arms raised, and a birdlike face. At either end of the scene and under the handles stand stylized plants of Egyptian derivation, such as palms and papyrus.

Chariot kraters have come to light primarily on the island of Cyprus, where refugees fled as the great palace centers of the Greek mainland collapsed. Scholars first assumed that the vases were made on Cyprus specifically for this group of immigrants. Excavations in Greece subsequently revealed that they were made in the Argolid, a region of the Peloponnesus in Greece, for export to Cyprus. There is some possibility that only the clay was

FIGURE 21. Rim and handles of an amphoroid krater (deep two-handled vase). Cypriot, 13th–early 12th century B.C. Copper-based metal, diam. 15⅝ in. (39.7 cm). The Cesnola Collection, Purchased by subscription, 1874–76 (74.51.5685)

FIGURE 22. Amphoriskos (small jar). Cypriot, Late Cypriot IIIA, ca. 1200–1100 B.C. Chlorite, h. 2⅝ in. (6.7 cm). The Cesnola Collection, Purchased by subscription, 1874–76 (74.51.5023a)

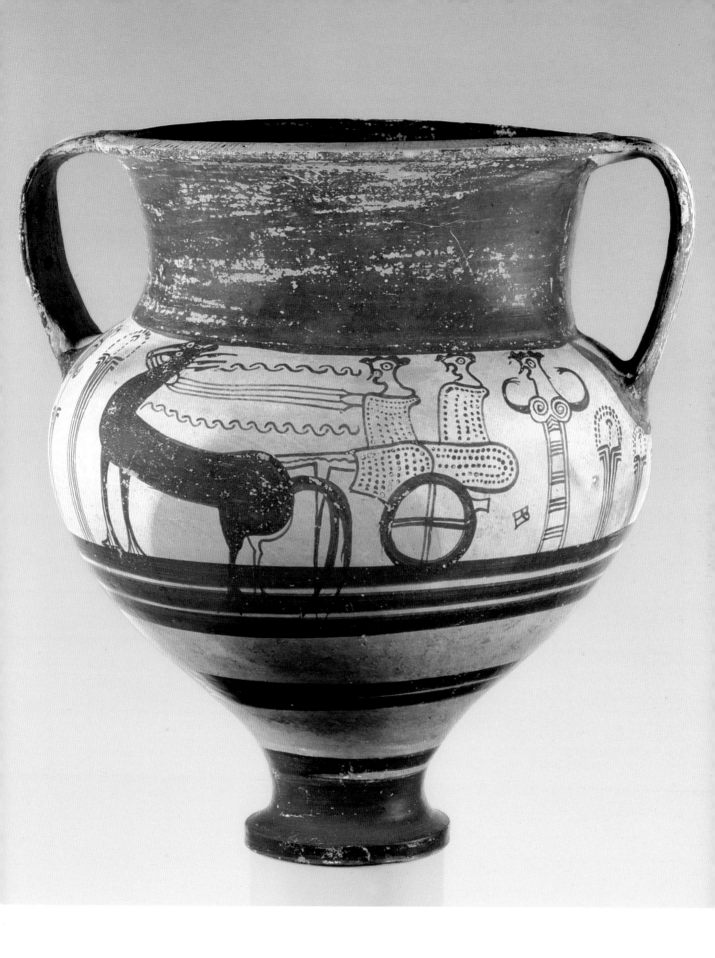

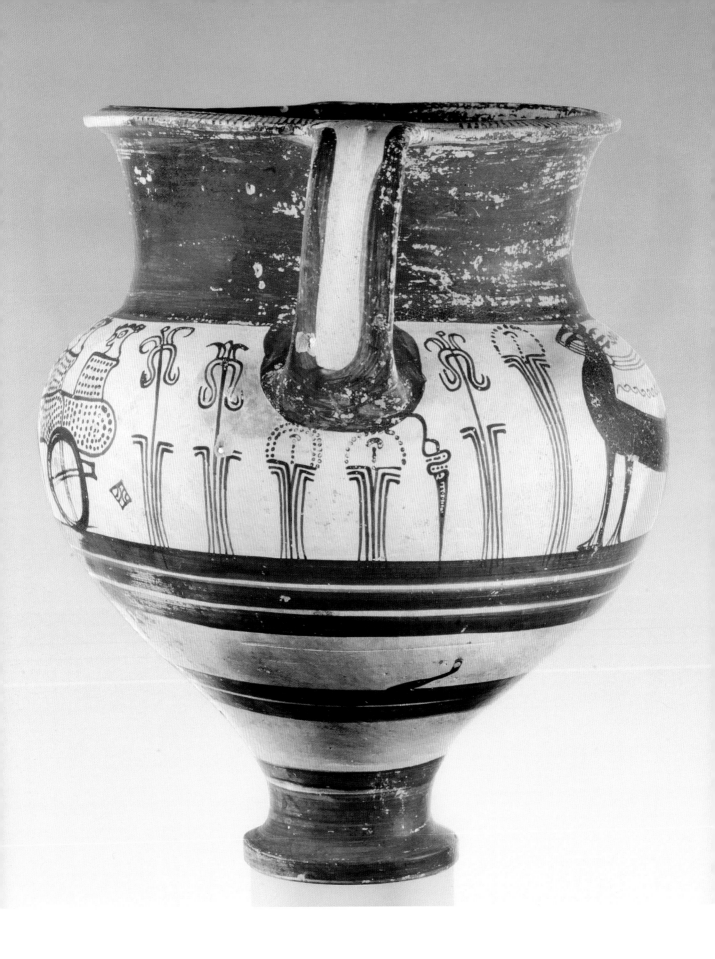

FIGURE 23. Statuette of a woman. Mycenaean, Late Helladic IIIB, ca. 1300–1230 B.C. Terracotta, h. 2⅛ in. (5.4 cm). Fletcher Fund, 1935 (35.11.19)

sent from the Argolid to Cyprus so that they also could be made locally on the island. Since chariot kraters were found principally in tombs, their function and meaning would have been funerary. They may have been used in related rituals before burial.

The decoration typically shows the chariot horses as a solid mass of glaze, while the car and its occupants are rendered in a combination of line and stippling. One wonders if the different manner of execution implies something about the reality of the figures—the horses possibly belonging to this world, the people belonging to the dead. The tall female behind the chariot is equally difficult to interpret. Her sex is clearly important, and the raised arms traditionally denote veneration; she might be a deity or a worshipper. Similar figures are well documented by contemporary terracotta statuettes (Fig. 23).

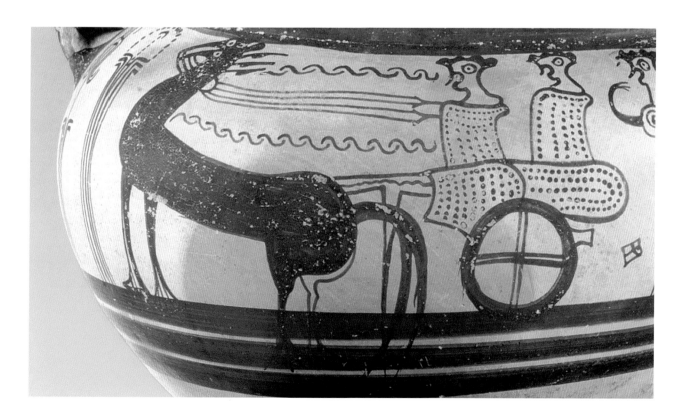

Skyphos (deep drinking cup) with pendant semicircles

Greek, Euboean, 1st half of the 8th century B.C.
Terracotta, h. 3⅜ in. (8.6 cm)
The Cesnola Collection, Purchased by subscription, 1874–76 (74.51.589)

FIGURE 24. Findspots of Euboean skyphoi with pendant semicircles

The fascination of a Greek vase does not always lie in its appearance, which is the reason for including here an aesthetically nondescript piece of exceptional importance. It belongs to a group of similar objects, known as "skyphoi with pendant semicircles," that were made between the ninth and eighth centuries B.C. on the island of Euboea. The skyphos is a deep, open cup with two handles, and it served for drinking. After the fall of the Mycenaean palaces and the ensuing period of stagnation, Euboea—like Cyprus—prospered, with major centers such as Lefkandi and particularly active trade and colonization. Much of the trade in antiquity was in commodities that have left

no traces over two millennia later—wine, oil, textiles and other objects made of organic materials. The skyphoi are quite indestructible and of little intrinsic value. They are, however, invaluable markers of the expansion of Euboean commercial activity from Thessaly and Macedonia across the Aegean Sea to Crete, the Cyclades, and Cyprus, as far as the Near East (Fig. 24). The archaeological evidence for their appearance in Southern Italy and Sicily is, so far, slight. Nonetheless, by the mid-eighth century B.C., Chalkis and Eretria, the two major cities of Euboea, were establishing colonies, at Pithekoussai on the island of Ischia in the Bay of Naples and also on the Chalcidice in northern Greece.

The skyphos illustrated here represents a typologically advanced form that occurs with some frequency on Cyprus. Characteristic are the competent potting and good control of the multiple brush, the tool with which the concentric semicircles were executed; the number of circles on a vase is variable. Skyphoi are among the longest-lived of Greek vase shapes, probably because they were easy to make and practical to use. They remained popular in Greece through the fourth century B.C. (see No. 29) and later in the wares of Southern Italy (see No. 33).

Krater (monumental two-handled bowl) with sea battle

Greek, Attic, 1st quarter of the 8th century B.C.
Attributed to the workshop of New York MMA 34.11.2
Terracotta, h. 39 in. (99.1 cm)
Fletcher Fund, 1934 (34.11.2)

Between about 900 and 300 B.C., Athens and the surrounding parts of Attica constituted the center of painted pottery production in mainland Greece. Although a high percentage of the region's output is no longer extant, enough remains to indicate that a large number of vases were made for use in specific social or ritual contexts. Perhaps the most prominent of these was funerary.

The vase represents a group of large examples that served as grave markers. A hole at the bottom of the body allowed liquid offerings to flow into the earth below. These works began the tradition of monumental tomb markers in the West and were replaced at the turn of the seventh to the sixth century B.C. by sculptures in stone

(see Figs. 26, 30). There is nothing intrinsically funerary in the krater shape, yet the scale makes it a public monument. It also provides considerable space for decoration. This early work unfortunately has suffered considerable losses, but what remains is extremely important. The upper and widest portion of the body, to just below the handles, is subdivided into horizontal bands and vertical compartments filled with the rectilinear and curvilinear motifs that give Geometric art its name. The square in the center of the handle zone on both sides originally contained a depiction of the prothesis, the laying out of the deceased. The vase that follows here (No. 6) will allow us to consider the subject in greater detail.

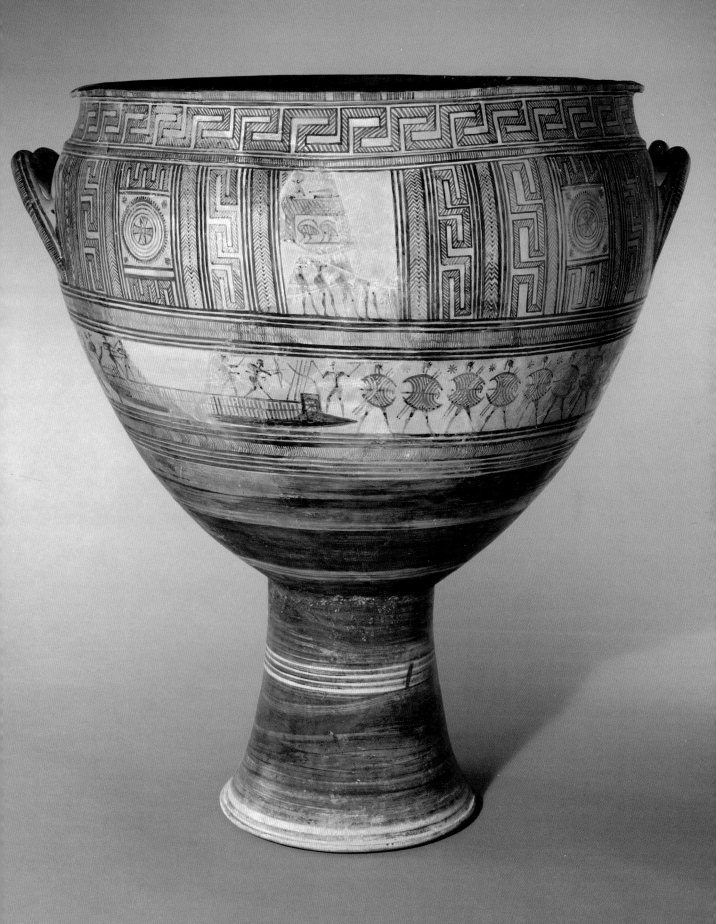

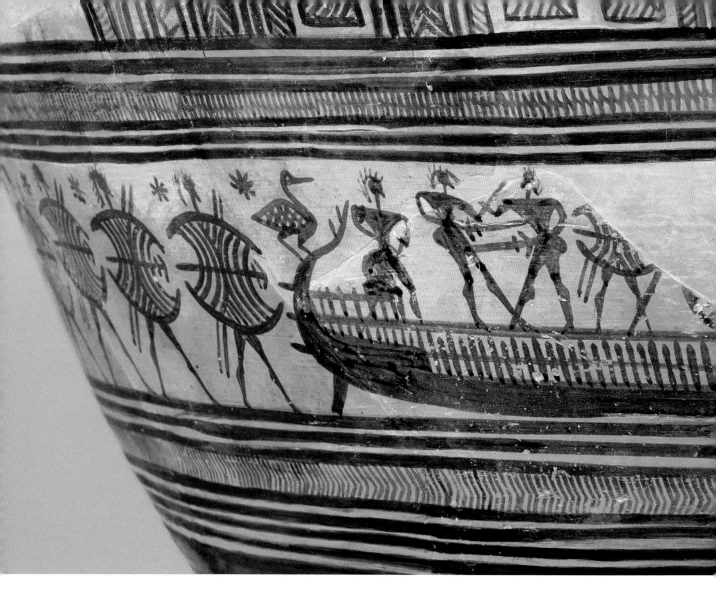

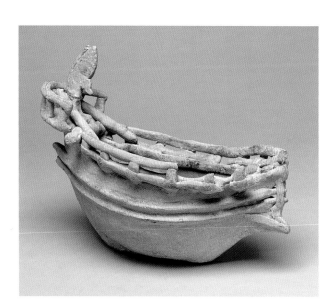

FIGURE 25. Model of a warship.
Cypriot, ca. 750–480 B.C.
Terracotta, h. 7 in. (17.8 cm).
The Cesnola Collection,
Purchased by subscription,
1874–76 (74.51.1752)

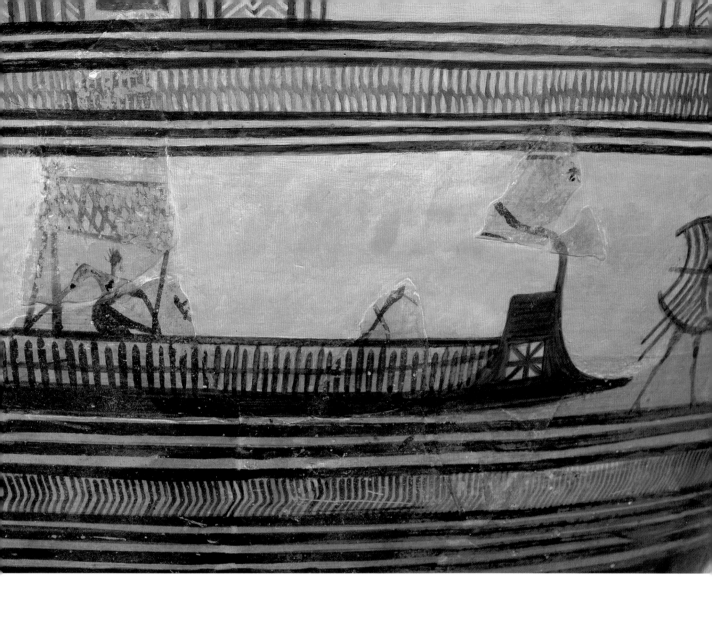

The most remarkable part of the krater is the zone that runs all around the body just below its widest point. Though damaged on both sides, the scene shows two warships that are beached and flanked by armed foot soldiers. There are combats on each ship. Of particular note is the figure preserved on one side. The spiky hair identifies her as a woman. She is seated under a sail or canopy of some kind in the middle of the vessel and may be fettered. A roughly contemporary model of a warship from Cyprus provides a less artistically accomplished but structurally detailed rendering of such a ship (Fig. 25).

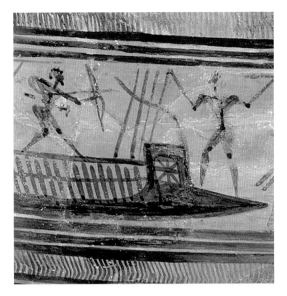

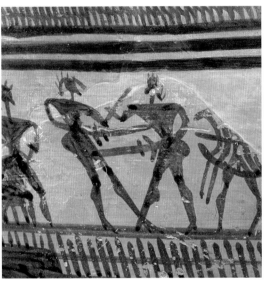

Although we have no way of interpreting the action correctly, the depiction itself is exciting. The decoration on Geometric vases evolved from the exclusive use of geometric ornament to the progressive introduction of animal and human subjects. On this example, though ornament still predominates, the figural zone presents a complex confrontation, implying a long, action-packed story. We catch a glimpse here of the situations that our Euboean skyphos (No. 4) and its counterparts must have been a part of as cargo ships and warships plied the Mediterranean Sea. We also see a visual counterpart to the events that Homer described, particularly in the *Odyssey*. Homer compiled his epics during the same century in which this vase was made, or slightly later. And, finally, this is also the time when writing was introduced into Greece by intermediaries familiar with Phoenician script; the alphabet ultimately allowed the poems of Homer, and much else, to be recorded. Interestingly, there is one reference to writing in the *Iliad*. It occurs in connection with King Proitos of Argos, who sent the hero Bellerophon to distant Lycia, "and gave him baneful tokens, graving in a folded tablet many signs and deadly . . . that he might be slain." (Homer, *The Iliad,* Book 6, lines 166 ff., trans. A.T. Murray, Loeb Classical Library [Cambridge, Mass.: Harvard University Press, 1988])

The ingredients of the scenes on the krater—large sailing ships, with soldiers, combats, possibly booty in the form of captives—show us an aspect of life in the eighth century B.C. and also of mythology. In Greek art, distinctions between the two are often difficult to draw because the two types of subject are rendered similarly and incorporate many of the same tangible details.

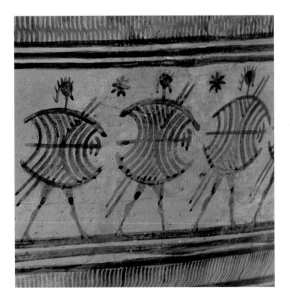

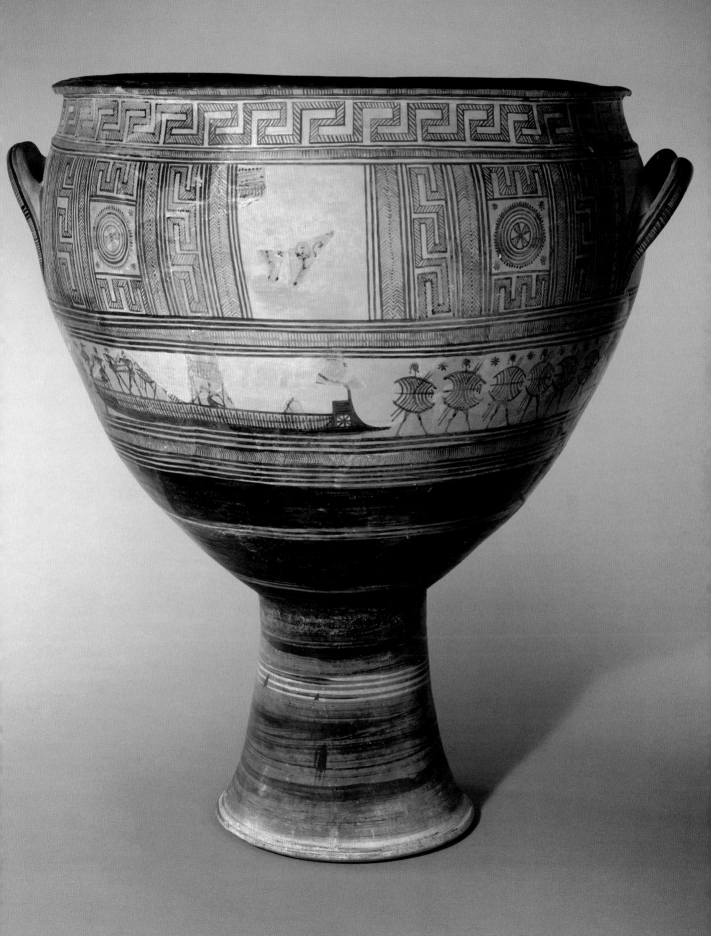

Krater (monumental two-handled bowl) with prothesis

Greek, Attic, ca. 750–735 B.C.
Attributed to the Hirschfeld Workshop
Terracotta, h. 42⅝ in. (108.3 cm)
Rogers Fund, 1914 (14.130.14)

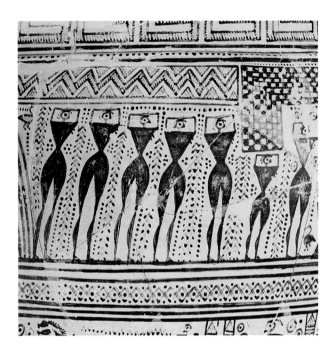 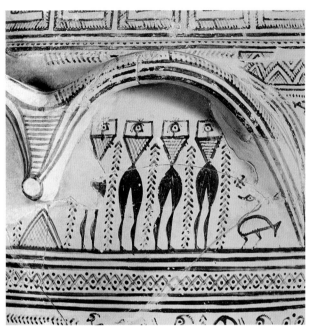

This krater, datable about a half century later than the preceding one (No. 5), shows the increased prominence of figural decoration in relation to ornament. In both the program and the execution, the decoration is also more fully integrated. The primary scene, centered between the handles in the shape of bulls' heads, shows the prothesis, the laying out of the deceased. The funerals of prominent individuals were elaborate events in Athens. On the day after death, the body was wrapped in a shroud and placed on a bier consisting of a bed or couch. Professional mourners as well as members of the person's household attended it. This is the subject of the upper figural frieze. The checkered shroud has been lifted for the benefit

of clarity. Family members are shown on the bier and at the foot of it. To either side, women wail their lament. Early on the third day, the burial took place—and it is only rarely depicted. The prothesis that seems to have been introduced almost incidentally on the preceding ship krater is now deployed over the whole front of the vase. Even 2,700 years later, we understand immediately what is going on, however schematic the execution might be. Although there is nothing that we would consider naturalistic in the rendering of volumes and spatial relationships, it is inaccurate to label the work simplistic or primitive; the precision with which all the motifs are executed on the large, curved surface indicates an extraordinary artist.

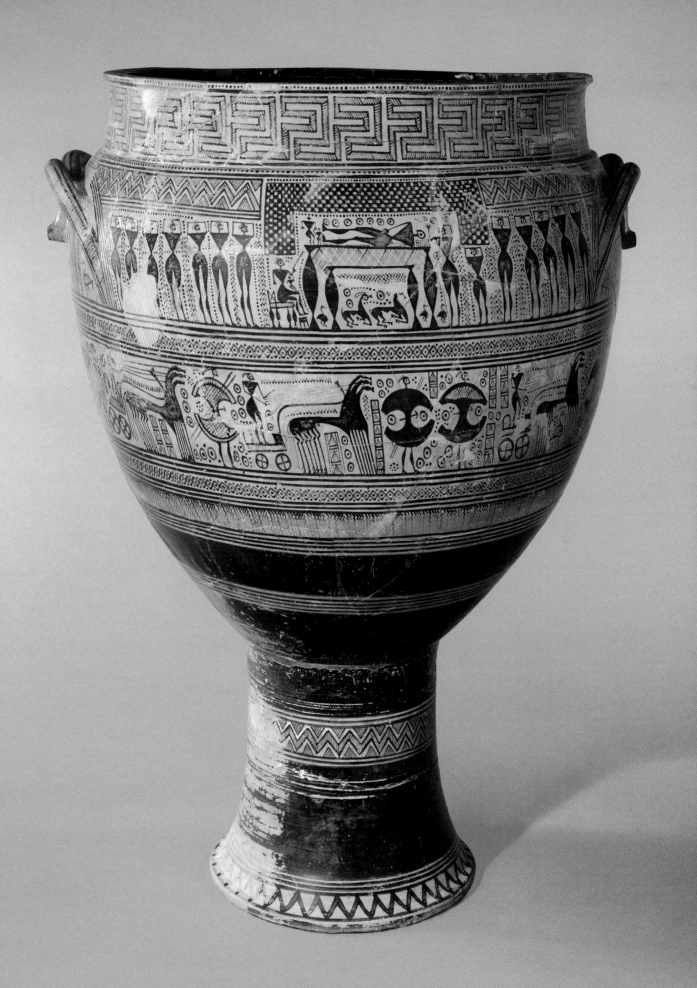

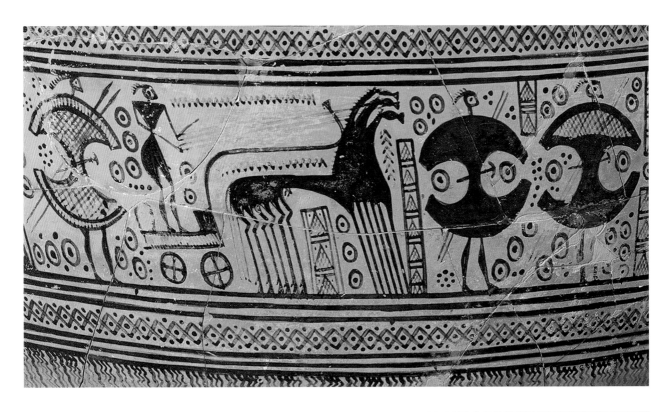

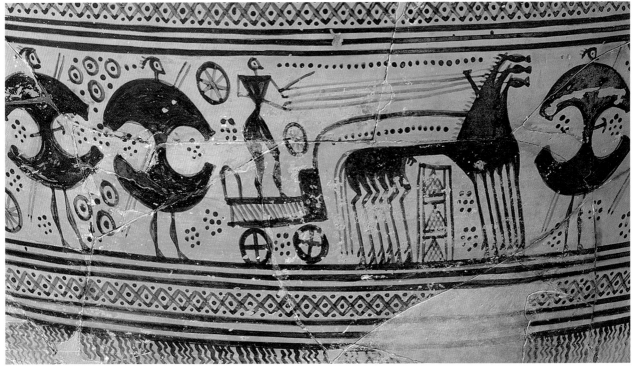

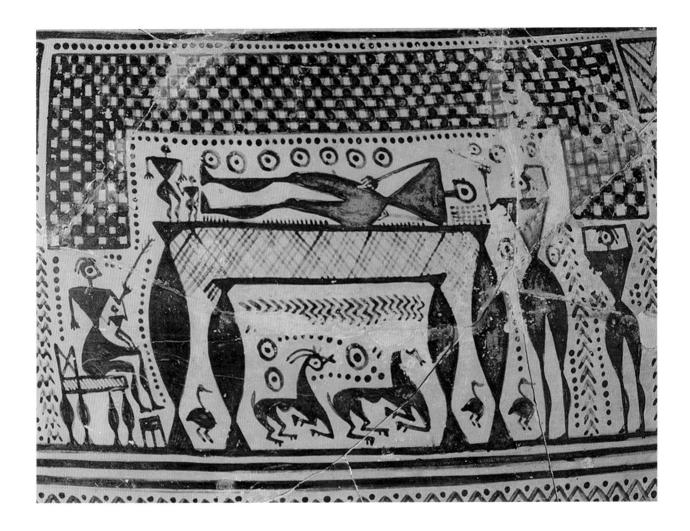

The lower band of decoration shows a procession of chariots interspersed with foot soldiers carrying swords and spears; some also have shields of hourglass form. Like prothesis scenes, processions of chariots and/or horses occur frequently on funerary vases. We have seen one before on the Mycenaean chariot krater (No. 3). There, as here, the meaning is unclear. By the eighth century B.C., chariots were no longer used in battle. They do figure prominently in the *Iliad* and *Odyssey*, Homer's epics of the Trojan War, which is generally dated to the thirteenth or early twelfth century B.C. In both prehistoric and historic times, horses and chariots imply wealth and status,

for only the privileged could afford the expense. The hourglass shields carried by the warriors are interpreted by some scholars as descendants of prehistoric counterparts; as no actual examples have ever been found, we do not know whether they are remembered, invented, or pieces of contemporary equipment. The zone of chariots, in any event, seems to glorify the deceased, metaphorically by comparing him to heroes of Greece's past or actually by celebrating a redoubtable warrior. The procession is an essential complement to the scene above, where the deceased, however significant in life, lies mourned but naked on the bier.

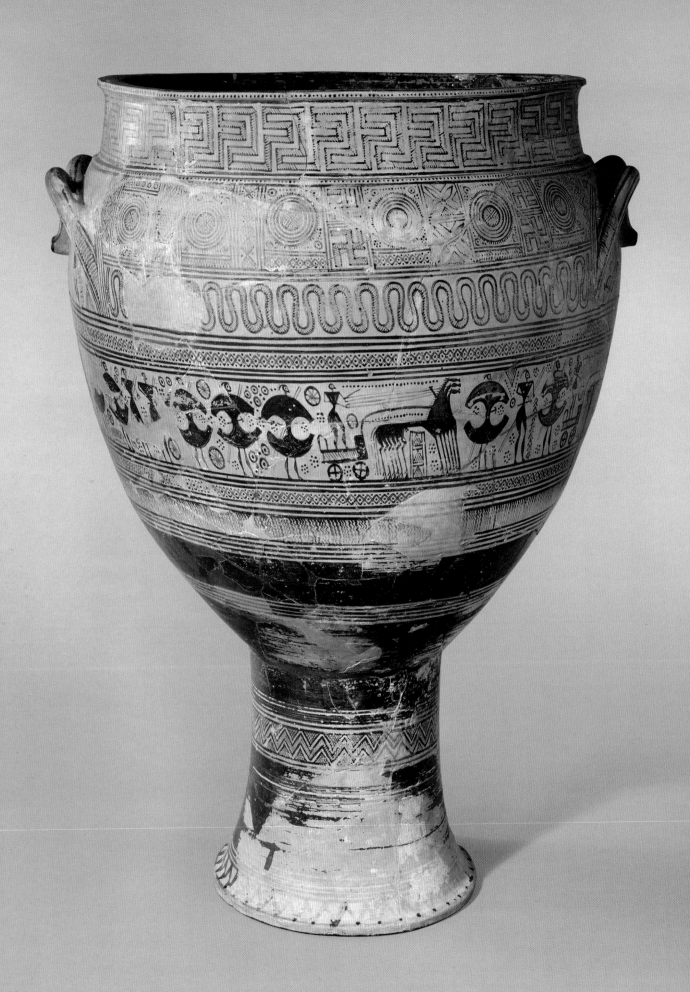

The nature and placement of the ornament contribute significantly to the homogeneous effect of the whole vase. The complex meander on the mouth provides a strong crowning element. The succeeding bands delimit the figural zones on the progressively narrow body. The intricacy and precision of the various motifs lend refinement, almost preciousness, to the surface of the krater, notwithstanding its size. The ornament performs a remarkable dual function of defining both the environment within the confines of the shape and the primary matter out of which the figures are formed.

7

Pomegranate

Greek, Attic, ca. 750 B.C.
Terracotta, h. 4 in. (10.2 cm)
Rogers Fund, 1912 (12.229.8)

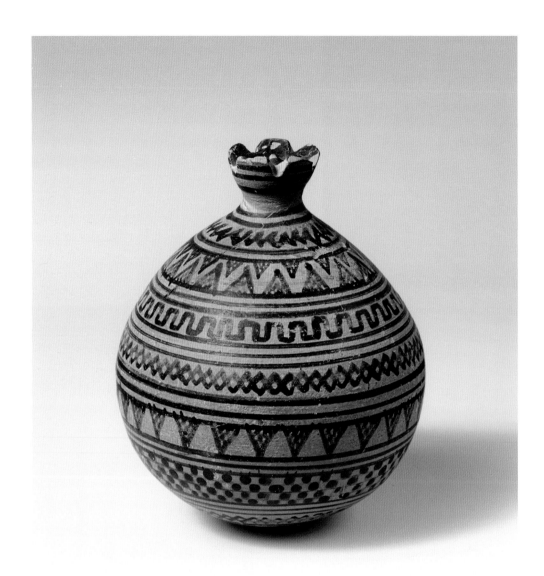

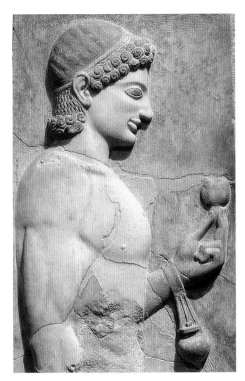

FIGURE 26. Grave stele (grave marker) of a youth and a little girl. Greek, Attic, ca. 530 B.C. Marble, h. 166 11/16 in. (423.4 cm). Frederick C. Hewitt Fund, 1911; Rogers Fund, 1921; and Anonymous Gift, 1951 (11.185a-c,f,g). Detail

Modern scholarship makes distinctions that were probably meaningless in antiquity. This work in the form of a pomegranate is considered a vase rather than a terracotta because it was turned on the wheel and has a small hole at the bottom that allowed for the introduction of liquids or possibly small pebbles; in that case, it would have served as a rattle. Vases in the shape of figures, parts of figures, and occasionally objects were popular throughout the history of Greek pottery. They encourage us to look at them not strictly as containers but rather as creations that have many points of reference, particularly to natural life.

The pomegranate is readily recognizable from its form and the floret at the top. It is decorated with a succession of geometric motifs separated by groups of three lines except at the top and bottom, where there are two. It is impossible to know if any of the patterns had a specific

meaning. One might wonder, for instance, if the checkerboard that appears here and serves as the cloth covering the deceased on the krater No. 6 could have a funerary reference. Pomegranates have had an exceedingly long history as symbols of fertility and regeneration. Clay counterparts like this one were deposited in tombs and dedicated as offerings. In later Greek art, especially sculpture, figures holding the fruit occur often. The most prominent example in the Museum's classical collection occurs on the fine Attic grave monument dedicated to a youth called Megakles and dated about 530 B.C. (Fig. 26).

The pomegranate came to Greece as part of a great influx of influences from Egypt and the East during the eighth and seventh centuries B.C. In art, the manifestation is clearest in the new subjects—compound creatures such as sphinxes, sirens, centaurs, and griffins; plant life such as lotuses and palmettes; and many stories of heroes killing monsters, such as Perseus lopping off the head of Medusa. The carriers of these innovations included perishable materials, notably textiles, that have vanished without a trace. As our pomegranate shows, the new fruit was assimilated quickly into the repertoire of shapes and was readily decorated with contemporary patterns. Moreover, the motif became popular not only in three dimensions but also interpreted as a framing and filling ornament. It is particularly characteristic of the sixth-century pottery of Laconia (Fig. 27). The applicability of forms to different uses is characteristic of Greek vases and, indeed, of all Greek art.

FIGURE 27. Kylix (drinking cup). Greek, Laconian, black-figure, mid-6th century B.C. Terracotta, diam. 7 3/8 in. (18.7 cm). Gift of The American Society for the Exploration of Sardis, 1914 (14.30.26)

Oinochoe (jug) with an animal frieze

Greek, Protocorinthian, black-figure, ca. 625 B.C.
Attributed to the Chigi Group
Terracotta, h. 10¼ in. (26 cm)
Bequest of Walter C. Baker, 1971 (1972.118.138)

The figural repertoire of Attic Geometric vases consists of a fairly limited selection, principally horses, birds, goats, and human figures. The new bestiary that was introduced from the East during the late eighth and the seventh centuries B.C. found rapid and ubiquitous acceptance among Greeks from Asia Minor (present-day Turkey) to Italy. Animals, typically arranged in rows, are a constant feature of vase-painting from the late seventh through the sixth century B.C.

The region of mainland Greece in which this animal style flourished most extensively was Corinth. The century from about 725 B.C. on produced the finest examples and saw the introduction of the black-figure technique. The jug represents one of the most common and utilitarian of all vase shapes. The conventional name—oinochoe, from the Greek words for wine and pouring—indicates the primary but certainly not exclusive function. The trefoil lip facilitated its use. Counterparts are known in bronze (Fig. 28) and silver.

The main decoration, around the widest portion of the body, shows an array of animals disposed in facing pairs, such as a stag and goat under the handle or the two sphinxes flanking a bird at the front; others are back to back. They are rendered in black glaze with details articulated in incision and added red to differentiate further the various parts of the bodies. Around the top of the shoulder appear tongues, each individually outlined, with three black ones alternating with one red. This interplay of two colors and incision continues in the network of meticulously executed scales. Finally, dot rosettes in added white decorate the mouth and neck.

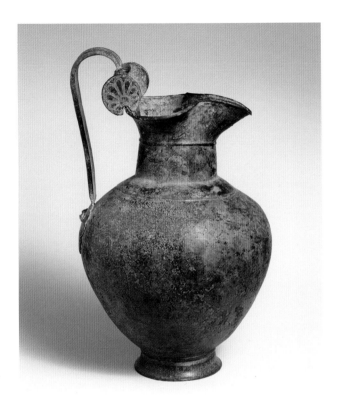

FIGURE 28. Oinochoe (jug). Greek, mid-6th century B.C. Bronze, h. 13⅛ in. (33.3 cm). Rogers Fund, 1945 (45.11.3)

The thousands of Corinthian vases that were produced—of progressively poor quality as the sixth century advanced—and the wide area over which they were exported served to disseminate both the iconography and the black-figure technique. The innovations that had been developed in Corinth bore the greatest fruit in the region of Athens.

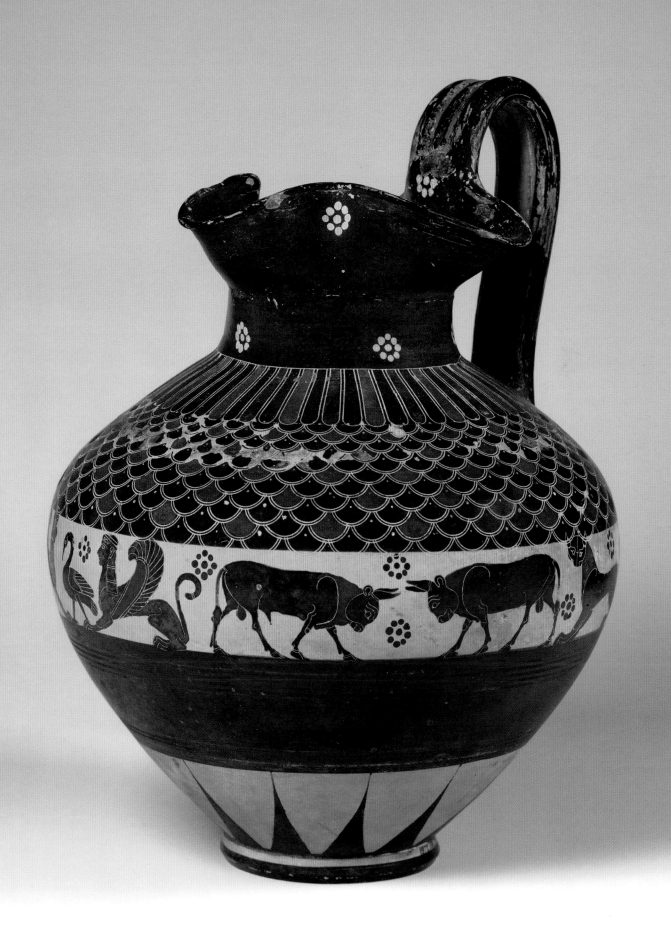

Aryballos (oil flask) with pygmies fighting cranes

Greek, Attic, black-figure, ca. 570 B.C.
Signed by Nearchos as potter; attributed to Nearchos as painter
Terracotta, h. 3¹/₁₆ in. (7.8 cm)
Purchase, The Cesnola Collection by exchange, 1926 (26.49)

This little oil flask is one of the most accomplished, original, and amusing vases in the Museum's collection. Every feature of the piece is perfectly integrated and interrelated. Together with other surviving works by Nearchos, the aryballos establishes his stature as one of the leading early Attic black-figure masters.

The size of a Greek vase is always appropriate to its function and its relation to the human body. The aryballos, like the pomegranate (No. 7), fits perfectly into the palm of the hand. As we can see on the Museum's funerary monument of Megakles datable about 530 B.C. (Fig. 26), the container could also be suspended from the wrist. Known in other materials such as bronze, silver, and later glass, the aryballos was an essential part of an athlete's equipment and identified a young Athenian in a manner that obviously carried social prestige. Training the body complemented educating the mind in preparing youths to become effective citizens and warriors.

The shape is of the early type adopted from Corinth (Fig. 29). It has a disk-shaped mouth and a single broad handle, both of which provide surfaces for decoration. The Nearchos vase is extraordinary for the combination of figural narrative subjects with three zones of polychrome, contrapuntal crescents. The principal representation, deployed around the lip, shows the combat between the pygmies and cranes. The story was already known to

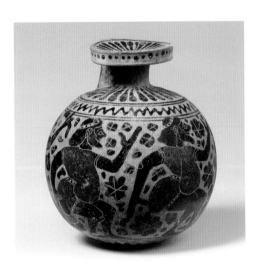

FIGURE 29. Aryballos (oil flask). Greek, Corinthian, black-figure, ca. 620–590 B.C. Attributed to the New York Comast Painter. Terracotta, h. 4³/₈ in. (11.1 cm). Rogers Fund, 1906 (06.1021.17).

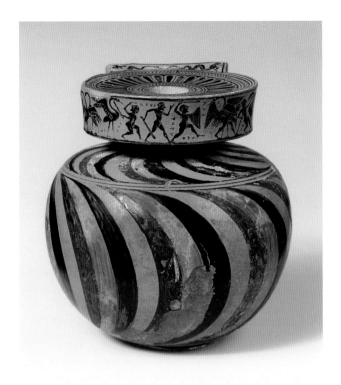

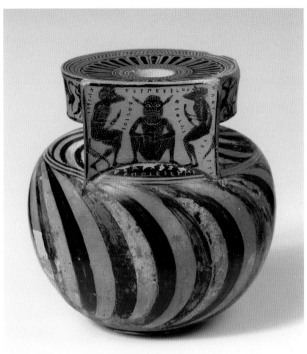

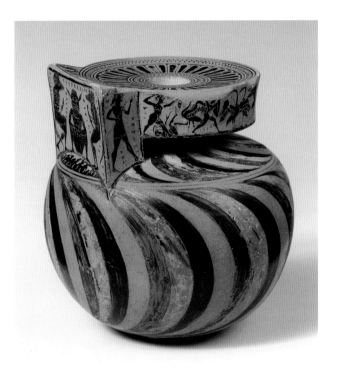

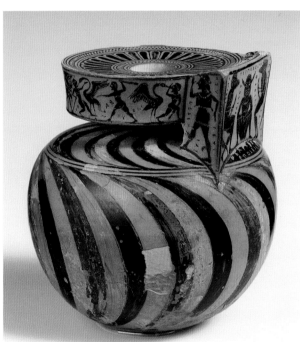

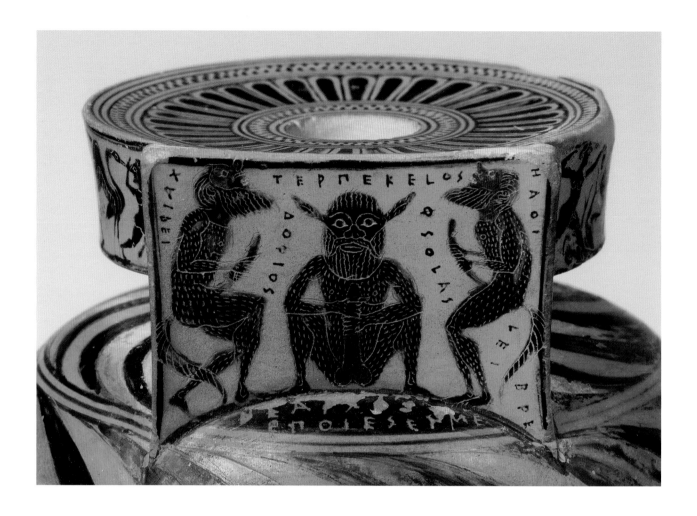

Homer and Hesiod, and it appears on the François Vase, a large volute-krater in the National Archaeological Museum, Florence, which is a compendium of mythological scenes and is contemporary with our aryballos. The essence of the tale is that, every autumn, the fields of the basically agricultural pygmies were threatened with devastation by migrating cranes. The pygmies mobilized to fight off the attack on themselves and their livelihood. Nearchos' imagination and technical mastery make the most of this ridiculous and deadly conflict. The principal surface of the handle shows three satyrs masturbating. Satyrs, part human, part equine, are the male followers of the wine god Dionysos. Their mythology basically belongs to that of Dionysos, and on this vase, they join the pygmies as

creatures that are uncouth, exotic, and full of vitality. The glaze inscriptions surrounding the pygmies and cranes have no obvious meaning; those around the satyrs give their names, which might be rendered loosely as Masturbator, Retracted Foreskin, and Enjoying It Up. Of particular note is Nearchos' signature as potter incised in the black field below the satyrs.

On the narrow sides of the handle appear Hermes and Perseus, with their names inscribed. Perseus was the hero who killed the Gorgon, Medusa, while Hermes was the messenger of the gods (see No. 27 and Fig. 55). They share the capacity for flight, although Hermes is not depicted with wings. The spandrels between the outer edge of the lip and the top of the handle are occupied by

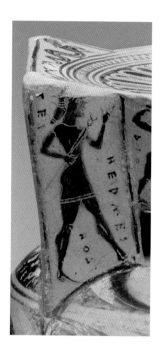
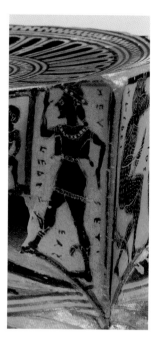

two tritons, inhabitants of the sea. The top of the lip shows tongues, alternately black and red. The body of the aryballos is decorated with three zones of crescents that whirl in opposite directions and are painted in reserve, black glaze, added red over glaze, and added white over glaze. These colors represent the limits to which the black-figure technique could be stretched in the early sixth century B.C.

The Nearchos aryballos is all about movement around the vase—and on land, sea, and air. How much more the iconography may imply is impossible to say. Since the shape is inextricably linked with athletes, one has to wonder whether the decoration of the lip and handle might be directed toward the activities of the gymnasium.

One might also ask whether the subjects bear any relation to a motif that is very common on Corinthian vases, especially aryballoi, and is well represented in other Greek fabrics. The squat fellows cavorting around these pieces are known as padded dancers or komasts (revelers). Recent scholarship has identified them particularly as performers in rituals and has weighed their possible connections with satyrs. Because they appear in Dionysiac contexts or with Dionysiac attributes, the komasts are linked with the wine god and his mythology. Nearchos' creativity on our aryballos may include a playful reference to these Corinthian comic types.

Amphora (jar) with Theseus and the Minotaur

Greek, Attic, black-figure, ca. 540–530 B.C.
Signed by Taleides as potter; attributed to the Taleides Painter
Terracotta, h. 11⅝ in. (29.5 cm)
Purchase, Joseph Pulitzer Bequest, 1947 (47.11.5)

The turn of the seventh to the sixth century B.C. brought two revolutionary innovations to Greek art, both of which developed most significantly in Athens. The first is the introduction into monumental sculpture of the nude standing youth known as a kouros (Fig. 30). The kouros established the nude male figure as a focus of artistic investigation. The function of the works was to serve as dedications in sanctuaries and more often as grave markers. The second innovation was the proliferation of narrative subject matter in all media, most plentifully in vase-painting. The two developments, in my view, are connected. The emergence of the kouros initiated the representation of man individually, as he looked, as he moved, and in time, as he thought. The depiction of narrative showed the broad range of situations, mythological and mundane, in which human figures, immortal and mortal, played a part.

By the middle of the sixth century B.C., vase-painting in Athens had acquired a canonical range of shapes, ornament, and subject matter; black-figure was the dominant technique. The amphora was the basic type of pot for storage. Although its original lid is missing, this one made by the potter Taleides offers a fine example. Within the very black surface, the panels containing the representations are placed so that the palmette lotus festoon at the top is just below the upper attachment of the handles, and the pictures are enhanced by the swelling volumes of the shape. The scene depicts the hero Theseus killing the Minotaur. In a distant mythological past, Athens was controlled by Minos, king of Crete. He required an annual tribute of seven Athenian youths and maidens whom he confined within his labyrinthine palace. The labyrinth also contained the Minotaur, a monstrous combination of

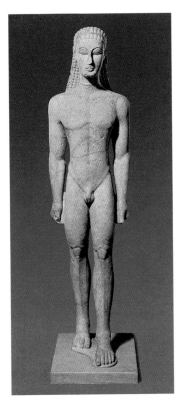

FIGURE 30. Statue of a kouros (youth). Greek, Attic, ca. 590–580 B.C. Marble, h. without plinth 76⅝ in. (194.6 cm). Fletcher Fund, 1932 (32.11.1)

a man with a bull's head, who killed and consumed the Athenians. Theseus, heir to the Athenian throne, set out to kill the Minotaur and liberate the likely victims. He did so with the help of Minos' daughter, Ariadne, who provided him with a clue, a ball of thread, to enable him to find his way out of the labyrinth. The protagonists on the vase are flanked by two youths and two maidens, possibly representing the yearly Athenian tribute. The meticulously patterned garments of the women, the dotted pelt of the Minotaur, and the details of Theseus' dress and hair

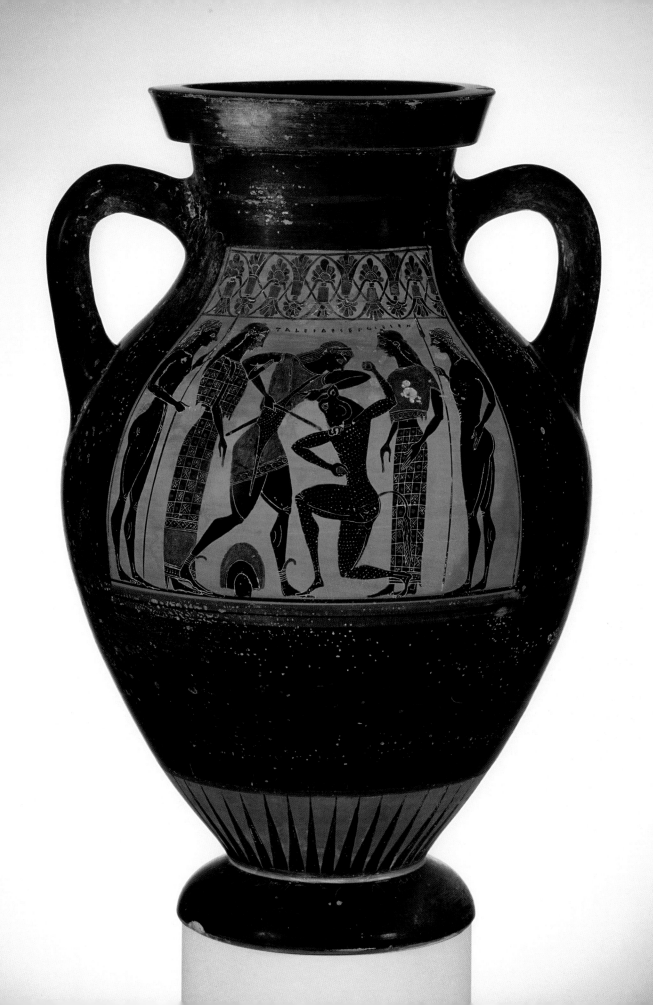

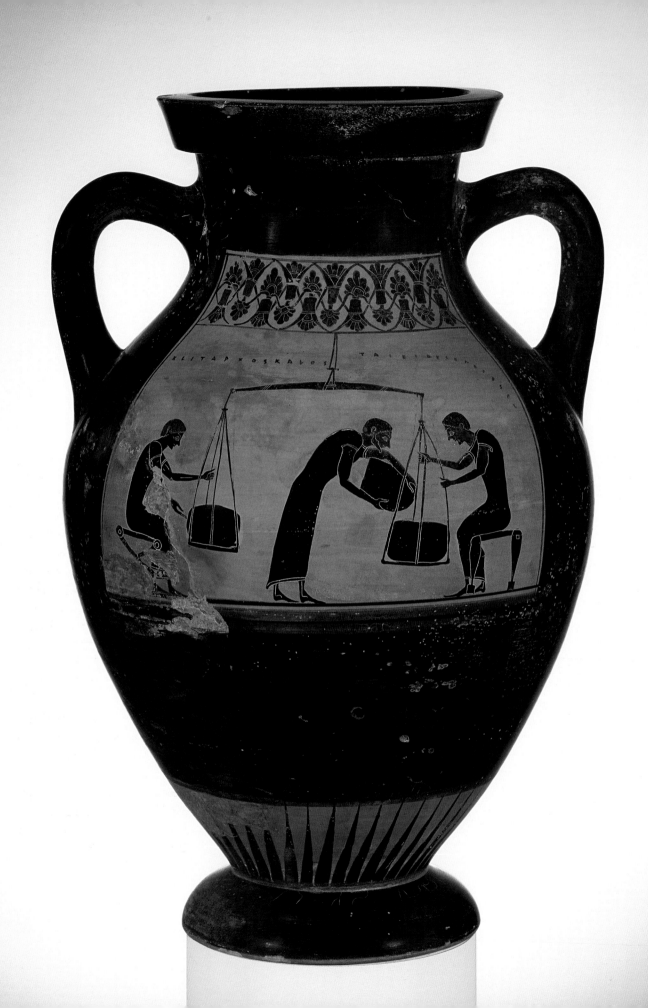

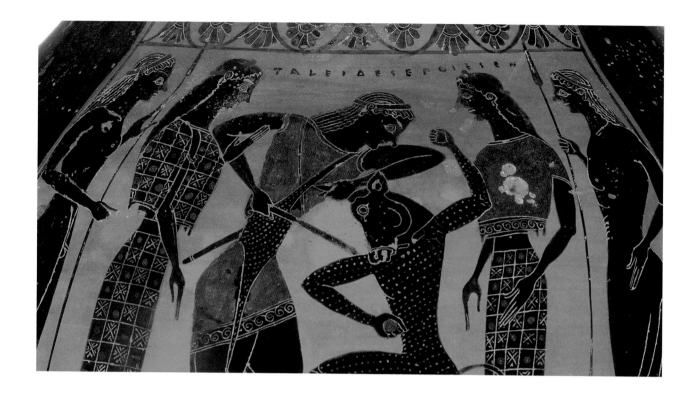

show the artist's command of incision. The object on the ground between the hero's legs is probably a folded garment. Fitted into the available space above the figures is Taleides' signature as potter.

The panel on the reverse takes us to a scene of daily life. A large balance is suspended from the line below the palmette-lotus ornament. Two youths are steadying the pans, in each of which is a deep round container. The youths sit on stools, one folding, one rigid. In the center, a man wearing the same long garment as his counterparts seems to be emptying the container he holds into the one on the scale; another possibility is that we are seeing the top of a large scoop of some kind. In any case, the seated youth is holding the suspension cords firmly in place. A nicely observed detail is that the container being filled is just a little lower than the other. Depictions of the logistical aspects of life that were fundamental to a complex social community—agriculture, crafts, commercial transactions—are rare, especially in view of how common they actually must have been. It is impossible to know what commodity is being handled here. Of interest is the appearance of the individuals with their close-cropped

hair painted red and their long, close-fitting garments. If the scene on the obverse reflects the appearance of sixth-century Athenian maidens and youths, dressed and nude, the manifestly different figures on the reverse may be foreigners. Of note also is that, perhaps owing to ample free space, two inscriptions appear on this side. One praises a youth called Kleitarchos. The other repeats the potter signature of Taleides. Taleides was clearly aware that this vase had two sides and wanted all who saw it to know that he had made it. The importance of the inscriptions extends beyond antiquity. The vase was discovered in or before 1800 in Agrigento, Sicily, and was first published in 1801. It is the first vase with a Greek potter inscription to become known in modern times.

The amphora raises one further consideration that is present in all vases whose decoration consists of more than one subject: are the subjects related? It is not unusual to find a mythological and a genre scene on opposite sides of a work. In the present case, a connection is not evident. At most, one could wonder if this storage jar might have contained the commodity depicted on the reverse or if the product were a specialty of Athens or Crete.

Neck-amphora (jar) with man and woman in chariot

Greek, Attic, black-figure, ca. 540 B.C.
Attributed to Exekias
Terracotta, h. 18½ in. (47 cm)
Rogers Fund, 1917 (17.230.14a,b) and Gift of J.D. Beazley, 1927 (27.16)

By contrast with the panel amphora (No. 10) that is an essentially dark vase, the neck-amphora is light, owing to the conventions of the decoration. The function of the two shapes was the same, and they were produced in quantity during the second half of the sixth century B.C. Exekias, who was both potter and painter, ranks as the most accomplished master of the black-figure technique and one of the most significant innovators in all Greek vase-painting. This neck-amphora exemplifies the individuality that an outstanding artist could achieve within established practices.

The shape is powerful thanks especially to the fullness of the body in relation to which the primary scene is perfectly placed. The effect is heightened by the handles set very much on top of the shoulder and by the presence of the lid. The figural decoration at the center of the two main sides is framed by the four pairs of spirals that emanate from the lower attachments of the handles. It is worth pausing to note the sureness required to draw such a number of regular spirals on a markedly convex surface. The scenes on the front and back are comparable. Four horses of consummate elegance draw a chariot occupied by a woman who holds the reins and a bearded man wrapped in a cloak; both figures wear wreaths. On the front, they are accompanied by a woman, a young man playing the kithara (the type of lyre used for performances), and a youth who stands at the front. The reverse shows a woman and an old man behind the horses, and here, the youth is missing.

A secondary scene on the shoulder depicts, on the obverse, three groups of three warriors fighting; the central group is flanked by two horsemen. On the reverse, two dueling warriors are flanked by two pairs of cloaked youths and a pair of youths with horses; they all carry spears. At the far end, two winged youths hasten away but look back.

The neck-amphora is impressive for its grandeur and seriousness. The ease and precision of line are extraordinary. These artistic features hold our attention all the more because the meaning and connection of the scenes

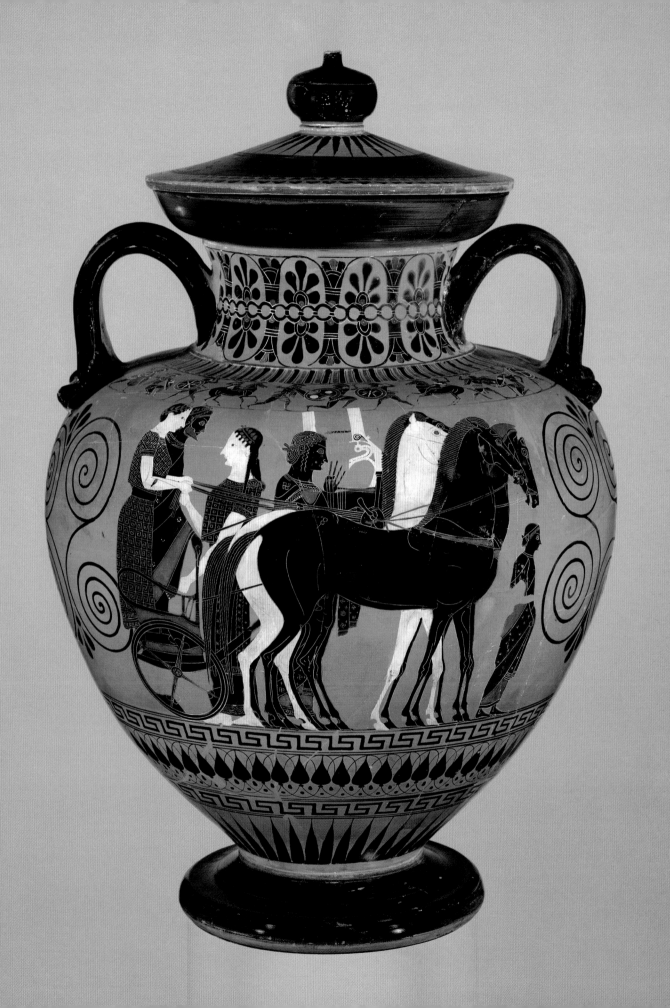

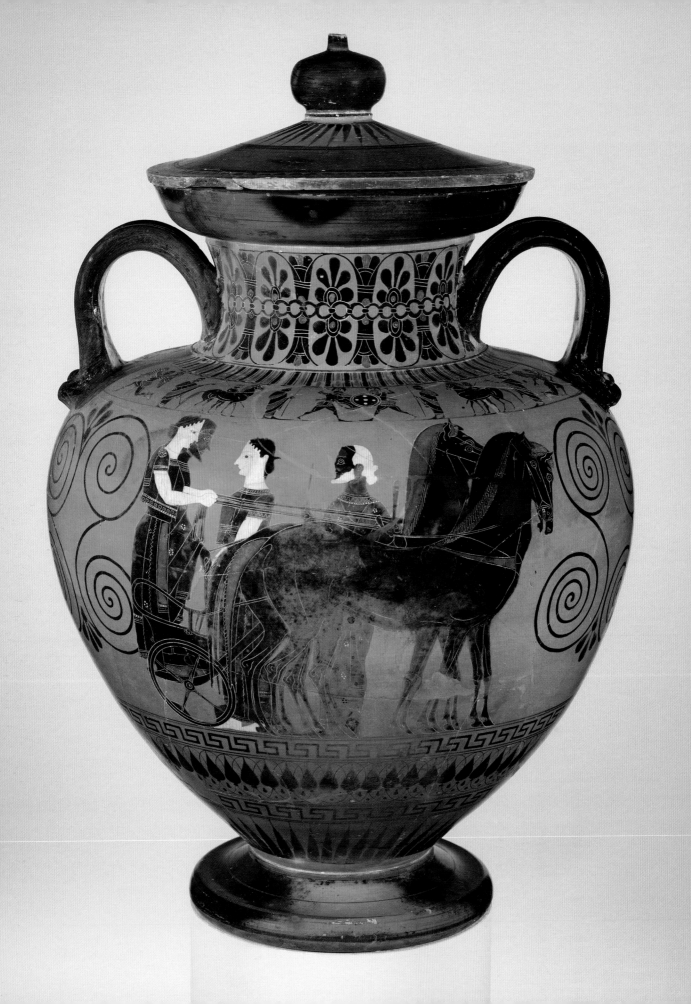

escape us. It is noteworthy that the essential features of the chariots are repeated on both sides, and one has to wonder if the substitution of the young musician by the white-haired man and the removal of the youth on the reverse possibly convey a progression in time. The couple in the chariot is also perplexing. Nothing identifies the female driver as a goddess or a personification. The kithara player lends the obverse a festive air, and his resemblance to Apollo suggests a mythological situation. Any attempt today to identify the representations or the figures must take into account that Exekias was capable of depicting anything that he wished. He could easily have provided attributes or inscriptions to leave no doubt about his intentions. Frustrating as it might be, one must allow for the possibility that the anonymity of the protagonists was intentional.

Contemporary iconography allows for the hypothesis that the subject is a wedding procession and that the couple are the sea nymph Thetis and Peleus. Thetis was fated to bear a son more powerful than his father so she married Peleus, a mortal whose father was a son of Zeus. Their respective lineages would justify the magnificent chariot and the presence of Apollo. The union produced Achilles, the Greek hero of the Trojan War, to which the fighting warriors on the shoulder of the vase may refer. Do we then speculate that the work was a wedding gift? And that, like the funerary krater (No. 6), the iconography elevated the status of the mortal honoree?

Neck-amphora (jar) with Herakles and Geryon

Greek, Attic, black-figure, ca. 540–530 B.C.
Attributed to a painter of the Princeton Group
Terracotta, h. 13 in. (33 cm)
The Bothmer Purchase Fund, 2010 (2010.147)

Artistic individuality, as we understand it today, is not an evident priority in Greek vases. The continuity of traditions—shape, iconography, technique—seems to have been most important. The neck-amphora by Exekias (No. 11) testifies to the power that an artistic personality could exert within existing prescriptions. The example with Herakles and Geryon is a rare preserved case in which the potter—or possibly his patron—felt quite unfettered by existing conventions. Immediately striking here is the complete absence of a foot; the smooth flat resting surface suggests that one was never intended. The absence of rays reinforces the likelihood. For an ostensibly utilitarian container intended for storage, the solution is unexpected. So also is the fact that the bottom of the vase is not more finished.

The mouth of the Geryon neck-amphora is equally distinct, with its disk-shaped lip above a narrow ring and all surfaces covered with glaze. At this time, the top of the lip normally would be reserved and support a lid, as in No. 11. Idiosyncratic as it is, the Geryon vase may also have been covered. As a final detail of the shape worth noting, at the base of each handle where it meets

the body, there is a small hollow, most likely made by impressing a finger.

The decoration of the body of the vase shows the encounter between Herakles and Geryon. Herakles, the most popular Greek hero, is featured here as an archer. In addition to his lion skin that is both belted and tied over the chest, he has a scabbard and a quiver opened to reveal a quantity of arrows. Drawing his bow, he aims at the opponent on the opposite side of the vase. Geryon was composed of three bodies, all fully armed. He lived to the far west on an island in the stream of Ocean that surrounds the world and had a large herd of cattle tended by the herdsman Eurytion and his dog, Orthros (or Orthos). One of the labors of Herakles was to obtain the cattle of Geryon. Here, he takes the first step. Two of Geryon's bodies, facing left, are still in fighting form. The third, turning back, has loosened his grip on the shield and is losing hold of his spear. In rendering all the figures, the artist has taken evident pleasure in articulating details such as Herakles' lion skin and bow or Geryon's garment and shield device. In the spaces under the handles between the two adversaries are sirens flying in the direction of Herakles' arrow.

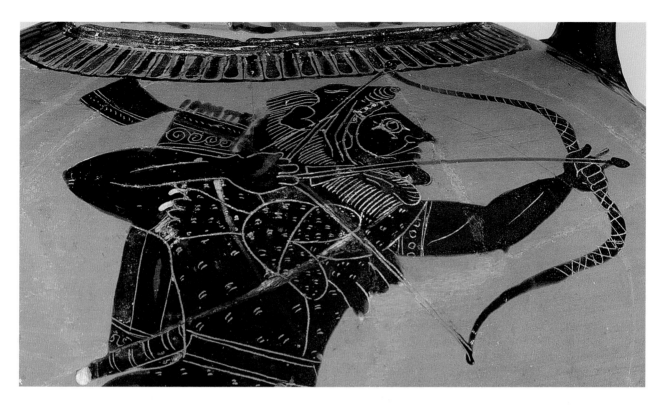

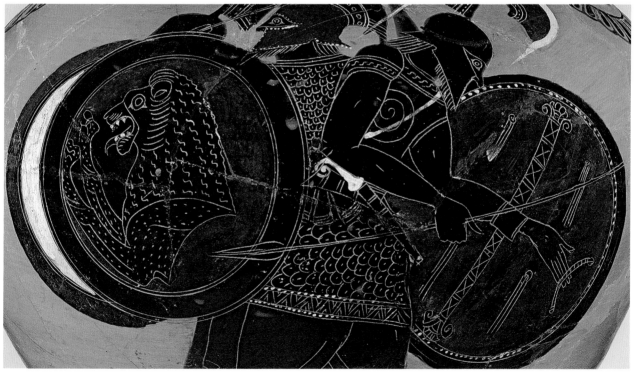

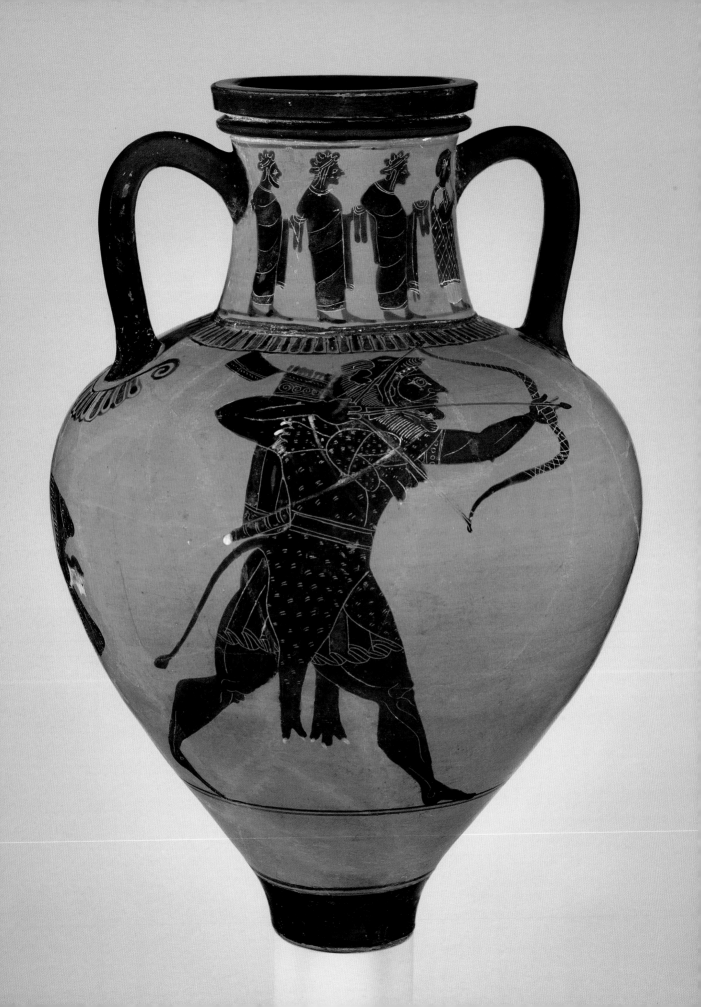

The story of Herakles and Geryon was known to the poet Hesiod, active during the seventh century B.C., and was the subject of a poem in the early sixth century by Stesichoros. It enjoyed some popularity in black-figure vase-painting. The convention, however, was to show both figures together on the same side of the vase. As remarkable as the peculiarities in shape is the allocation of each protagonist here to one side of the pot. This practice became quite common on red-figure works of the fifth century, but was exceedingly rare earlier. As our neck-amphora makes clear, the effect is to emphasize powerfully both the shape and the subject matter.

The decoration on the neck takes us from the realm of mythology to that of civic observances. Each side shows a flute player leading a procession, with two youths and a man above Herakles and two youths followed by a male of indistinct age above Geryon. The men wear wreaths and with their left hands carry something articulated as circular with two pendant appendages. While one might guess that it is meat for a sacrifice, what they carry has not been identified securely. An equally important question is if the iconography here is directly connected with that on the body. Several considerations can be raised. In view of where Geryon lived, this exploit of Herakles has been associated with Greek colonization and trade in the western Mediterranean. Is it possible that the procession on the neck reflects some venture? Or might the vase be connected with the public recitation of a literary work concerning Herakles' pursuit of Geryon?

As part of the larger context of the Geryon tale and the neck-amphora, it is worth noting that the subject was popular in the art of archaic Etruria in the west but also of Cyprus in the east. The Metropolitan Museum's rich collection of Cypriot sculpture includes at least four representations, all of which were dedications in a sanctuary at Golgoi. Particularly evocative is a relief from the base of a statue (Fig. 31). The main section shows the snub-nosed herdsman Eurytion carrying a tree and standing behind the herd of cattle. At the left edge of the slab, Herakles strides forward with the tail of his lion skin between his legs. He has dispatched an arrow into the throat of one of the three heads of Orthros, on the upper right.

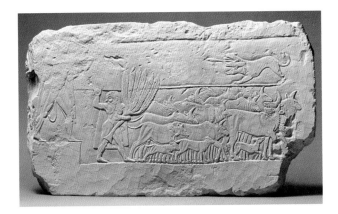

FIGURE 31. Relief with Herakles taking the cattle of Geryon. Cypriot, early 5th century B.C. Limestone, h. 20 1/2 in. (52.1 cm), l. 34 3/8 in. (87.3 cm). The Cesnola Collection, Purchased by subscription, 1874–76 (74.51.2853)

13

Lip-cup with inscription and hen

Greek, Attic, black-figure, ca. 540 B.C.
Signed by Tleson as potter; attributed to the Tleson Painter
Terracotta, diam. 9 3/16 in. (23.3 cm)
Fletcher Fund, 1956 (56.171.34)

The repertoire of Greek vase shapes includes several for drinking, with the kylix as the most common. It first appeared in the Geometric period and evolved through a succession of forms particularly during the sixth and fifth centuries B.C. At that time, the use of kylikes was probably most closely connected with the symposium. Rooted in the association of men performing military service, this was an aristocratic institution that brought Athenian males together to drink, converse, and pursue their pleasure (see No. 23). The symposium was separate from, and followed, a meal. It was conducted according to rules administered by a symposiarch, who presided over the occasion and determined, for example, the ratio of water in the wine that would be consumed. The decoration of kylikes often refers to the symposium directly or through motifs relating to Dionysos, the god of wine.

During the second quarter of the sixth century, the lip-cup was one of the predominant types of kylix. It is a light vase characterized by a horizontal chamfer that divides the bowl into an upper and a lower part. The interior is black and may have decoration in a tondo at the center of the bowl. Even without figural embellishment, the shimmer of the wine on the dark glossy surface would have provided an ever-changing effect. The exterior, as in this example, typically has a motif in the upper register.

Here, we see a hen with remarkably anthropomorphic legs and feet. On the lower register, there is normally a palmette at each handle. The space between often contains an inscription instead of figural decoration. In precisely rendered letters, we read here, "Tleson, son of Nearchos, made [me]." This feature is remarkable in several respects.

Inscriptions—artists' signatures, the names of figures and sometimes even of objects—occur on Attic vases starting in the late seventh century B.C. The texts are

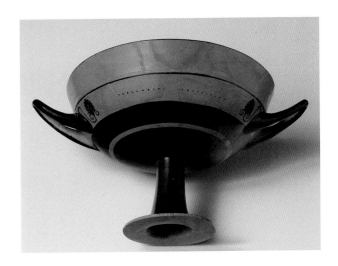

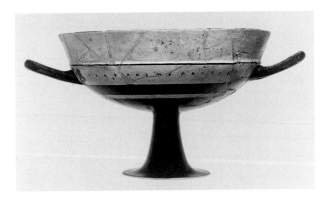

FIGURE 32. Kylix: lip-cup (drinking cup). Greek, Attic, black-figure, ca. 560–550 B.C. Signed by Nearchos as potter. Terracotta, diam. 7¹⁄₁₆ in. (17.9 cm). Purchase, Christos G. Bastis Gift, 1961 (61.11.2)

introduced where appropriate or where there is space (see Nos. 9 and 10). The difference on the lip-cup is that the inscription is treated as decoration. In addition, it addresses the viewer. We can be quite sure because other lip-cups are inscribed with a greeting, "hail," or with the exhortation "hail and drink well" or "hail and drink this." Vases connected with the symposium engage the viewer or drinker in other visually compelling respects, as for instance on the krater No. 16.

A further feature of particular interest in the inscription on the cup is that Tleson is the son of Nearchos, whom we have met as the potter of the aryballos No. 9. Although some vase painters include the patronymic in their signatures, it is unusual. Tleson undoubtedly wished to identify himself as the son of the famous artist. Moreover, we know that Nearchos also made lip cups, thanks to a signed example in the Museum's collection (Fig. 32).

One may ask what significance there could be in decoration that consists of a hen and a potter signature. Since roosters were given as love gifts between men, the hen may also have an erotic connotation (compare, for instance, the French "poule"), and the subject fits the iconography of symposia. The inscription implies that Tleson could write, and as such, it serves as an advertisement for his work but also for his education. It further implies that the symposiasts could read. Reading and writing were exceptional skills in the mid-sixth century B.C. It is worth noting that there are cups with nonsense inscriptions consisting of letters without evident meaning or glaze forms suggesting letters. The Tleson cup, and the numerous inscribed works like it, would be special adjuncts to the gatherings, emphasizing the attainments of all participants.

14

Kylix (drinking cup) with scenes of the Trojan War

Greek, Attic, black-figure, ca. 540 B.C.
Attributed to the Amasis Painter
Terracotta, diam. 10⅛ in. (25.7 cm)
Gift of Norbert Schimmel Trust, 1989 (1989.281.62)

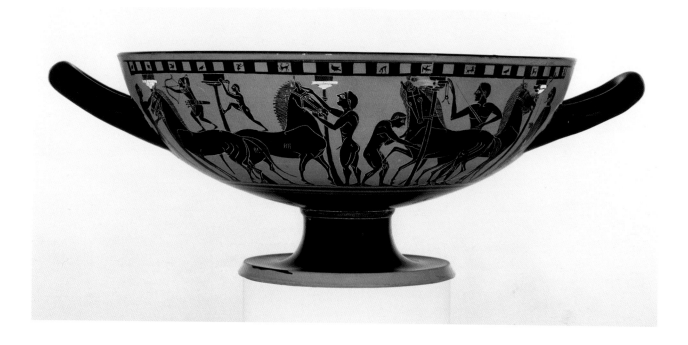

The Amasis Painter ranks with Exekias among the most innovative and skillful of black-figure artists. Although the Amasis Painter seems to have had the longer career, the two were contemporaries, aware of each other's work and quite different in temperament. From signatures, we know that Exekias was both potter and painter. No painter signature survives for Amasis, but the refined concurrence in his pottery among shape, ornament, and decoration makes it likely that he both made and decorated vases. One might think of these two masters in the Athenian Kerameikos—the potter's quarter—as counterparts to Raphael and Michelangelo working in the Vatican for Pope Julius II during the Italian Renaissance.

About 540 B.C., Exekias introduced into black-figure vase-painting a type of cup that had a deep bowl with a continuous profile, a short stem with a clay ring at the junction to the bowl, and a rather broad sturdy foot. The shape predominated during the latter part of the sixth century B.C., and the Amasis Painter used it here. The decoration on the exterior depicts two episodes from Book 13 of Homer's *Iliad*. We are extraordinarily fortunate that Homer's fame in antiquity was as great as in subsequent centuries. And given the fact that Greek artists rendered virtually all subjects in the trappings of their own day, the events narrated by Homer acquire a compelling immediacy.

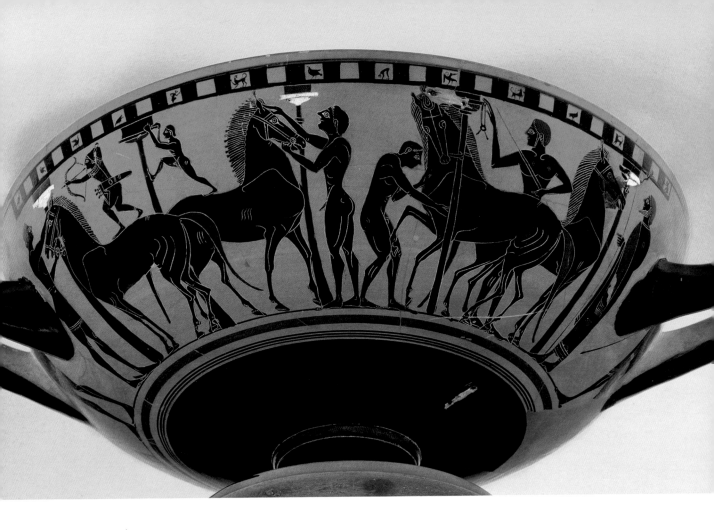

FIGURE 33. Kylix (drinking cup). Greek, Attic, red-figure, ca. 480 B.C. Attributed to the Briseis Painter. Terracotta, diam. 12 1/16 in. (30.7 cm). Purchase, Joseph Pulitzer Bequest, 1953 (53.11.4)

Suddenly down from the mountain's rocky crags
Poseidon stormed with giant, lightning strides
and the looming peaks and tall timber quaked
beneath his immortal feet as the sea lord surged on.
Three great strides he took, on the fourth he
 reached his goal,
Aegae port where his famous halls are built in the
 green depths,
the shimmering golden halls of the god that
 stand forever.
Down Poseidon dove and yoked his bronze-hooved
 horses
onto his battle-car, his pair that raced the wind
with their golden manes streaming on behind them,
and strapping the golden armor round his body,
seized his whip that coils lithe and gold
and boarded his chariot launching up and out,
skimming the waves, and over the swells they came...
the stallions vaulting, speeding Poseidon toward
 Achaea's fleet.

(Homer, *The Iliad*, Book 13, lines 20–39, trans. Robert
 Fagles [New York: Viking Penguin, 1990])

The obverse of the cup depicts the god Poseidon's stables at the bottom of the sea. It is worth noting a red-figure rendering of Poseidon's palace by the Briseis Painter (Fig. 33). The hero Theseus is shown with his father Poseidon and his stepmother, Amphitrite. The Amasis Painter, with his own magic, transformed the contour of the bowl into an architectural setting. Just below the lip, he introduced a row of metopes and five columns. Four men and an overseer prepare to harness

Poseidon's horses—here more than two—so that he can be transported to Troy and rouse the hard-pressed Greek forces. The magnificence of the stables is conveyed, first of all, by the beautiful and high-strung horses, each of which has an attendant. The column capitals and the blocks above them show added red and white, probably indicative of fine materials. But in this impressive setting,

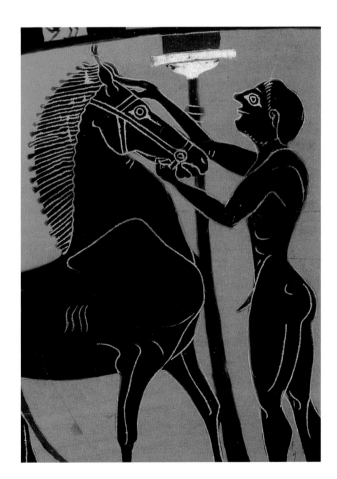

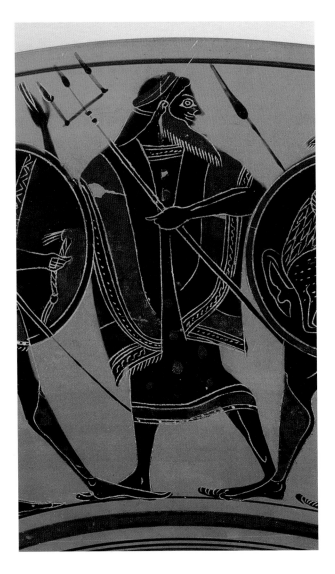

there are also strange forces at work, none of them obvious. Examination of the metopes reveals that every other one is inhabited. Starting from the left, we encounter an assortment of birds and animals, including a panther and two monkeys. On the far right, a little archer shoots to the left. Immediately before him is a monkeylike creature who is not in his square; he may be moving on his own volition, or the archer may have taken aim at him. Farther left, on the backs of the first and second horses stand two little figures, the left one an archer, the other a nude youth climbing on the adjacent column. They give the impression of intruders who make it necessary for the grooms to quiet their charges. The representation here is exceptional for the complexity of the space, the deployment of the animals and men, and the implication of multiple levels of reality.

The reverse shows Poseidon, recognizable by his trident, at Troy among six warriors and two onlookers. Each figure overlaps the next at least slightly, giving the impression of a varied but close line of fighters. We cannot assign a name to each of the heroes, but their status is indicated by their evident communication with the god and by the splendor of their dress and equipment. This scene is less extraordinarily pictorial than the depiction of the stables, but it is a noble complement. In the context of a symposium (Fig. 1 and Nos. 13, 16, 23), the two sides present themes consistently favored by the wealthy aristocratic participants—horses, warfare, and Homeric traditions.

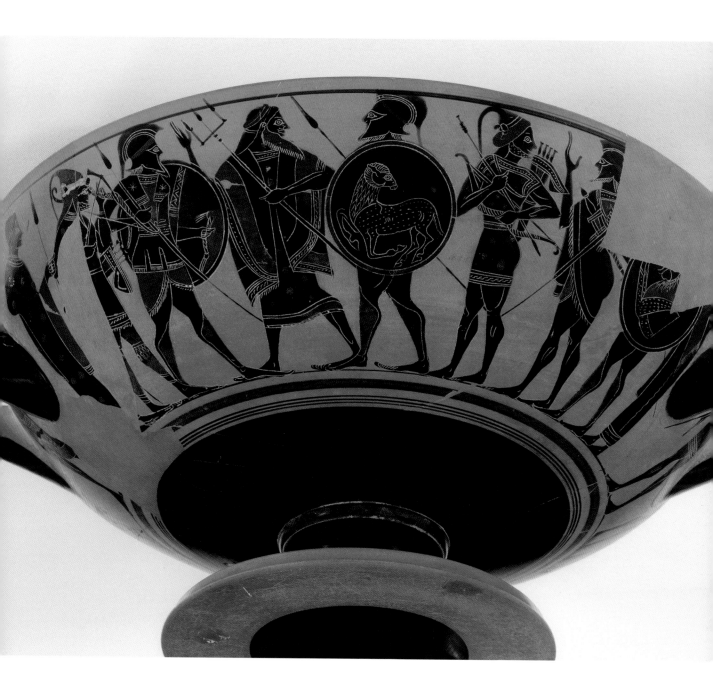

Alabastron (perfume vase) in the form of two women back to back

Greek, East Greek, mid-6th century B.C.
Terracotta, h. 10⅝ in. (27 cm)
Fletcher Fund, 1930 (30.11.6)

The depiction of the stables of Poseidon on the Amasis Painter kylix (No. 14) makes unmistakably clear the degree to which potters and painters thought of their works in three dimensions. The symbiosis between shape and decoration produces other manifestations. In Eastern Greece particularly, there was a predilection for vases shaped as figures in the round. I would like to single out a type of perfume vase consisting of a woman holding a dove. Our example actually shows not one woman but two who are rendered back to back. Each of the ladies wears an undergarment, the chiton, and a short himation, the overgarment especially favored in Eastern Greece. The proper left hand, held against the chest, supports a bird, probably a dedication. On one side, the right hand gathers the chiton, creating a play of folds. On the other side, both hands hold the bird. The bare feet stand on a small plinth, and a round disk at the top provides the mouth of the alabastron. The figures would have been made in a mold and joined at the sides. They preserve traces of the original polychromy.

The inspiration for this type of vase lies in the stone sculptures known as korai, or "maidens," that were the predominant freestanding representations of women during the Archaic period (Fig. 34). Though incomplete, the example illustrated resembles our alabastron in dress, the gesture of grasping the garment, and the bird held in front of the body. The meaning of the korai has been much discussed; they were dedications and funerary monuments, probably in some cases images of votaries as well. In the many examples of high quality, the beauty of the garments and the masterful renderings of the textures and play of folds are significant features. As current research is revealing, added color would have

supplemented the sculpted articulation. The attributes of the marble figures undoubtedly devolved upon the cheaper terracotta pieces whose function was to hold scented oil and to express a rather formalized femininity.

Every small portable Greek object that we see in a photograph or even through a glass case in a display loses one major feature, its tactility. Part of looking at Greek vases is considering how the work would be handled. In his fifth *Roman Elegy*, the German poet Goethe (1749–1832) wrote of seeing with a feeling eye and feeling with a seeing hand. Though the object of his attention was different from ours, his celebrated formulation is especially pertinent to a work like the alabastron. The duplication of the female figure can be compared with the Taleides amphora (No. 10), the lip-cup by Tleson (No. 13), and perhaps also the neck-amphora by Exekias (No. 11), where the artists deliberately repeated a message or subject on both sides.

FIGURE 34. Statue of a kore (maiden). Greek, last quarter of the 6th century B.C. Found at Miletos. Marble, h. 41¾ in. (106 cm). Staatliche Museen zu Berlin, Stiftung Preussischer Kulturbesitz, Antikensammlung Sk 1577. Photograph courtesy of the Staatliche Museen zu Berlin

Column-krater (bowl for mixing wine and water) with masks of Dionysos and a satyr between eyes

Greek, Attic, black-figure, ca. 520–510 B.C.
Terracotta, h. 13½ in. (34.3 cm)
Rogers Fund, 1906 (06.1021.101)

One of the most galvanizing iconographical innovations in black-figure vase-painting is the introduction of a pair of eyes into the decoration; when the shape is habitually decorated on both sides, the eyes generally appear on both. The earliest significant appearance of the motif in the third quarter of the sixth century B.C. occurs on a new form of cup, the earliest important example of which is signed by Exekias as potter. We have seen the shape used without eyes on the cup by the Amasis Painter (No. 14). The meaning of the eyes has been much discussed, and there is general agreement that they are connected with the wine god, Dionysos. In the roughly half-century of their popularity, eyes appeared on virtually every Attic shape, most especially those connected with drinking and specifically cups. Our column-krater shows eyes flanking a mask of Dionysos and that of one of the god's followers, a satyr, who is

distinguishable by his animal ears. The eyes might appear with a nose, with other forms of ears (see No. 17), and with a wide variety of seemingly unrelated subjects such as warriors or chariots. Their meaning has elicited a range of interpretations that are not mutually exclusive. They may be apotropaic, warding off evil, including the effects of intoxication. When painted on drinking vessels, they may seem to give the vase an anthropomorphic face or turn the vase into a mask when held up over the drinker's face.

The circumstances leading to the appearance of the eyes is also unclear. Beginning in the second quarter of the sixth century B.C., Dionysos became steadily more important in Attica. There is a question as to whether this phenomenon is connected with contemporary politics such as the rule of the Peisistratids, an important Athenian family that held power intermittently but influentially between

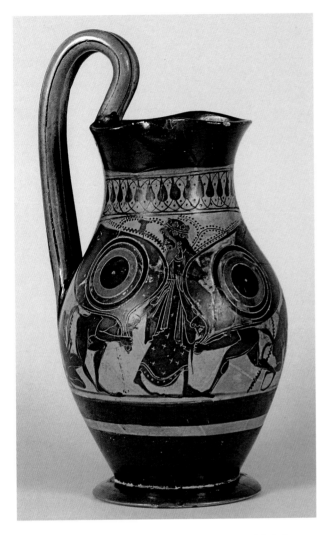

FIGURE 35. Olpe (round-mouthed jug). Greek, Attic, black-figure, 3rd quarter of the 6th century B.C. Attributed to the Painter of the Jena Kaineus. Terracotta, h. 10⅝ in. (27 cm). Berkeley, Phoebe A. Hearst Museum of Anthropology inv. 8/3379. Copyright © Phoebe A. Hearst Museum of Anthropology and the Regents of the University of California, Catalogue No. 8/3379

an oinochoe (jug) of the third quarter of the sixth century in Berkeley (Fig. 35) presents in succinct visual terms something of what was happening. We see Dionysos, holding vine branches, between two satyrs, each of whom approaches, bent under the weight of a wineskin in the form of an eye. Although the vase is not exceptionally fine, it is instructive in the elements that it brings together.

The Museum's column-krater is decorated both with eyes and with the faces of Dionysos and one of his male familiars. These faces may well be masks, because later vases depict a Dionysiac festival, the Lenaia, in which similar masks attached to vertical supports are the focus. What makes the iconography of our krater potent is the combination of elements gazing directly at the viewer. The connection between a vase and its user exists on many levels, beginning with the handling of the object and continuing with such features as an inscription addressed to the user (see No. 13) or the relation between the scenes on each side. The multiplicity of elements in vases produced for the symposium is as complex as the symposium itself.

In the words of Alkaios, the Greek poet of the late seventh century B.C.,

Let us drink! Why do we wait for the lamps? There is only an inch of day left.

Friend, take down the large decorated cups. The son of Semele and Zeus [Dionysos] gave men wine to make them forget their sorrows. Mix one part of water to two of wine, pour it in brimful, and let one cup jostle another.

(*Greek Lyric*, vol. 1, pp. 378–81, no. 346, trans. David A. Campbell, Loeb Classical Library [Cambridge, Mass.: Harvard University Press, 1982])

560 and 514 B.C. They established a period of peace and prosperity, undertook significant construction of public buildings, fostered numerous cults, notably of Dionysos, and played a role in the development of the Panathenaic festival (see No. 22). Thus, if they did not actively promote the importance of the wine god, they created an environment conducive to his popularization. The decoration on

Kylix (drinking cup) with eyes, nose, and ears

Greek, Chalcidian, black-figure, ca. 540–520 B.C.
Attributed to the Group of the Phineus Painter
Terracotta, diam. 7⅝ in. (19.4 cm)
Purchase by subscription, 1896 (96.18.65)

The cup illustrated here exemplifies the geographical complexity that is so characteristic of Greek art in the sixth century B.C. The decoration on the exterior of the bowl includes a pair of eyes like that we have seen on the krater No. 16; their presence is certainly also motivated by the force of Dionysiac cult. The cup goes much further in the presentation of a face through the inclusion of a nose and ears. The nose, albeit in somewhat different form, is present on the eye-cup developed by Exekias (see No. 16) and some other early Attic examples. The ears, however, are a feature characteristic of the fabric known as Chalcidian. In the present case, they are of an animal, by extension probably those of a satyr, but they can also occur in human form. Whereas Attic cups and vases of other shapes combine eyes and the occasional nose with seemingly unrelated subjects such as a frontal chariot, the Chalcidian examples more often depict a mask. The ornamental conventions connected with the shape persist with the inclusion of the handle palmettes (see No. 13). In addition to their decoration, the Chalcidian cups are distinguished by their fine fabric, by the often delicate and controlled drawing of glaze lines, and by the foot in the shape of a truncated cone.

The geographical considerations surrounding Chalcidian pottery contribute to its special interest. Examples first became known in the Canino excavations at Vulci and through Eduard Gerhard's "Rapporto volcente" (see Introduction, p. 21). Scholarly emphasis at that time was on inscribed material, and Adolf Kirchhoff in 1863 recognized that the alphabet used was that of Chalkis, an important center on the Greek island of Euboea, and of her colonies in Southern Italy. As more and more of this fabric came to light, its predominance in the West became clear, mainly in Italy but also extending as far as Ampurias in Spain and Marseille in France, with no examples from the Greek mainland. The production center has not yet been established definitively, but Reggio, in the modern region of Calabria, is a strong possibility owing to the high proportion of finds that came from both sanctuary and funerary contexts.

The pottery of the sixth century B.C. is fascinating because of the commonality of shapes, subjects, and ornaments throughout the Greek world, from Magna Graecia to Ionia, at the same time as the existence of pronounced regional differences. The Chalcidian eye-cups present an ongoing challenge for specialists to discover their centers of production and elucidate their relation to the Attic examples.

Hydria (water jar) with fountain scene

Greek, Attic, black-figure, ca. 510–500 B.C.
Attributed to the Class of Hamburg 1917.477
Terracotta, h. 14¾ in. (37.5 cm)
Rogers Fund, 1906 (06.1021.77)

Greek vases bring us close to the time in which they were created not only because we know that this very water jar was made and handled by Athenians at the end of the sixth century B.C. but also because they depict subjects that provide glimpses of contemporary life. Such scenes began to appear in the third quarter of the century and became increasingly frequent.

The hydria is perfectly designed for receiving and transporting water because it has a wide mouth, a broad foot, a horizontal handle at each side for lifting, and a vertical handle at the back for pouring. The shape is well attested in terracotta and in metal, particularly bronze (Fig. 36). The decoration on terracotta hydriai often pertains to water. Here, we see five young women bringing their jars to be filled at a fountain house.

While the representation of architecture is unusual on vases, fountain houses enjoyed some popularity. They are a necessary feature in depictions of the ambush of Troilos by Achilles, an episode of the Trojan War (Fig. 37). Troy could not be taken by the Greeks as long as Troilos, a son of the Trojan king Priam, was alive. Troilos accompanied his sister Polyxena as she went to fetch water and was killed by Achilles, who lay in wait behind the fountain house. This mythological subject was favored early in the sixth century; scenes of women as on the hydria became popular later in the century. This was also the time when local water supplies were being improved in numerous Greek cities; Athens saw the construction of the Enneakrounos, the fountain with nine spouts.

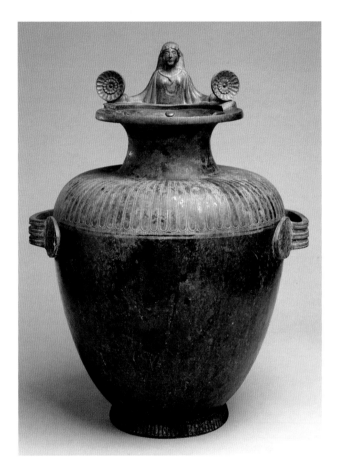

FIGURE 36. Hydria (water jar). Greek, Argive, mid-5th century B.C. Bronze, h. 20¼ in. (51.4 cm). Purchase, Joseph Pulitzer Bequest, 1926 (26.50)

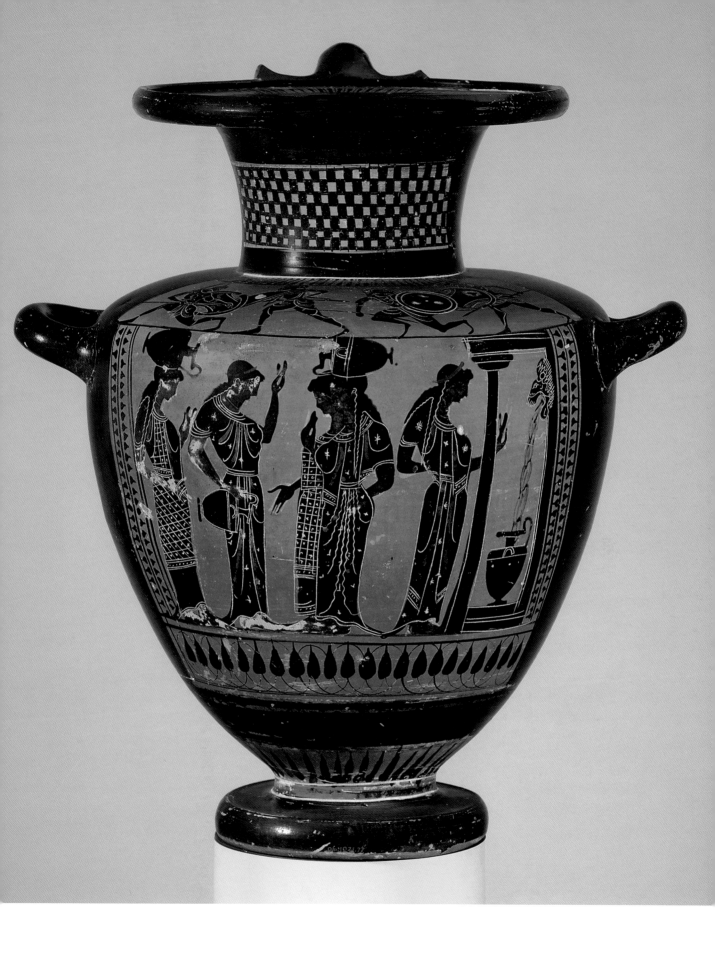

FIGURE 37. Kylix: Siana cup (drinking cup). Greek, Attic, black-figure, ca. 575 B.C. Attributed to the C Painter. Terracotta, diam. 9 ⅝ in. (24.5 cm). Purchase, 1901 (01.8.6)

The structure on our hydria is summarily rendered with a sloping roof supported by a column, a raised floor, and on the back wall, a lion's-head spout gushing water. The hydria being filled is precisely rendered, down to the side handle. Of interest is the horizontal line incised directly below the handle. It recurs on two other vases in the scene and almost certainly indicates that they are of bronze. In a bronze piece, this is the area where the mouth and shoulder would be joined to the body. A terracotta hydria could not and would not be made in sections, because it would never be able to hold water. In the picture, we note also that, being empty, the vases are carried horizontally, by the vertical handle or balancing on the head. The woman at the far left uses a donut-shaped cushion, a tule.

Viewing the scene, we can be quite sure that it contains many directly observed details. At the same time, we have to wonder who the young women are and if their appearance on a water jar has some special significance, apart from the obvious. We need also to consider the subject on the shoulder showing warriors fighting. Hydriai—and water—served many functions, notably in symposia and in funerary rituals. The ladies could be young Athenian women at a public fountain house, but one questions whether they would have left their homes unescorted. They may be hetairai (see Nos. 13 and 23), or they may be fetching water for some observance, possibly funerary. In such a context or in that of a symposium, the battle might evoke the exploits of Athenian citizens and their ancestors. The contrast between the two images on the vase seems extreme and irreconcilable. However, we have already seen such pairings on the Geometric krater (No. 6) and the Taleides amphora (No. 10), and they are frequent on red-figure vases, especially of the sixth and fifth centuries B.C. and beyond (for instance, Nos. 20, 32).

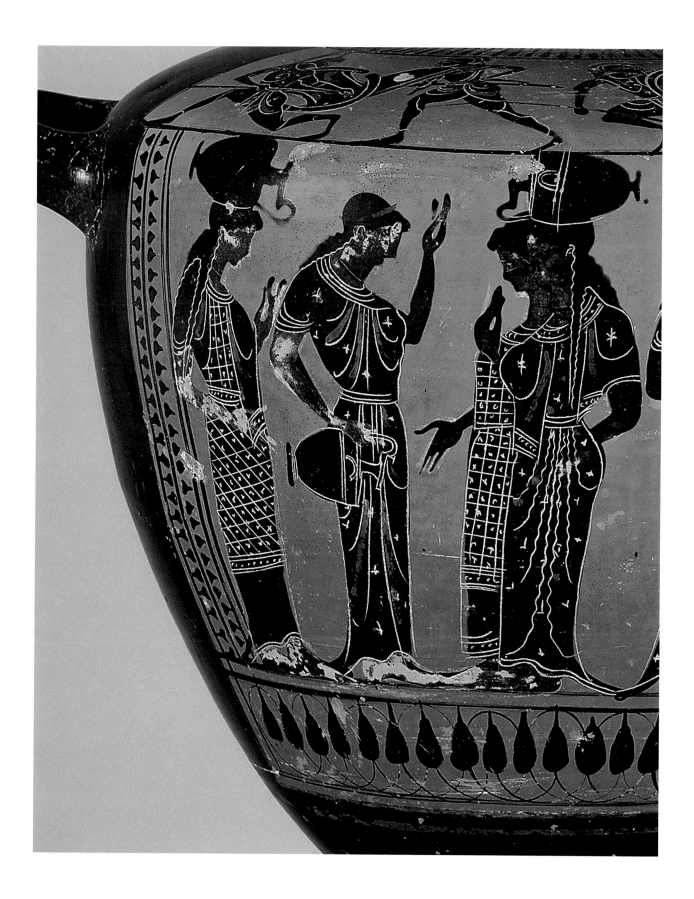

Lekythos (oil flask) with Helios, Nyx, Eos, and Herakles sacrificing

Greek, Attic, black-figure, ca. 500 B.C.
Attributed to the Sappho Painter
Terracotta, h. 6¹³⁄₁₆ in. (17.3 cm)
Rogers Fund, 1941 (41.162.29)

This exceptional vase makes one keenly aware and regretful of the Greek art that is lost. The scene is grandiose and lyrical as well as precisely descriptive. In the center of the body, opposite the handle, is Helios, the sun, his name inscribed. He is shown as a charioteer, holding the goad and rising between the four horses of his chariot. Above his head is a disk surrounded by a halo of dilute glaze (see Introduction, p. 25) and articulated inside with an incised circle and dilute glaze as if to convey the three-dimensionality of the orb. A remarkable detail is the golden color of the ends of his hair, catching the light. On the upper part of the body, Nyx (Night) and Eos (Dawn) are dispersing in opposite directions; their names are indicated. In some early literary accounts, Eos and Helios are siblings. Although Nyx and Eos seem to have only two horses each, the number of legs indicates that they too are driving quadrigae (four-horse chariots). The two personifications are differentiated by the orbs above their heads; that of Nyx is dark red, while that of Eos has two incised circles.

Only the upper bodies of the figures and horses are indicated, with the rest ostensibly hidden by the trails of mottled brown glaze that descend to the bottom of the picture. The identity of the trails is unclear. Homer situated the home of Helios beyond Ocean, the great stream that surrounds the earth. At night, Helios descends into Ocean to his palace and returns to the East in a great open cup. The trails under Nyx and Eos could be clouds, but they might also indicate the great stream. The trails are significant to the representation because they introduce a spatial and atmospheric dimension to the surface of the vase, which would otherwise appear flat and neutral. This element is particularly appropriate in view of the scene directly under the handle.

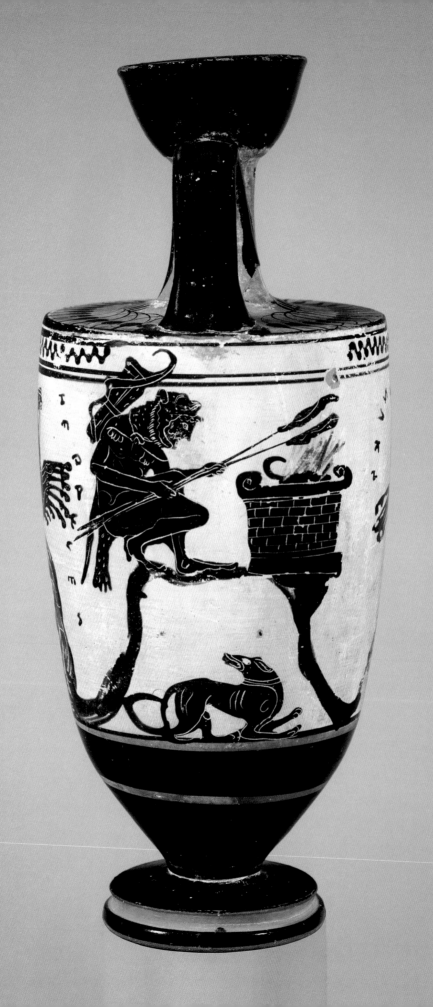

As cosmic events unfold on the front, Herakles, the most represented hero of Greek mythology, is roasting two skewers of meat over a flaming altar. An irregular glaze line identifies the location as a low rise with a flat top. Herakles is recognizable by the lion skin, and he also has his bow and quiver. He performs the ritual of burning, on long skewers, the entrails of an animal that has been sacrificed to the gods. The meat on the altar includes the ox tail that curves upward auspiciously. It is impossible to establish the exact relation between the two scenes on the lekythos. It may be partly narrative, because in the performance of his twelve labors, the hero had two encounters with Helios. He obtained the cup of the sun on the way to stealing the cattle of three-headed herdsman Geryon (see No. 12). He also cleaned the stables of Augeias, the son of Helios. The most remarkable aspect of the representation is that it makes visible powerful elemental forces that affect human existence. Herakles, himself a combination of the mortal and divine (see No. 24), seeks the favor of the gods, as Dawn, Night, and the Sun run their inexorable courses. The strands that are interwoven here are complex indeed.

The shape on which this decoration has been painted is a lekythos, an oil flask. At a time in the sixth century B.C. that we cannot precisely establish, it became the funerary offering par excellence. About 520–510, the shape also began to be covered with a white slip such as we see on the Sappho Painter's vase. The artist takes his name from a hydria depicting the poetess Sappho, with her name inscribed. From the 470s until the end of the fifth century B.C., white-ground lekythoi are decorated with an array of funerary subjects, drawn from both mythology and daily life (see No. 28), and they are typically placed on

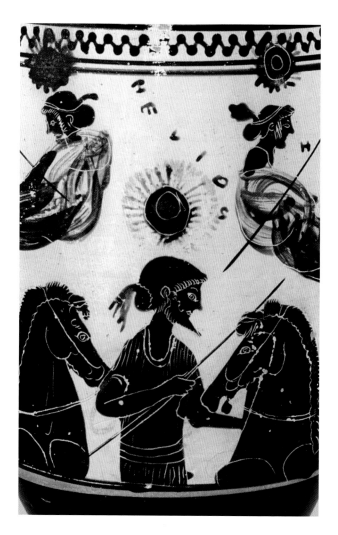

graves as dedications. It is very possible that the shape of our vase, the presence of the slip, and the scenes all have a common meaning. The lekythos is one of a group of four found in a tomb in Athens.

Amphora (storage jar) with Herakles and Apollo fighting over the Delphic tripod

Greek, Attic, ca. 530 B.C.
Signed by Andokides as potter; attributed to the Andokides Painter for the red-figure decoration,
the Lysippides Painter for the black-figure decoration
Terracotta, h. 22⅝ in. (57.5 cm)
Purchase, Joseph Pulitzer Bequest, 1963 (63.11.6)

One of the hallmarks of Greek art is the vitality that informs its creations individually and that constantly generated its renewal. This phenomenon is admirably demonstrated by the introduction about 530 B.C. of the red-figure technique. The innovation could not have been simpler, because all the prerequisites were at hand; the materials were exactly the same, and drawing, in contrast to silhouette, had been practiced before. We do not know, however, whether the catalyst for change was one factor or a combination of several. In black-figure, the subjects had been painted in glaze and turned black during firing in the kiln. In red-figure, they remained the orangey color of the clay surface; the background was filled in and turned black in firing. The extraordinary advance brought by a seemingly small switch was that forms could now be drawn freely, both their contours and interior articulation. Glaze could be applied in many ways, from wiry relief lines to delicate washes. The modulated trails on the lekythos No. 19, for instance, are directly attributable to the new technique.

The workshop in which red-figure appeared is generally identified as that of the potter Andokides. He signed vases that were decorated in red-figure, black-figure (Fig. 38), and sometimes both together; such vases are known as bilingual. On the vase No. 20, his meticulously incised signature appears on the foot. The shape is a new variety of amphora that emerged at about the same time as the deeper form of cup (see No. 14), and both are connected with Exekias. The decoration on the body of the Museum's amphora is attributed to Andokides' anonymous red-figure collaborator, known as the Andokides Painter.

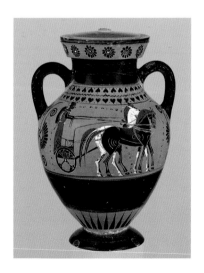

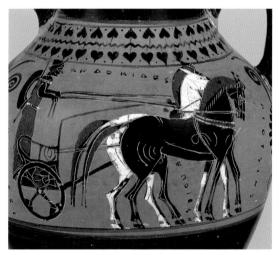

FIGURE 38. Amphora with lid (storage jar). Greek, Attic, black-figure, ca. 540 B.C. Signed by Andokides as potter. Terracotta, h. 10⅜ in. (26.4 cm). Gift of Mr. and Mrs. Christos G. Bastis, in honor of Carlos A. Picón, 1999 (1999.30a,b). Detail

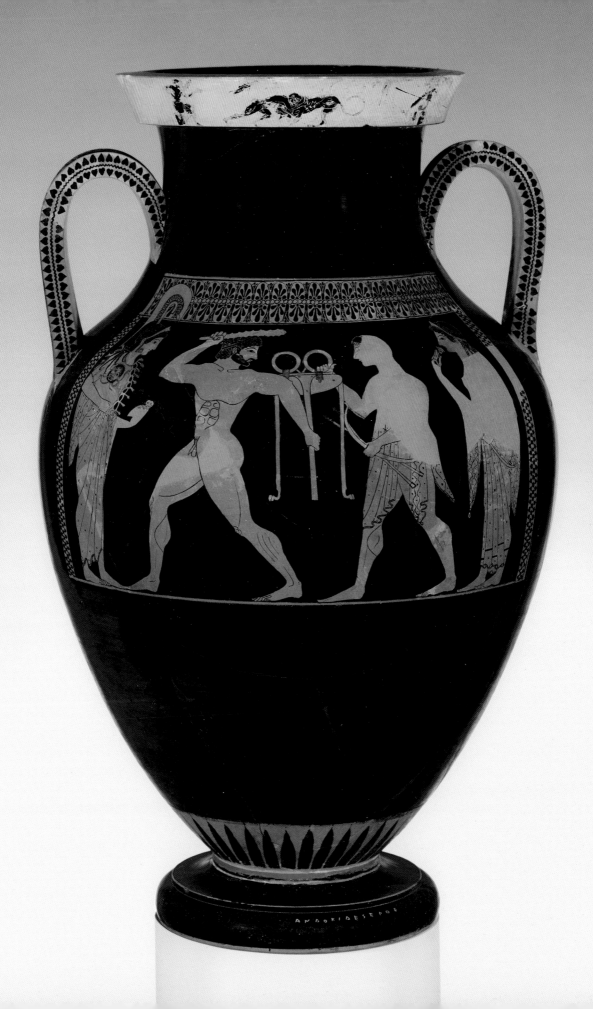

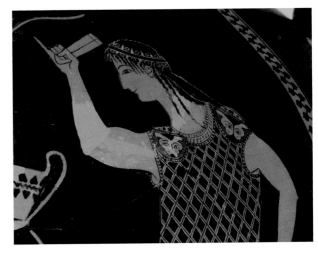

The primary scene depicts a popular subject at the time, the hero Herakles and the god Apollo vying for possesion of the most important piece of equipment in Apollo's sanctuary at Delphi, the tripod. Seated upon it, the presiding priestess delivered oracles that were often ambiguous but usually fateful for the suppliant. Intending to establish an oracular sanctuary of his own, Herakles tried to steal the Delphic tripod and became involved in a tug of war over it. The protagonists are flanked by their divine allies; Athena, patron goddess of Athens, supports Herakles, while Artemis, goddess of the hunt, seconds her brother Apollo. The reverse shows the wine god Dionysos—much favored in red-figure—between a satyr and maenad, his followers. Dionysos and Apollo held sway over Delphi jointly, Dionysos in the winter, Apollo in the summer. Although the execution of the scenes here is slightly awkward and quite stylized, the long lines of musculature, the fine folds, and the ease of rendering small details demonstrate the advantages of drawing over incision.

That artists and probably also their clients recognized the differences between black-figure and red-figure is indicated by the so-called bilingual vases, mainly amphorae and cups, that juxtapose the two techniques on the same piece. The Museum's amphora offers a particularly elaborate refinement, because the black-figure ingredient is confined to the lip and is applied over a white slip. The bilingual vases have been interpreted as publicity for the new red-figure technique, demonstrating its possibilities by comparison. On our work, Andokides and the painters with whom he collaborated seem to be showing that they were on the cutting edge of innovation.

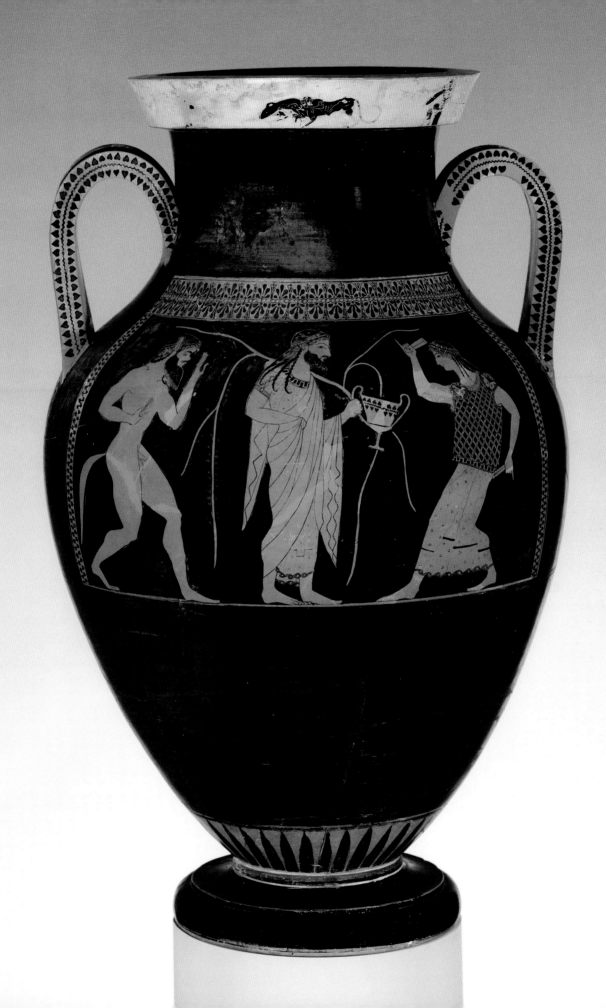

Two stands

a. Iris and sphinx
Greek, Attic, red-figure, ca. 520 B.C.
Terracotta, h. 10 in. (25.4 cm)
Louis V. Bell Fund, 1965 (65.11.14)

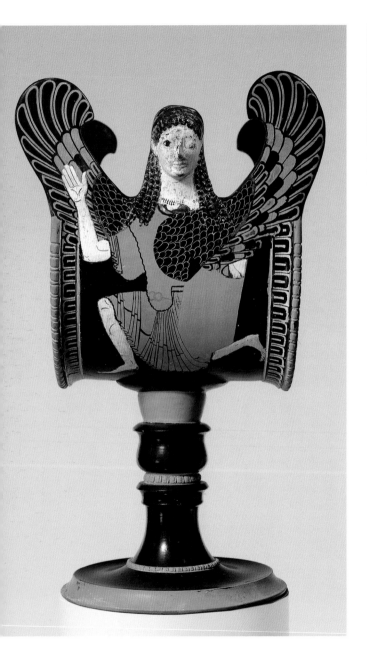
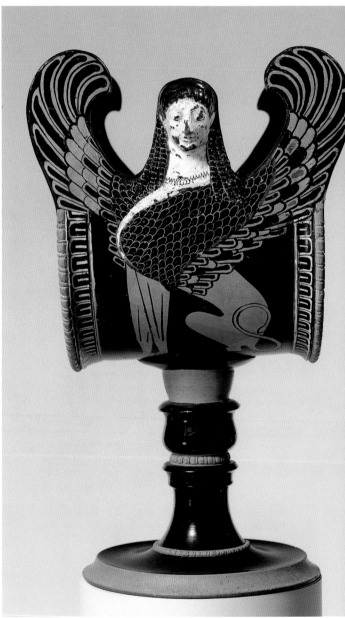

b. Two sphinxes
Greek, Attic, red-figure, ca. 520 B.C.
Terracotta, h. 10¼ in. (26 cm)
Gift of Mr. and Mrs. Norbert Schimmel, 1980 (1980.537)

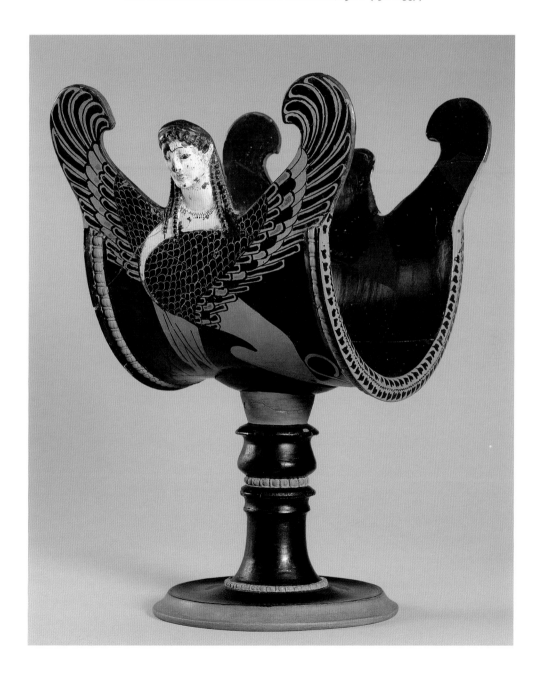

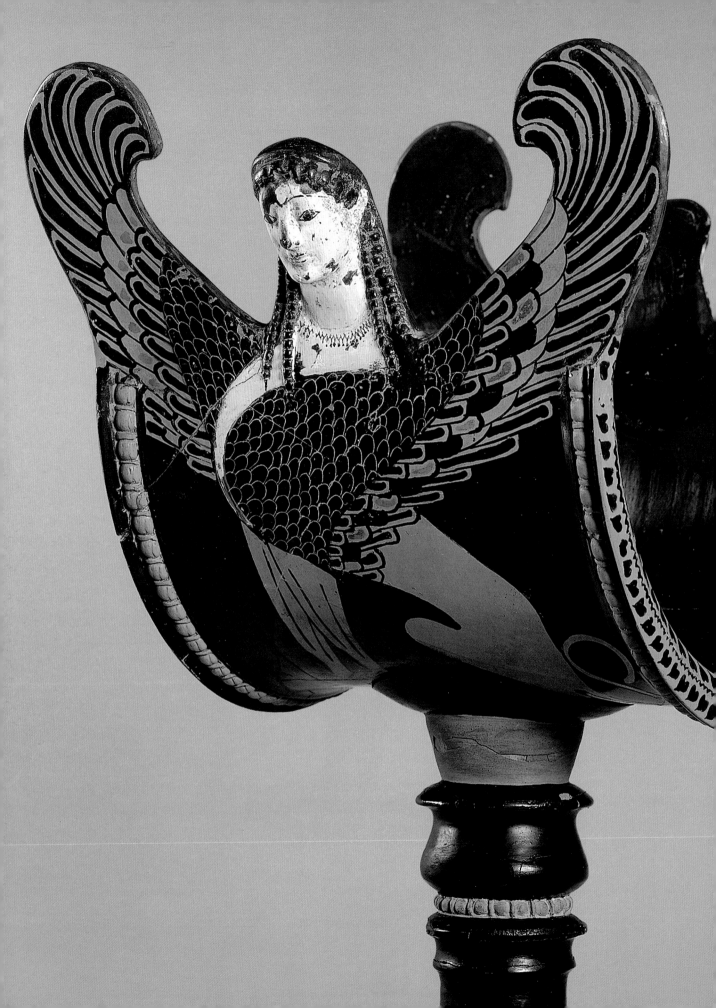

From the early sixth century B.C. on, the repertoire of shapes in Attic vase-painting remained quite consistent by virtue of the functions they were required to perform. New types occasionally appeared, however. These stands are particularly interesting because they catered specifically to the Etruscan market. Given the thousands of Attic vases that have come to light in Etruria, recent scholarship has begun to establish informative patterns concerning, for example, the preference for certain standard Greek shapes at particular sites and the preponderance of certain subjects. Although they have been found in houses and sanctuaries, the great majority of pieces have come to light in graves. Indeed, between sixty and eighty percent of all Etruscan burials of the second half of the sixth and the fifth centuries B.C. contain some Attic pottery.

The criterion for identifying the stands as export ware is that they are elaborate versions of a characteristically Etruscan shape in the local matte black fabric known as bucchero (Fig. 39). The function of such pieces was probably to hold offerings. The elaborateness of the Attic interpretations suggests that the works were specially commissioned. The order is likely to have been placed with a middleman in Etruria, where trading centers such as Gravisca, near Tarquinia, attracted merchants from throughout the Greek world, including Athenians. There is no evidence for a resident Etruscan mercantile community in Attica or elsewhere in mainland Greece.

Of particular interest in the works—which may or may not constitute a pair—is the interrelation between their structure and iconography. Both are decorated with winged female figures to which the open section of a cylinder has been adapted. One shows the messenger goddess Iris and a sphinx; the other two sphinxes. Each is at

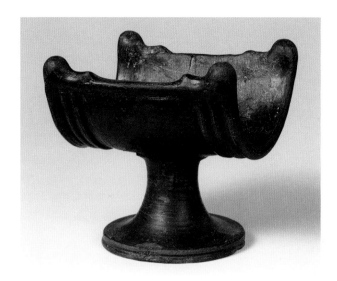

FIGURE 39. Stand. Etruscan, bucchero, 6th century B.C. Terracotta, h. 3¾ in. (9.5 cm). Purchase, 1896 (96.9.102)

least as much the creation of a coroplast (craftsman who models clay) as of a potter. The pronounced wings and heads call to mind the predilection for sphinxes and sirens on bucchero pottery, but even more, the terracotta figures with wings or upraised arms that crowned the roofs of Etruscan temples and other structures during the late sixth and fifth centuries B.C. The figures on the stands were entirely familiar to Athenian artists, although the shape was not. Both the figures and the shape were familiar to Etruscan clients, suggesting, for want of a better formulation, that a special effort was made to render these works particularly Etruscan. They conjure up a wealthy, worldly individual who wanted a ceremonial object in the latest style of the Athenian Kerameikos, arguably the leading center of fine pottery production. Compare in recent times, the Princess Nilüfer of Hyderabad, who had saris made in the 1930s by Parisian fashion designer Jeanne Lanvin.

Panathenaic prize amphora (storage jar)

Greek, Attic, black-figure, ca. 500 B.C.
Attributed to the Kleophrades Painter
Terracotta, h. 25 in. (63.5 cm)
Rogers Fund, 1916 (16.71)

Because each of the techniques of Attic vase-painting flourished during definable periods, there is a tendency to think of them in chronological terms. At least two techniques, however, became inseparably associated with a shape and its function. By the early fifth century B.C., white-ground lekythoi served in funerary rituals (see Nos. 19, 28). After the introduction of red-figure, black-figure declined steadily, except on one shape, the Panathenaic prize amphora, which survived into the fourth century A.D.

Panathenaic prize amphorae were awarded in the athletic and equestrian competitions held every four years in honor of Athena, the patron goddess of Athens. The organization of the Panathenaic games evolved during the second quarter of the sixth century B.C. and became established by the third quarter. The actual reward consisted of the special olive oil that the vases contained and the resale value of the oil in excess of what the victor could use. Over the very long period of their existence, the prize amphorae remained consistent in shape, contents, iconography, and technique. Containing about one metretes (forty-two quarts) of oil, the vases display a narrow mouth, neck, and foot, a full body, and two vertical handles. The main, front side shows Athena, with a helmet, shield, aegis, and spear, while the reverse depicts the event in which the prize was won. Athena's helmet crest projects into the band of tongues above her, and she typically stands between two columns, with "[a prize] from the games at Athens" inscribed along the left column. The decoration is consistently in black-figure.

On this example, Athena's purposeful stride causes her cloak to fall in very soft, flowing folds. If we compare the incision of her garment with that on the Exekias neck-amphora (No. 11), we note that the touch is lighter, breezier. What we are seeing on the Panathenaic is one of the major red-figure artists, the Kleophrades Painter, working in black-figure. Although his control of the old technique is perfect, his hand reveals a fluency transferred from red-figure. The attribution to this artist depends on stylistic features. Additionally, the Kleophrades Painter favored the winged horse as the device on Athena's shield, and there has been scholarly speculation as to whether particular artists or workshops favored specific devices.

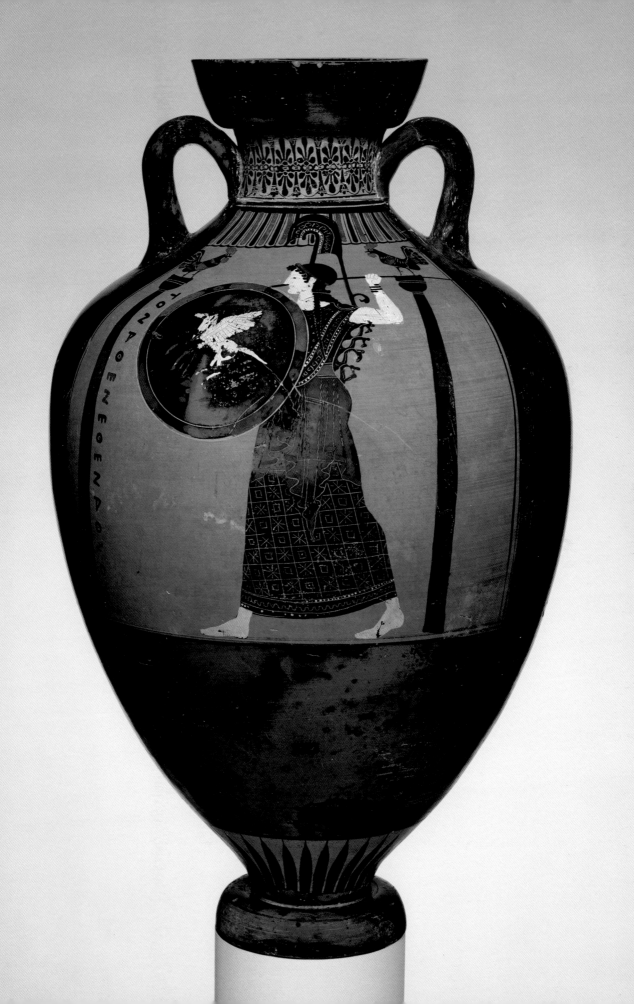

In a shortened panel on the reverse, the trainer on the right observes two men engaged in the pankration. This was the most dangerous event, a combination of boxing and wrestling in which everything was allowed except biting and eye-gouging. Here the heavy man in the center has kicked his opponent, who has caught the leg and is about to throw the man back. The weight and mass of the forms, especially against the light background, contrast with the deftness of the incision for both the anatomy and the folds and patterns of the trainer's himation (overgarment).

. . . in athletic competitions a man gains
the glory he desires, when thick crowns
wreathe his hair after winning victory with his hands
or the swiftness of his feet.
But men's valor is determined by the gods.

(Pindar, *Isthmian Odes*, no. 5, lines 7–11, trans. William H. Race, Loeb Classical Library [Cambridge, Mass.: Harvard University Press, 1997])

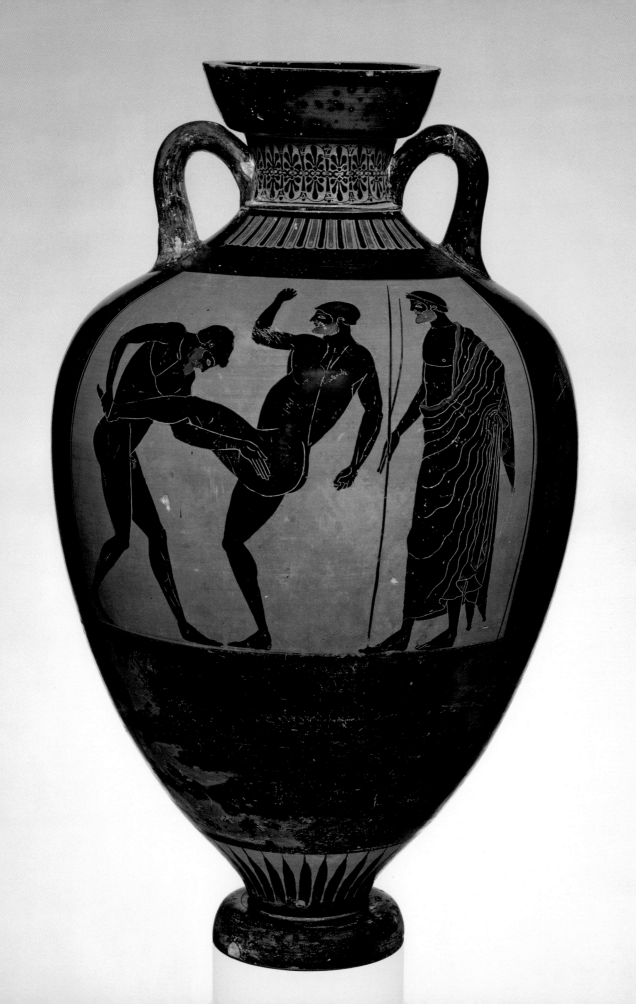

Kylix (drinking cup) with symposium scenes

Greek, Attic, red-figure, ca. 480 B.C.
Signed by Hieron as potter; attributed to Makron as painter
Terracotta, diam. 13 1/16 in. (33.2 cm)
Rogers Fund, 1920 (20.246)

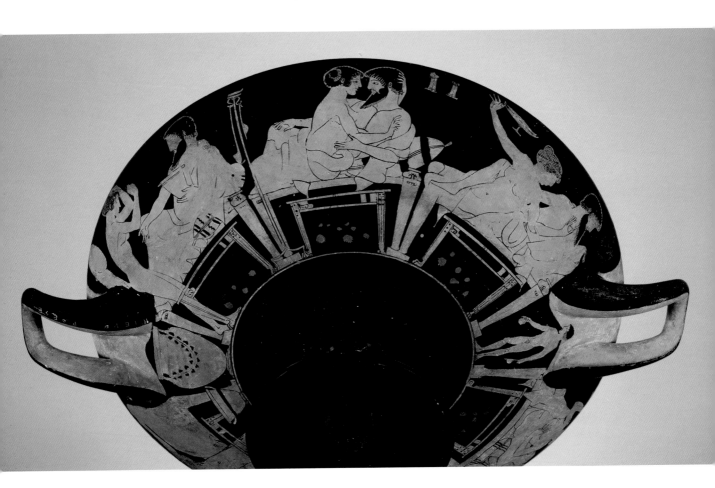

With the advent of the red-figure technique about 530 B.C. (see No. 20), scenes drawn from the lives of Athenians—its privileged citizens—became much more frequent than they had been on black-figure vases. There is considerable debate as to how realistic the representations really are. Allowing for some margin of artistic license, however, a cup like this one enables viewers over two millennia later to visualize a symposium during the early Classical period. Its surface, unfortunately, is quite worn. Each side shows three klinai (dining couches) with thick cushions. In front of them stand lower, shorter tables, here with florals but often with drinking cups or food; the symposium

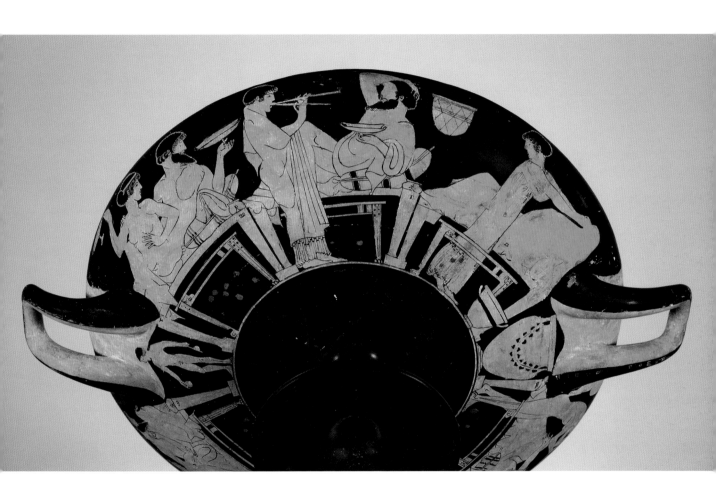

typically followed the meal. The figures on each side consist of three couples. The women are hetairai; perhaps they may be better described as courtesans than prostitutes, because the pleasures they offered were not limited to sex. Three of the couples are shown sharing a couch. In the other three cases, the woman ties her hair, plays the flute, or turns away from her companion who vomits into a skyphos on the floor. Under one handle stands a large column-krater (see No. 16) wreathed in ivy. Under the other, a young serving boy holds a small jug and a strainer of bronze or silver (Fig. 40). A tall lampstand, undoubtedly of bronze (Fig. 42), supports a lamp at the top; a ladle

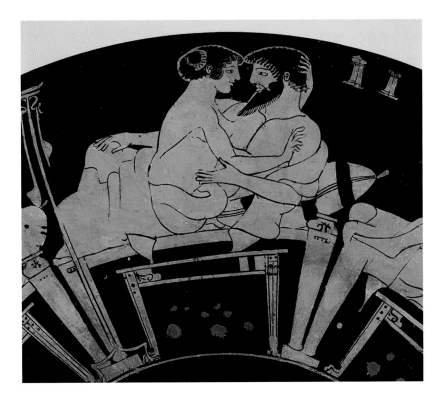

FIGURE 40. Strainer. Etruscan,
5th century B.C. Bronze,
l. 9¹³/₁₆ in. (25 cm). Rogers
Fund, 1922 (22.139.17)

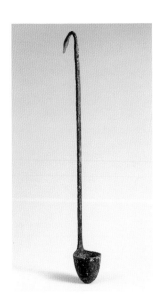

FIGURE 41. Ladle. Etruscan,
late 5th century B.C. Bronze,
l. 17¹⁵/₁₆ in. (45.6 cm). Museum
Accession (x.21.90)

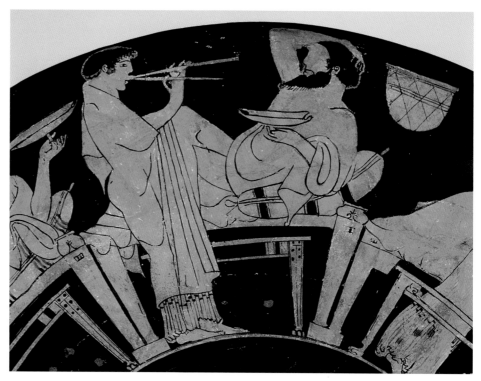

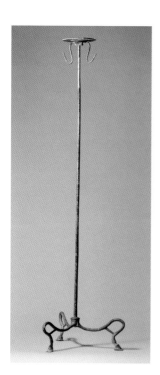

FIGURE 42. Lampstand. Greek or Cypriot, late 6th century B.C. Bronze, h. 25¾ in. (65.4 cm). The Cesnola Collection, Purchased by subscription, 1874–76 (74.51.5666)

(Fig. 41) and strainer, of bronze or silver, hang right below. Fastened to the back wall are a picnic basket, a bundled garment, and a pair of krotala (clappers). The scene is remarkable not only for its detail and variety but also for the sympathetically objective depiction.

The tondo on the interior of the bowl complements the exterior perfectly. On the left, a satyr plays the flute. He is beautifully groomed; note the ordered strands of his tail, the regular curls framing his face, and the neat ends of the hair at the nape of his neck. He is serenading a maenad who moves to the left; she holds her thyrsos, the fennel stalk crowned with ivy that is the attribute of the female followers of Dionysos. The music leads her to

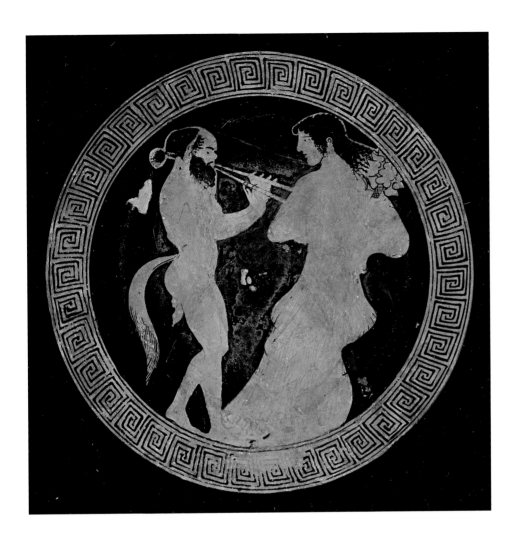

sway gracefully. Although the worn surface deprives us of the detail of her abundant drapery, the quality of the scene comes across clearly.

We are able to identify the artists responsible for this extraordinary juxtaposition of figures under the spell of Dionysos. Both specialized in drinking vessels, some skyphoi, mainly kylikes. One handle of our piece bears the incised name of Hieron, a potter who inscribed his name frequently and regularly worked with the painter Makron. Their signatures appear together on only one surviving vase, but the distinctive style of Makron and his predilection for Dionysiac scenes leave little doubt about the frequency of their collaboration.

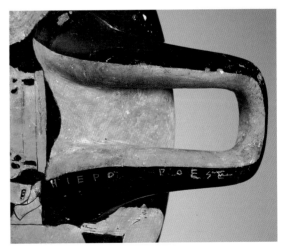

24

Kalpis (water jar) with baby Herakles strangling the snakes

Greek, Attic, red-figure, ca. 460–450 B.C.
Attributed to the Nausicaa Painter
Terracotta, h. 14½ in. (36.8 cm)
Fletcher Fund, 1925 (25.28)

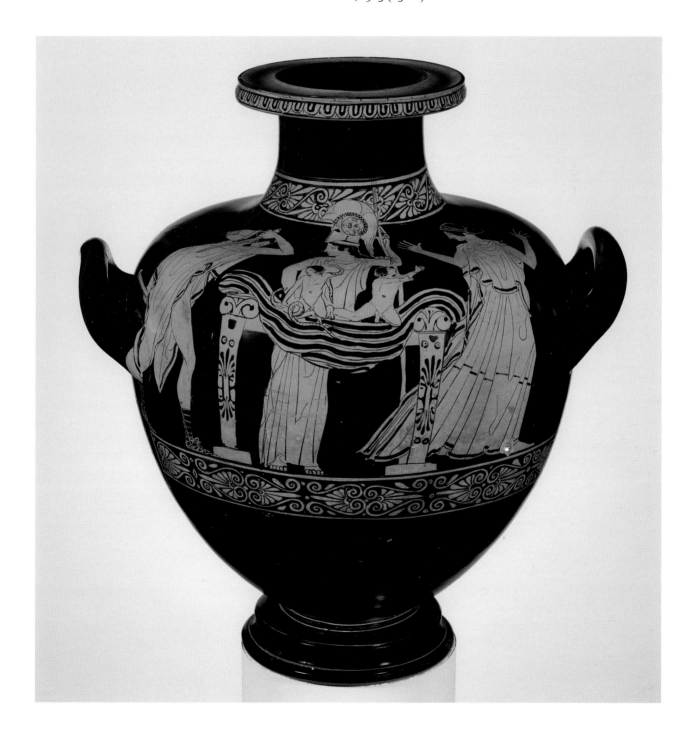

...as soon as Zeus' son [Herakles] came down from his
 mother's womb into the wondrous brightness of day,
fleeing her birth pains
 with his twin brother [Iphikles],
he did not escape the notice of Hera on her golden
 throne
when he lay down in his yellow swaddling clothes,
but the queen of the gods
with anger in her heart immediately sent snakes.
When the doors had been opened
they went into the deep recess of the bedroom,
 eager to wrap their darting jaws
around the babies. But the boy lifted
 his head straight up and engaged in his first battle,
grasping the two snakes by their necks
in his two inescapable hands....
Unbearable fear
struck all the women who at the time
 were attending Alkmene's bed...
and Amphitryon arrived brandishing his unsheathed
 sword in his hand....
He stood there, stunned with wonder both painful
and joyous, for he saw the extraordinary
determination and power
of his son....

(Pindar, *Nemean Odes*, no. 1, lines 35–56, trans. William H.
Race, Loeb Classical Library [Cambridge, Mass.: Harvard
University Press, 1997])

Among mythological subjects in Greek vase-painting, the
hero Herakles occupies a preeminent position. While the
life and deeds of other heroes such as Achilles or Theseus
were popular, the variety of narrative situations and the
sheer number of representations were smaller. Herakles'
exceptional nature became evident in infancy, and this
delightful scene is depicted on the form of hydria (com-
pare No. 18) that entered at the end of the sixth century
B.C., about the same time as the introduction of the red-
figure technique.

Amphitryon, the son of the king of Tiryns, wished to
marry Alkmene, daughter of the king of Mycenae. In an
accident, Amphitryon killed Alkmene's father and fled
with her to Thebes. In order to marry her, Amphitryon was
required to perform a series of exploits. While he was
returning home, Zeus in the guise of her husband slept
with Alkmene. Later the same night, Amphitryon himself
followed suit. Alkmene bore two children, Herakles, son
of Zeus, and Iphikles, son of Amphitryon. In her rage
against her husband, Zeus, Hera sent snakes against his
baby. In this most engaging depiction, Herakles and
Iphikles are shown on top of a couch covered with an over-
hanging striped mattress reminiscent of a present-day
comforter. Iphikles gesticulates wildly toward his mother,
who runs away. Herakles makes a show of strangling the
snakes with one arm up and the other down. He looks
calmly toward his father, who rushes in with sword drawn.
The goddess Athena, Herakles' steadfast protectress, stands
in the background, her downward gaze paralleling that of
her protégé. In one image, the artist has captured the
essence and dynamic of an extended narrative.

There are extremely few subjects in Attic vase-painting
that can with some certainty be identified as intentionally
humorous. On the present vase, the verve of the Nausicaa
Painter's depiction prompts our amusement; ancient
viewers must have responded similarly.

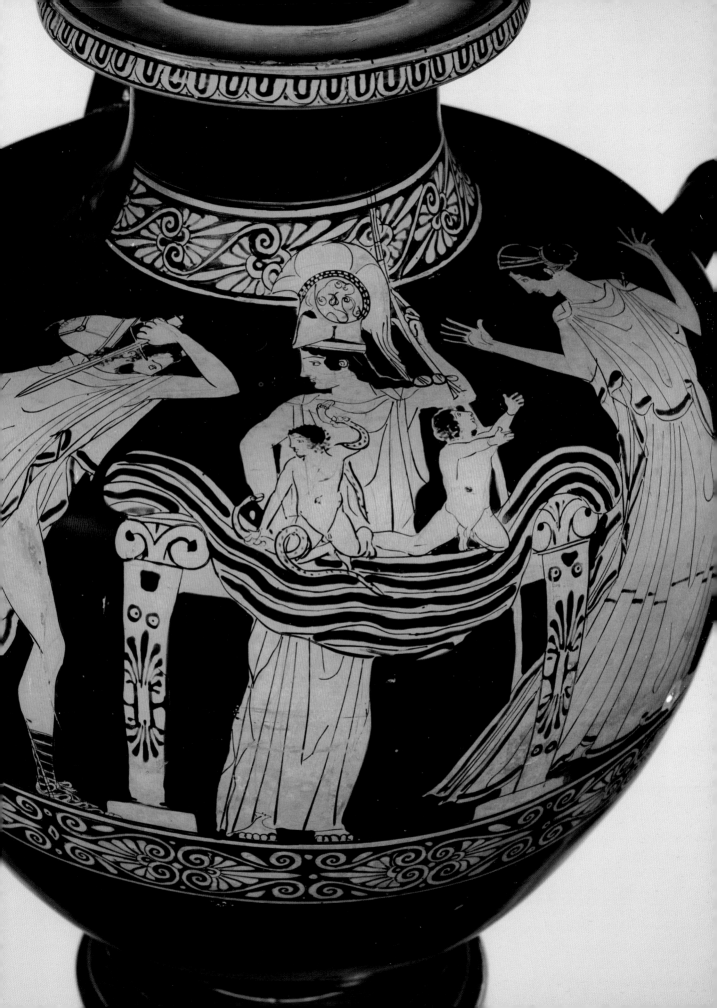

Volute-krater (bowl for mixing wine and water) with Amazonomachy and Lapiths fighting centaurs

Greek, Attic, red-figure, ca. 450 B.C.
Attributed to the Painter of the Woolly Satyrs
Terracotta, h. 25 in. (63.5 cm)
Rogers Fund, 1907 (07.286.84)

Different subjects in Greek vase-painting were popular at different times, and considerable scholarly attention is devoted to elucidating the underlying reasons. The second quarter of the fifth century B.C. saw a dramatic interest in scenes of conflict between Greeks and peoples from the East, notably Amazons. This imposing vase is a fine example. Although the figures cannot be identified with certainty, the mounted Amazon may be the queen, Hippolyte or Antiope, and the Greek warrior before her, wearing a cap beneath his helmet, Theseus. There can be little doubt that, in some form, such representations reflect the decisive and momentous victory of the Greeks in the Persian Wars

(490–479 B.C.). However, they also include other subtexts that, today, are difficult to assess accurately. For instance, if the scenes reflect a historical reality, using the iconography of Amazons introduces a mythological dimension. We cannot assume that Amazonomachies, the legendary battles between Greeks and Amazons, are purely metaphorical. In what terms do we differentiate the historical from the mythological? A somewhat analogous situation is posed by depictions of the Trojan War. In both cases, enemies though the Trojans and the Amazons or Persians were, on Greek vases they are most often shown as noble antagonists, worthy adversaries to the Greeks (see Fig. 55).

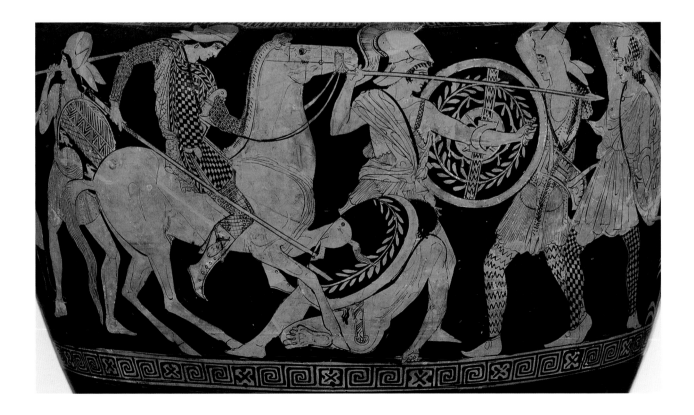

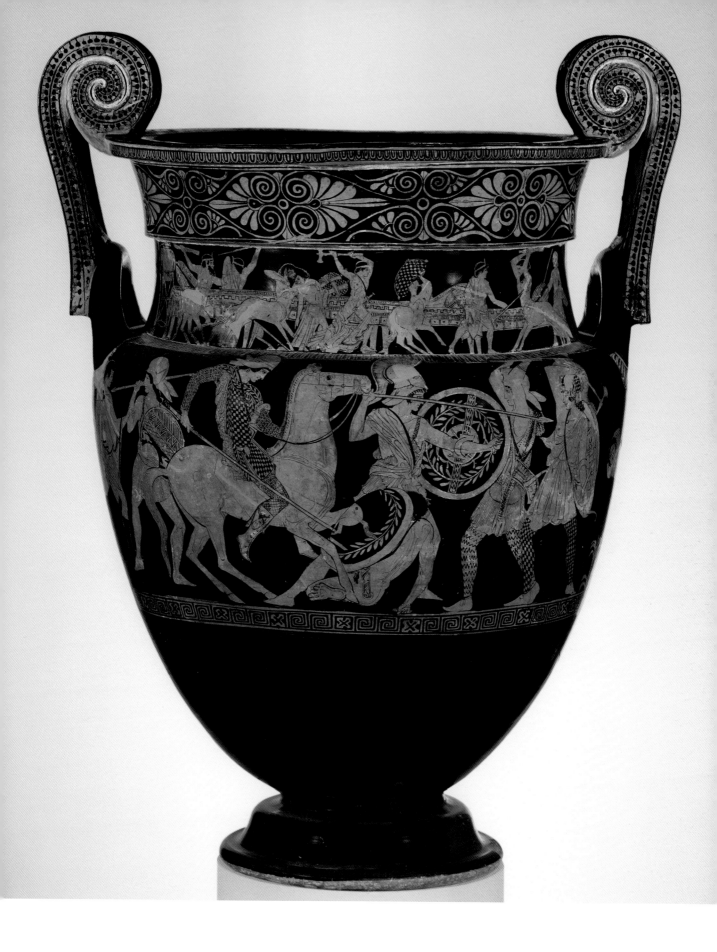

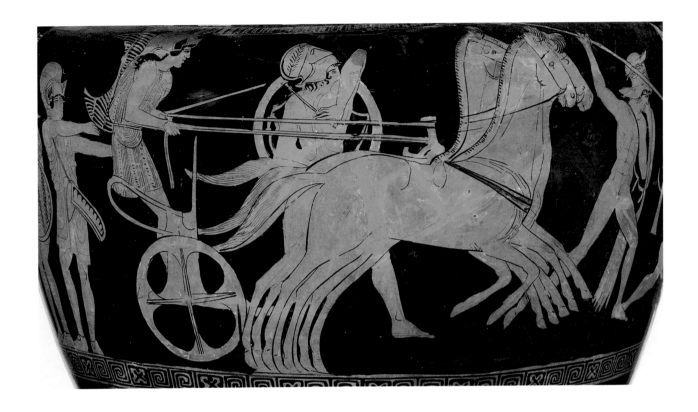

Another aspect of the Amazonomachies concerns an appropriate understanding of the combats between Greek warriors and women whose foreignness is ambiguous. Amazons wearing Persian trousers and caps and fighting on horseback appear exotic. However, with their short tunics, helmets, and other battle gear, many Amazons appear to be Greek warriors in female form. In their dress and activity, these women could not be further from the wives and mothers of Attic citizens, but they have much in common with the men. Recently, some scholars have argued that Greeks in the fifth century B.C. would have considered Persians, Amazons, and other such barbarians as their weak and depraved inferiors.

The ramifications of such considerations are magnified by the presence of large-scale representations of Amazonomachies on the walls of public buildings in the Agora, the civic center of Athens, notably the Theseion, dedicated to the hero Theseus, and the Stoa Poikile (the Painted Stoa). Now lost and known principally from ancient literary texts, the wall paintings were executed during the second quarter of the fifth century B.C. by Polygnotos of Thasos and Mikon of Athens. In his *Description of Greece* (I.17.2–3) written in the second century A.D., Pausanias wrote:

> By the gymnasium there is a sanctuary of Theseus.
> There are paintings here of the Athenians fighting
> the Amazons.... Also painted in the sanctuary
> of Theseus is the battle of the Lapiths and centaurs.
> Theseus is there and has already killed a centaur.
> Among the others, the battle is still an equal match.
> The painting on the third wall is not very clear to
> those who have not heard what they tell about it,
> in part because of its age and in part because Mikon
> did not depict the whole story.

(J. J. Pollitt, *The Art of Ancient Greece: Sources and Documents* [Cambridge, 1990], p.142)

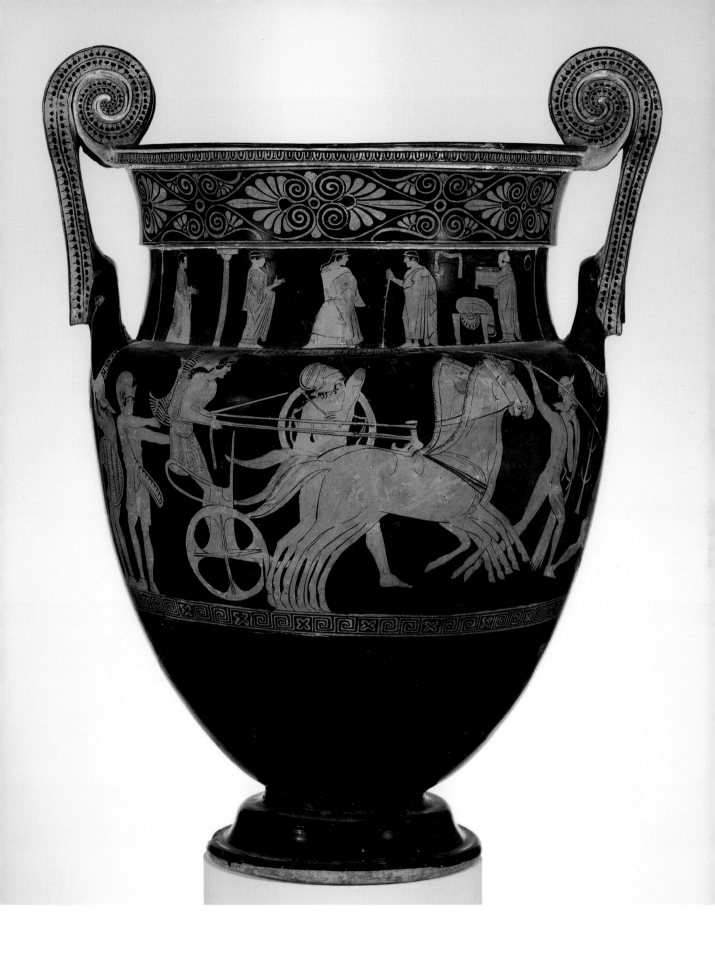

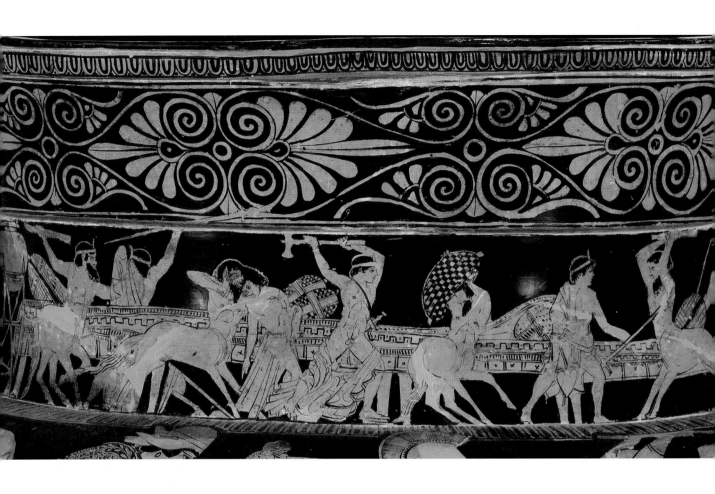

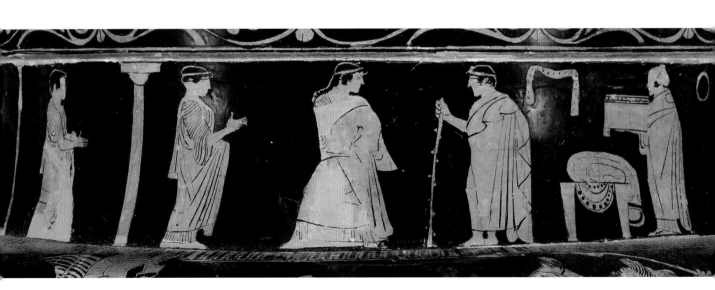

Although painting using a range of colors on a flat surface had existed previously in Greece, these early Classical works were significant because of their scale, their very public location, and an artistic innovation that was changing the way narrative scenes were being depicted. Rather than showing the many protagonists in complex narratives lined up in a row or slightly overlapping, these paintings placed the figures on many levels in an unprecedented attempt to indicate their placement in space. And as we recognize with hindsight, the changes represent a major step toward the development of Western illusionistic painting as we know it. The lost wall paintings influenced the way in which the Amazonomachy was rendered on vases such as the Museum's volute-krater, but they also presented very prominently a series of messages that today resist easy interpretation.

On the front of the vase, the lower frieze of the neck shows the mythological encounter between Lapiths and centaurs, both inhabitants of Thessaly and sworn enemies. The centaurs—part man, part horse—were invited to a celebration for the Lapith leader Perithoos. The centaurs tried to carry off the Lapith women, causing a fierce conflict. In some sources and representations, Theseus is a participant. The engagement appears violent and dense compared with the rather balletic confrontation in the Amazonomachy below. On both the vase and the wall paintings, the subjects that are juxtaposed concern women as well as notions of civilized conduct and barbarism. The reverse of the neck shows a quiet interior with a young man among women. The casket at the right suggests a courting scene.

Finally, it is pertinent to note that the scenes, with their many overtones, appear on an imposing vase with an unmistakably architectonic structure. The Amazonomachy is crowned by the neck in two degrees, one with a narrative frieze, the other with a measured foliate ornament, and, above that, a band of tongues around the lip. The tall handles terminating in volutes produce a columnar effect. The shape, decoration, and ornament create a decidedly structured whole.

Neck-amphora (jar) with Neoptolemos departing

Greek, Attic, red-figure, ca. 440 B.C.
Attributed to the Lykaon Painter
Terracotta, h. 24⅛ in. (61.3 cm)
Rogers Fund, 1906 (06.1021.116)

The volute-krater by the Painter of the Woolly Satyrs (No. 25) presents one reflection of the Persian Wars in Attic vase-painting of the mid-fifth century B.C. This beautiful and poignant neck-amphora offers another. The names of all the figures are inscribed. Neoptolemos, the statuesque male figure in the center, is characterized as a warrior by the scabbard at his side and the spear in his left hand. Antimachos, to the right, holds his elaborate helmet and shield. Neoptolemos clasps hands in a gesture of farewell with a seated, elderly man, Antiochos, who is probably his father. At the far left, Kalliope, perhaps the warrior's wife, holds an oinochoe (jug) and phiale (libation bowl) to pour an offering for Neoptolemos' safe return. We have no way of knowing if these figures were all members of a family. Their inscribed names, however, are richly evocative. In mythology, Neoptolemos was the son of Achilles, the Greek hero of the Trojan War. Antiochos was a son of Herakles and the hero who gave his name to one of the ten Attic tribes, Antiochis. The name Antimachos appears in several mythological contexts, including the Amazonomachy, the battle of the centaurs and Lapiths (see No. 25), and the Calydonian boar hunt. Even without identification, the figures on the neck-amphora are impressively grave and dignified. They could be mortals, but the inscriptions raise them to a mythological, if not immortal, sphere.

The subject matter is of further interest. It reflects both the continuity of certain themes in Attic art and the evolution of the iconography. The handclasp between seated and standing figures occurs frequently on the marble grave monuments that became part of Athenian funerary practice about 440–430 B.C. after an interlude of over half a century (Fig. 43). The depiction on vases seems to have preceded that on the stone monuments. The

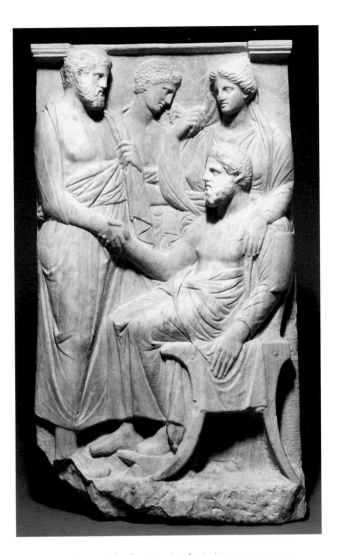

FIGURE 43. Grave stele of a man. Greek, Attic, ca. 375–350 B.C. Marble, h. 56 in. (142.2 cm). Fletcher Fund, 1959 (59.11.27)

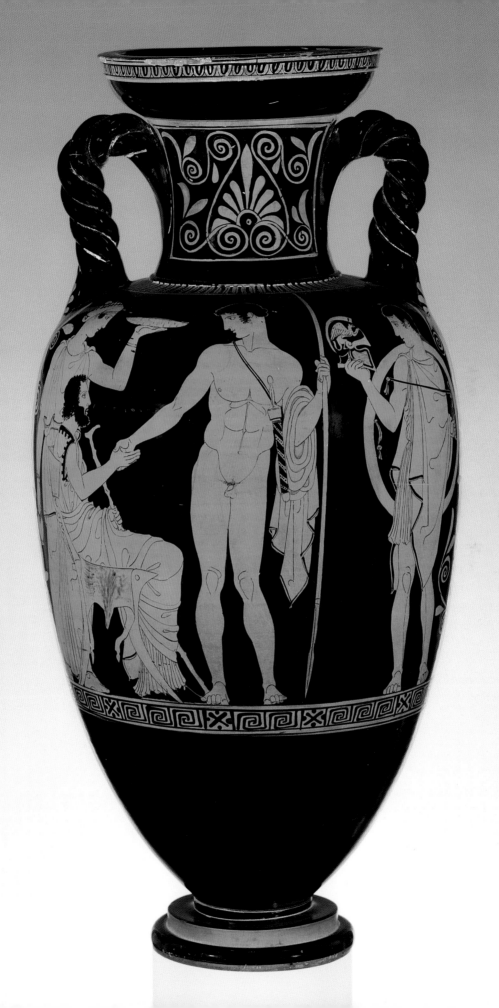

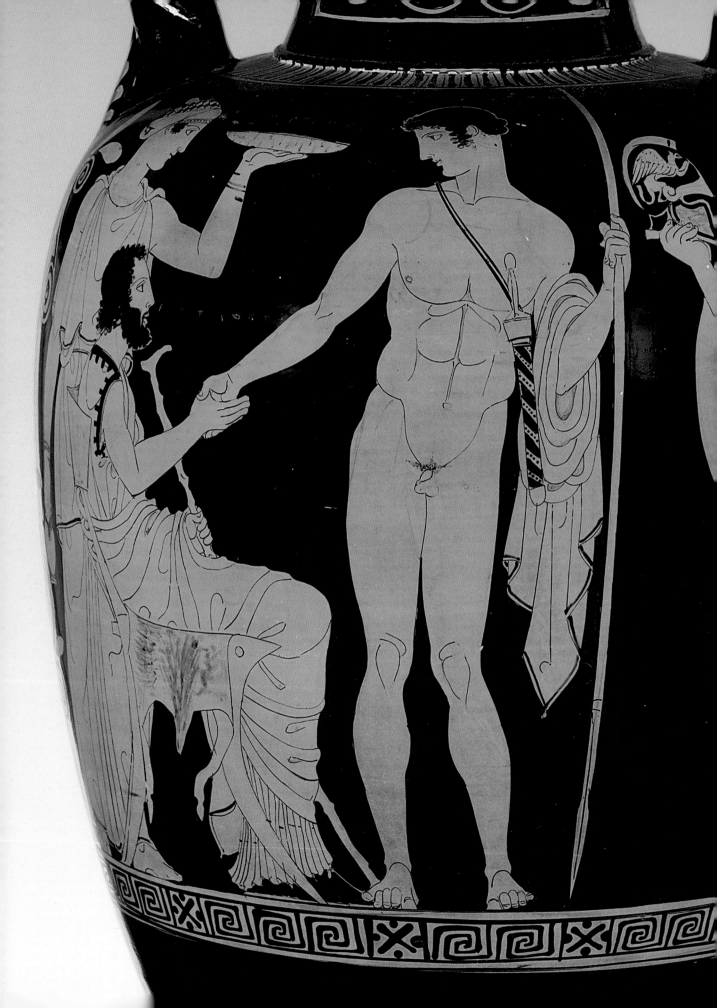

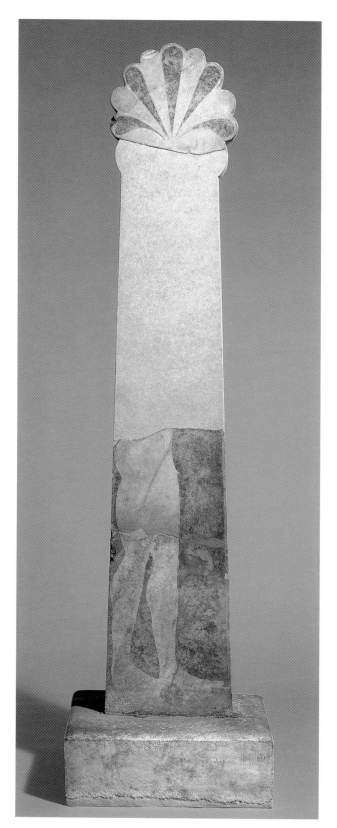

palmette ornament on the neck of the vase recalls the funerary stelai (shafts) crowned with a palmette that began in the sixth century B.C. and continued well into the fifth (Fig. 44). Marble grave reliefs and terracotta vases represent two very different kinds of objects in classical Athens. Tomb monuments were public memorials commissioned by citizens of wealth and status, while vases, however accomplished, were by and large utilitarian objects for personal use. Nonetheless, vases such as this one and the funerary reliefs clearly drew on certain elements whose meaning was commonly understood.

FIGURE 44. Grave stele of Antigenes. Greek, Attic, end of the 6th century B.C. Marble, h. 88 ½ in. (224.8 cm). Rogers Fund, 1915 (15.167)

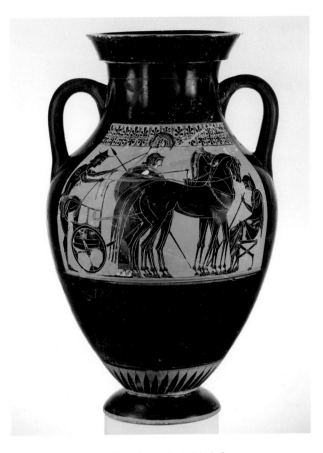

FIGURE 45. Amphora (jar). Greek, Attic, black-figure, ca. 530 B.C. Attributed to the manner of the Lysippides Painter. Terracotta, h. 19 in. (48.3 cm). Museum Accession (x.21.26)

The interplay and interconnection of subjects and motifs in Attic art are complex, and a scene such as this one has overtones about which we can only conjecture. For instance, the canonical depiction of a warrior's departure on black-figure vases of the second half of the sixth century B.C. shows a warrior setting out in a chariot, often surrounded by members of his household, male and female, old and young, standing and seated (Fig. 45). Chariots had not been used in warfare since the Bronze Age (see Nos. 3, 6), so that these black-figure scenes were imbued with a heroic element, reinforced on the amphora by the presence of the goddess Athena with her helmet and spear. On the Lykaon Painter's vase, the heroic element is conveyed by the protagonists' names and emphasized further by the scale and nudity of Neoptolemos. And even the smallest details are calculated. Note that the warrior's proper right foot and the tip of his spear occur just above a saltire square in the ornament below, defining his particular space.

What is one to make of the reverse of the vase? A bearded man stands in the center, leaning on his staff and flanked by a woman holding a torch and another holding a phiale (libation bowl). There are no inscriptions. The torch suggests that the group is waiting for news into the night.

Bell-krater (bowl for mixing wine and water) with the ascension of Persephone from the Underworld

Greek, Attic, red-figure, ca. 440 B.C.
Attributed to the Persephone Painter
Terracotta, h. 16⅛ in. (41 cm)
Fletcher Fund, 1928 (28.57.23)

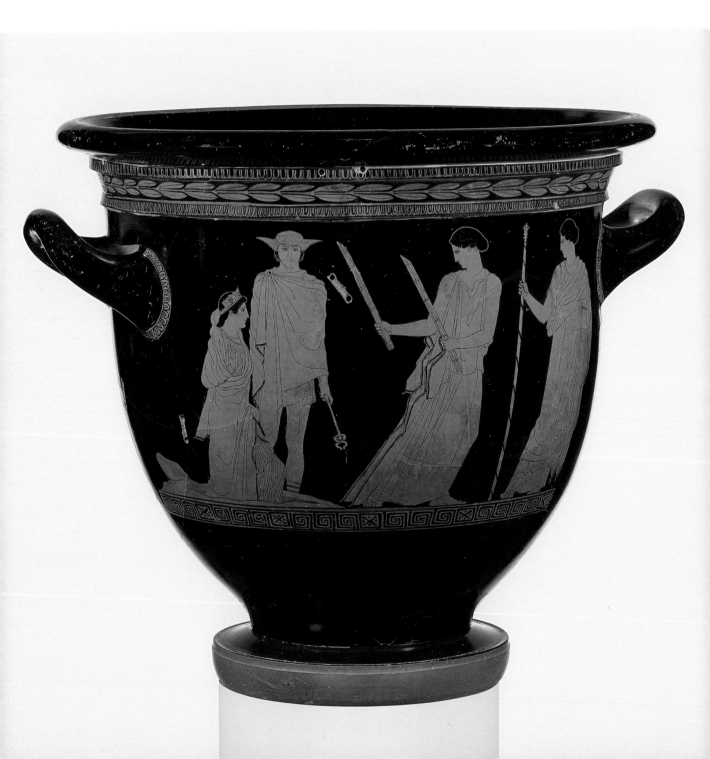

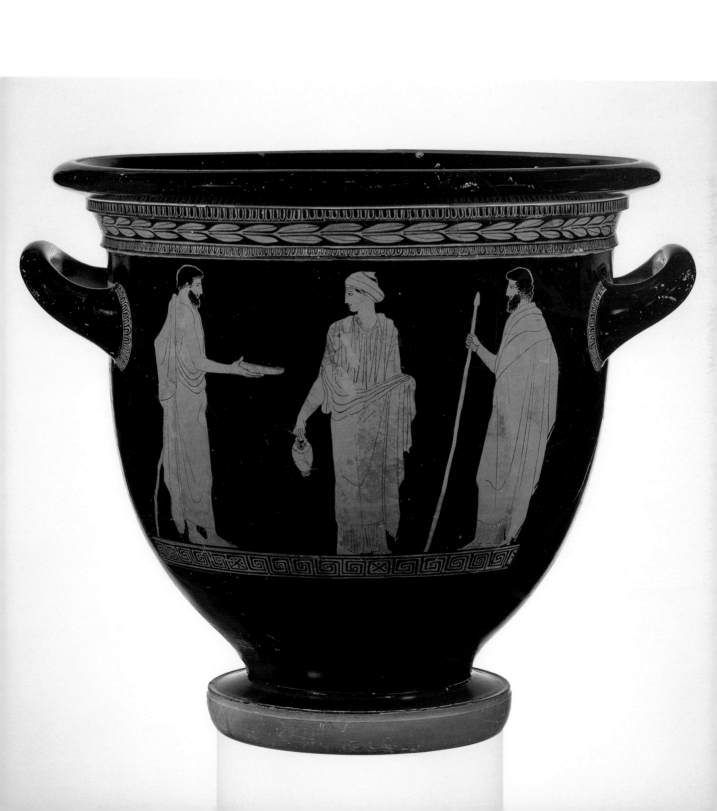

As the fifth century progressed, the limitations of red-figure vase-painting in rendering the spatial dimensions of complex narrative scenes became increasingly acute. The volute-krater No. 25 illustrates how some artists addressed the challenge. By contrast, the bell-krater showing Persephone emerging from the realm of Hades is breathtaking in the artist's use of his medium over an expansive surface to evoke the event as though it were occurring before our eyes. Daughter of Demeter, the goddess of fertility and grain, Persephone was carried off by the god Hades, ruler of the Underworld, to be his bride. And because she had eaten in the Underworld—pomegranate seeds (see No. 7)—she was condemned to spending a portion of every year there with her spouse. The period of her absence was marked by the cessation of growth and fertility on earth.

The obverse of the bell-krater depicts the ascension of Persephone from Hades. The name of every participant is inscribed. Persephone is about to step out of a narrow opening in the ground onto a small patch of soil. Her guide for the ascent is the divine messenger, Hermes. Looking straight toward us, he stands close to her; he holds his kerykeion (herald's staff) (Fig. 46) with the finial down, indicating that his job is done. It has passed, however, to Hekate, a goddess of earth and fertility who also presides over magic, roads, and crossroads. Here, she prominently holds up two flaming torches to light Persephone's progress toward Demeter; scepter in hand, she waits sovereignly on the far right. The torches identify the time as night, which the deep and even glaze renders with palpable blackness. The scene is extraordinarily still, majestic, and solemn. Persephone has left the gloom of the Underworld for the darkness of earth. When she is reunited with Demeter, life will reawaken.

Although the Persephone Painter is not one of the very greatest Athenian artists, this vase is a masterpiece in its integration of shape, technique, and subject matter. Its dramatic immediacy raises the question of whether some kind of performance underlies the iconography. The question allows for no definite answer but is essential. Demeter and Persephone were major goddesses in many parts of Greece, with several festivals dedicated to them, a developed mythology, and particularly significant here, a mystery cult at Eleusis, in Attica. The Museum is fortunate to own a Roman copy of the Great Eleusinian relief (Fig. 47), the original of which dates to the third quarter of the fifth century B.C. and is now in the National Archaeological Museum, Athens. It depicts the two presiding deities as well as a young boy, possibly Triptolemos; he traveled around in a winged chariot as an emissary of Demeter, introducing to the Greeks the cultivation of corn.

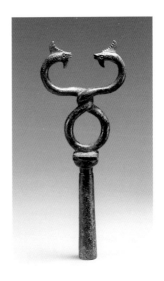

FIGURE 46. Finial of a kerykeion (herald's staff). Greek, late 6th–early 5th century B.C. Bronze, h. 7 3/8 in. (18.7 cm). Gift of Norbert Schimmel Trust, 1989 (1989.281.57)

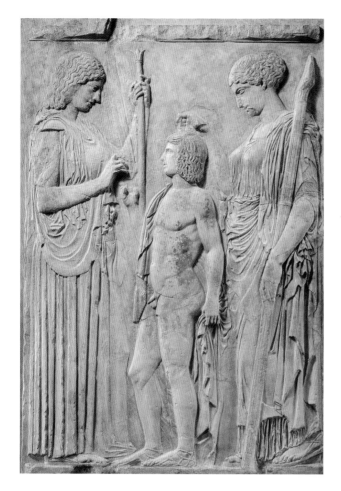

Although secrecy was a condition of initiation into the Eleusinian Mysteries, quite a bit is known about the initiates, those who administered the sanctuary and its observances, as well as the rituals themselves. There was significant Athenian participation in all aspects, and one of the major events was a great public procession from Athens to Eleusis, a distance of about fourteen miles. The mystery rites, some of which took place at night, included a reenactment of Persephone's banishment to the Underworld.

Our bell-krater was used in a symposium (see Nos. 13, 23), a context quite different from that of the Eleusinian sanctuary. We have no way of knowing the source underlying the iconography, although extensive scholarship has been devoted to the question. It might have come from some echo of the Eleusinian observances. It might have been influenced by a literary source, such as the Homeric Hymn to Demeter. Generally dated to the sixth century B.C., the poem recounts the myth in great detail and refers to the Mysteries that the goddess instituted. However, the iconography of the vase differs from the text in important respects, notably in that Persephone returns to earth on foot rather than in a chariot as the poem describes. The various interpretations of the myth indicate its popularity in the fifth century B.C. Whether the Persephone Painter was rendering quite literally a source now lost to us or his own vision of a major subject, he has created a compelling evocation.

Lekythos (oil flask) with seated youth and woman

Greek, Attic, white-ground, ca. 440 B.C.
Attributed to the Achilles Painter
Terracotta, h. 15½ in. (39.4 cm)
Rogers Fund, 1907 (07.286.42)

The search for greater pictorial expressiveness during the fifth century B.C. went beyond new ways of working with the red-figure technique. Beginning in the second quarter of the century, the practice of introducing a white slip as the surface for decoration became increasingly common. It had existed before (see Nos. 19, 20), but during the Classical period, the white-ground technique was typically applied to lekythoi, oil flasks that served in rituals for the deceased, and it became associated with funerary iconography. This use of lekythoi is well illustrated on a work showing a youth and a woman at a tomb on the steps of which appear wreaths and vases, including two types of lekythoi (Fig. 48); note those that have fallen over.

The popularization of a white slip as the surface for decoration dramatically expanded the artists' range of

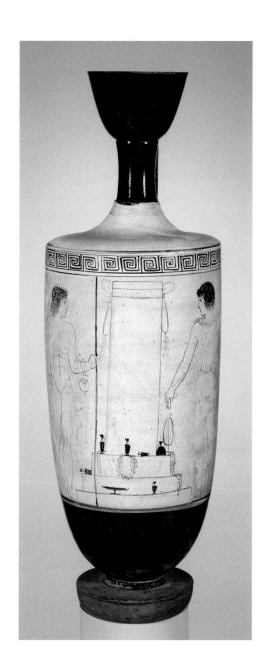

FIGURE 48. Lekythos (oil flask) with mourners at a tomb. Greek, Attic, white-ground, ca. 440–430 B.C. Attributed to the Bosanquet Painter. Terracotta, h. 15¼ in. (38.7 cm). Rogers Fund, 1923 (23.160.38). Detail, dedications

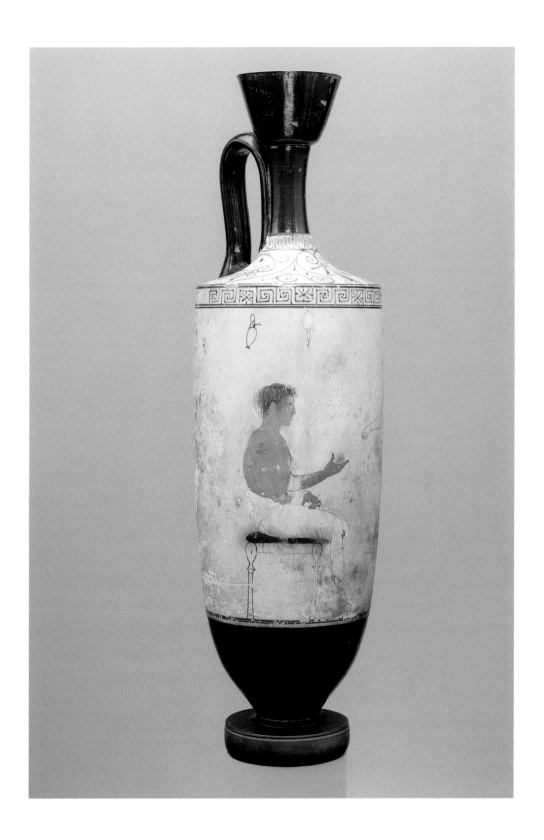

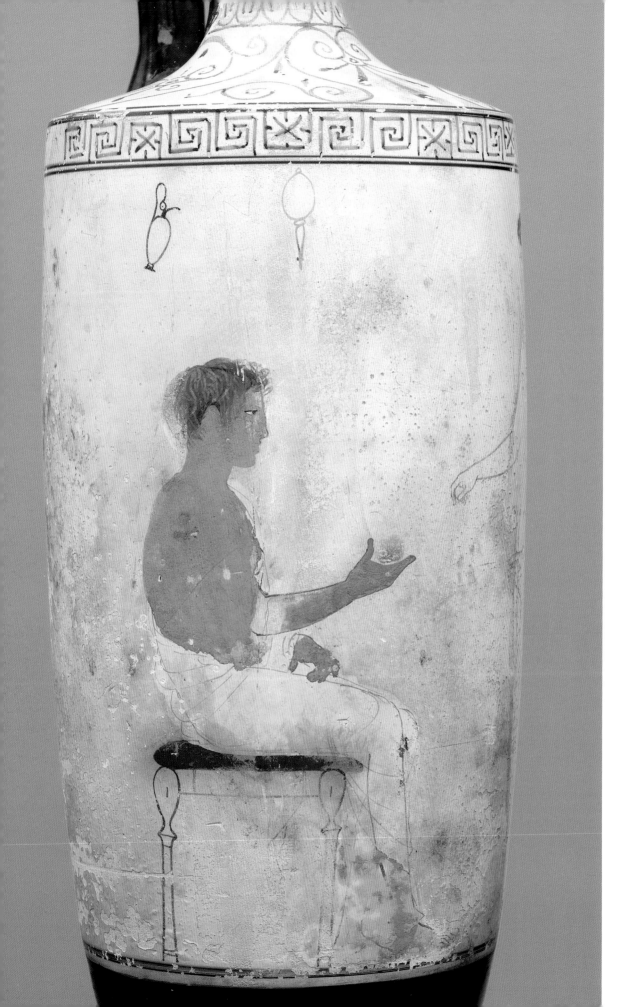

colors. At first, the pigments were still applied before firing and therefore needed to withstand the temperatures within a kiln. By about 430 B.C., the decoration was executed after firing, allowing the introduction of a new spectrum of pinks and purples, greens and blues. The style of drawing also tended to become increasingly free. The fragility of the white surface and the transiency of the new unfired colors have caused many vases to survive in damaged condition. What remains, however, is often still spectacular.

The Achilles Painter was the master of Classical white-ground decoration. The figures in his spare compositions are as cool and noble as their sculptural counterparts—one has only to think of those on the Parthenon. The woman on the lekythos illustrated here is typical of his work, with the surely drawn contours of her head and limbs, dilute glaze rendering her dark curly hair, and exquisite folds of her garment, whose color is now lost. The mirror and the sakkos (snood) suspended in the background identify the setting as the women's quarters of the house. The most remarkable feature on the vase is the seated youth. The use of a pale brown pigment to depict his flesh is exceptional, as is the delicate polychromy of his face and hair. The garment around his lower back and legs originally would have been a strong red, juxtaposed with the darker tonality of the cushion on which he sits. In his right hand, he holds out a piece of fruit, now mostly lost. Canonical black-figure and red-figure vases provide abundant evidence of masterful drawing, but what remains of the youth preserves what we think of today as painting on the highest level. The wispy delicacy of his hair implies motion and imminent change. The image is so powerful because of the equilibrium between the timeless, balanced composition and the incredibly specific and tangible detail.

Skyphos (deep drinking cup) with scenes of women

Greek, Attic, red-figure, ca. 350 B.C.
Terracotta, h. 6⅞ in. (17.5 cm)
Rogers Fund, 1906 (06.1021.181)

An iconographical phenomenon of the Classical period, from the middle of the fifth century B.C. on, is a marked increase in representations of the life of women—their participation in ceremonial observances whether private (see No. 26) or civic, their preparations for marriage (Fig. 17), their various roles in rituals for the dead (see No. 28).

This development does not simply reflect an interest in the subject matter but is also connected to the shapes on which the scenes are depicted. The so-called fountain hydriai (see No. 18) from the sixth century provide excellent examples of the pairing of shape and subject, as do the white lekythoi from the fifth century (see No. 28).

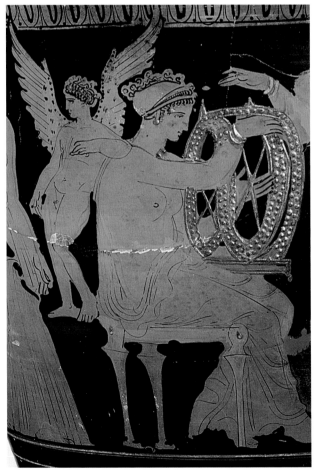

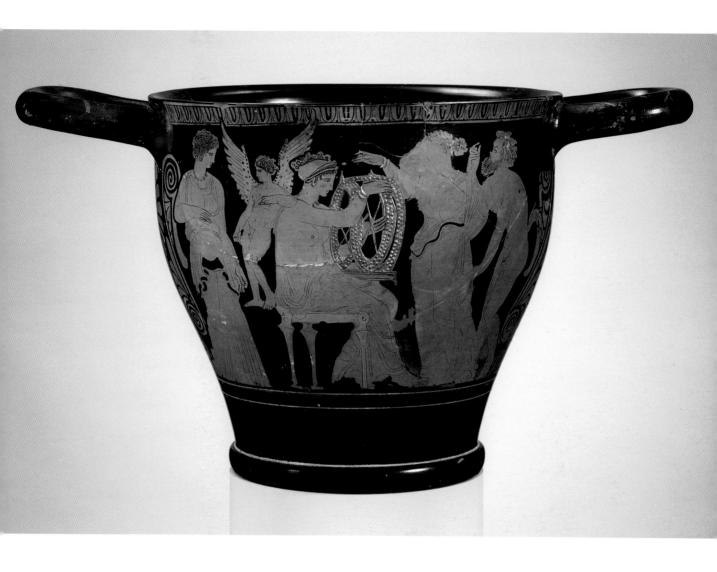

The skyphos follows the kylix as the most important type of drinking cup in Athens, and it offers two fairly regular vertical surfaces for decoration rather than the three circular surfaces of a cup. The scenes here reveal a magnificence that we have not encountered and that is noteworthy at a time when Athens had lost her previous prestige and great affluence. In the center of the main side, a woman sits majestically on a stool with finely turned legs and gilded dowels. She wears a himation (cloak) draped over her left shoulder and around her lower torso and legs. Her curly, almost tousled hair is bound up with a broad fillet. Most

conspicuous of all is her gold jewelry: the belt at her waist, heavy bracelets, necklace, and earring. On her lap, in front of her nude torso, she holds a large ceremonial basket, also gilded. Somewhat awkwardly rendered, it consists of a flat base to which almost circular uprights are attached; they are embellished with small relief bosses and reinforced by crosspieces. This elaborate object is a classical variant of a flat, three-handled basket that, since the end of the Bronze Age, figures in ritual scenes such as animal sacrifices or the bringing of offerings to a tomb. During the fifth and fourth centuries B.C., this high-end version

often appears in representations connected with marriage. Although the open construction would seem impractical, it allowed the special paraphernalia to be readily visible.

The context of the scene is established by the figures flanking the seated woman. Before her stands a woman, wrapped in a chiton (undergarment) and himation and wearing a gilded bracelet, necklace, earrings, and a clasp holding her hair in a kind of ponytail. Behind her, a satyr with a gilded fillet is touching her posterior with his left hand that is partly concealed behind her body; his raised right hand gestures equally suggestively. Behind the seated woman, a small, exceedingly relaxed Eros stands on an indeterminate elevation; his fillet preserves gilding. He faces a woman in a belted peplos (garment), with gilded earrings and necklace. The seated woman, richly embellished and accompanied by both attendants and

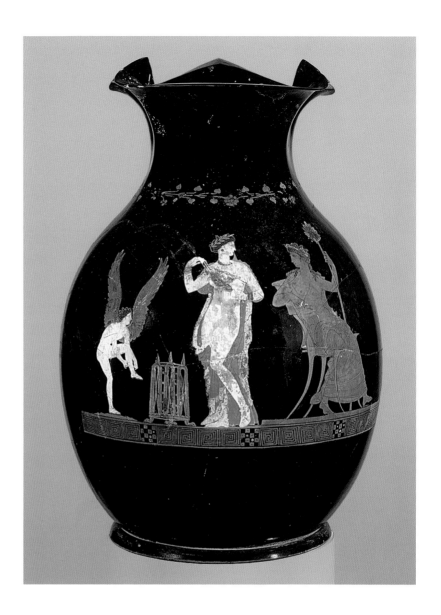

FIGURE 49. Oinochoe: chous (jug). Greek, Attic, red-figure, mid-4th century B.C. Terracotta, h. 9¼ in. (23.5 cm). Rogers Fund, 1925 (25.190)

Eros, evokes Classical wedding iconography. Since these scenes are considered to have taken place within the women's quarters of the house, the presence of the satyr indicates a Dionysiac intrusion. The two realms are known to have come together during a major Athenian festival, that of the Anthesteria, which primarily celebrated the year's new wine in late February. On the evening of the second day, the ritual marriage between Dionysos and the wife of the archon basileus, one of the city's chief magistrates, took place in secret. It was preceded by a procession to the site of the wedding near the city center, the Agora (marketplace). The elaborate basket was appropriate to such functions. Indeed, a contemporary vase in the Museum's collection (Fig. 49) shows Pompe, a personification of procession, with Eros, Dionysos, and such a basket.

The image on the reverse of the skyphos presents a variant of the obverse. An Eros holding a large casket and a sash flies toward a woman who is seated on a chest. She is richly adorned and faces a standing woman with a patterned garment and sakkos (snood). The satyr on the far right perches on a rock, introducing an outdoor element to what otherwise would appear to be an indoor scene. The iconography of both sides of the skyphos, as well as the appreciable amount of gilding, suggest that the vase played a role in a significant event, such as a woman's participation in the Anthesteria and/or her own wedding.

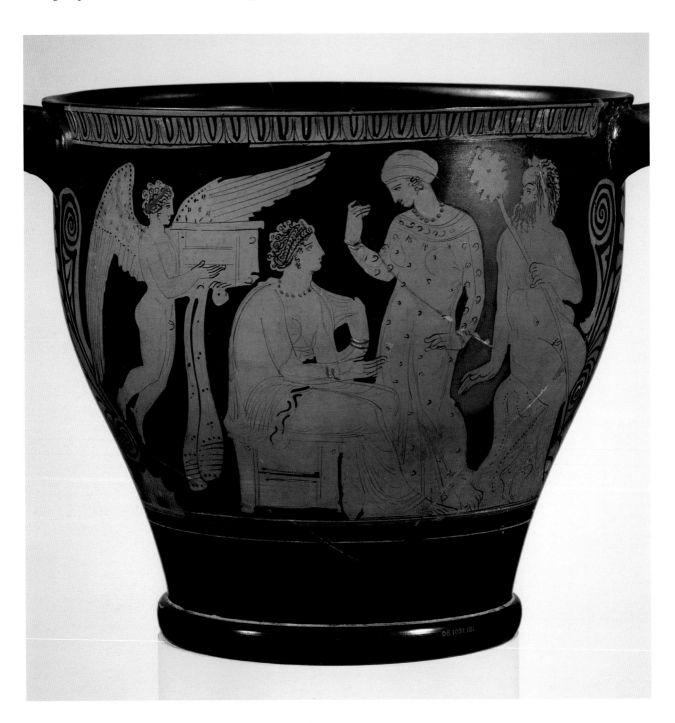

Kalpis (water jar) with gilding

Greek, Attic, black-glaze, 4th century B.C.
Terracotta, h. 15½ in. (39.4 cm)
Funds from various donors, 1923 (23.74)

LEFT: FIGURE 50. Hydria (water jar). Greek, early 4th century B.C. Bronze, h. 20^{3}/$_{16}$ in. (51.2 cm). Purchase, Joseph Pulitzer Bequest, 1956 (56.11.3)

RIGHT: FIGURE 51. Auguste Rodin. *The Birth of the Greek Vase.* French, ca. 1900–13. Graphite with gouache wash on white paper, h. 19^{3}/$_{8}$ in. (49.2 cm), w. 12^{5}/$_{8}$ in. (32.1 cm). Gift of Thomas F. Ryan, 1913 (13.164.2)

The decoration on Greek vases tends to engage one's attention more than the shape, but there is one category of fine ware in which the primacy of the shape is uncontested. Known as "black-glazed" pottery, for evident reasons, it began during the sixth century B.C. and became popular throughout the Greek world, owing to the establishment of local workshops as well as trade. During the fifth century B.C., various types of embellishment appeared, including stamped or relief elements that are glazed with the rest of the surface—and therefore read as black—as well as a very focused application of gilding.

This kalpis provides a beautiful example. Its tight profile represents an evolution beyond the black-figure hydria No. 18 and the kalpis of the mid-fifth century No. 24. The foot is small, the very vertical handles close to the body, and the gilded lip generous. A gilded, delicately articulated vine tendril with leaves and grapes circles the neck like a choker. Narrow gilded bands surround the side handles, and below the vertical handle is an attenuated foliate composition distantly descended from pendant palmettes. Between the glossy black surface and the wiry gold enhancements, the effect is metallic, but especially elegant.

It is interesting to compare the kalpis with a roughly contemporary bronze hydria (Fig. 50). There are similarities, as in the pronounced tapering of the body to a small foot. The plaque beneath the vertical handle has a palmette composition, but it is heavier due to the execution by casting and the need for a broad surface to secure the handle to the walls of the vase.

The conceit of adorning a vase with a necklace became astonishingly widespread between the late fifth and the third century B.C. and appeared on a range of shapes decorated in black glaze including Panathenaic amphorae (see No. 22), hydriai (see No. 24), kraters (see Nos. 27, 31), and oinochoai (Fig. 49), among numerous others. The jewelry applied to the vases is often paralleled in actual examples (Fig. 52). It is difficult not to find here a subtle anthropomorphism, as the nineteenth-century French artist Auguste Rodin expressed in his evocative watercolor that he called *The Birth of the Greek Vase* (Fig. 51).

FIGURE 52. Armband with Herakles knot. Greek, 3rd–2nd century B.C. Gold, garnets, emeralds, and enamel, diam. 3^{1}/$_{2}$ in. (8.9 cm). Purchase, Mr. and Mrs. Christos G. Bastis Gift, 1999 (1999.209)

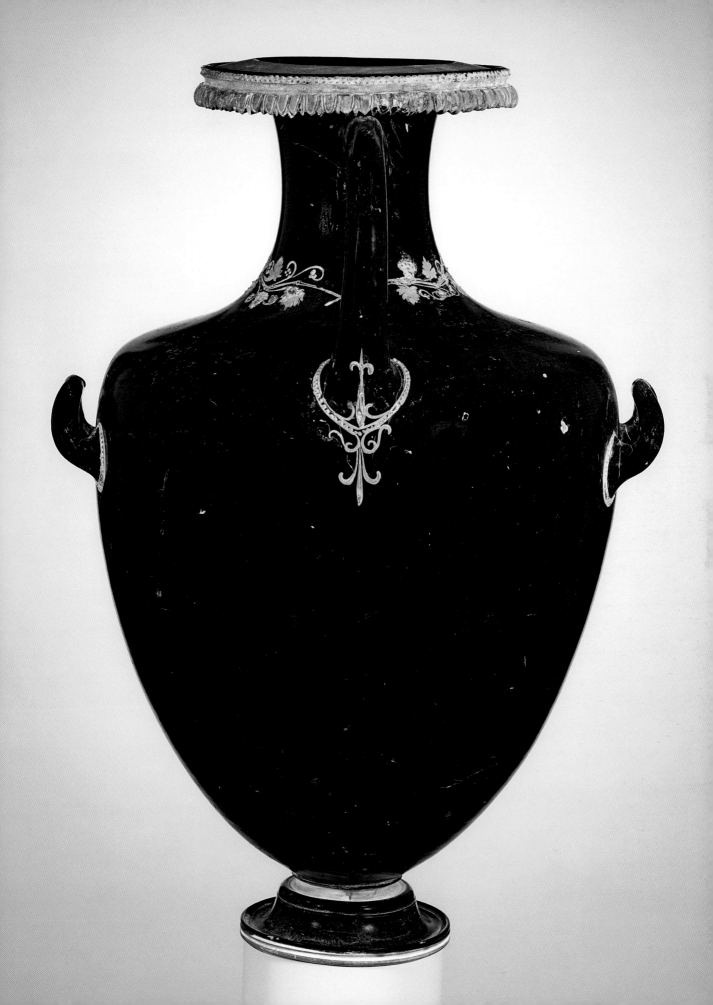

Calyx-krater (bowl for mixing wine and water) with the apotheosis of Herakles and Amymone surprised by satyrs

Greek, Attic, red-figure, 4th century B.C.
Terracotta, h. 19⁹⁄₁₆ in. (49.7 cm)
Purchase, Joseph Pulitzer Bequest, 1952 (52.11.18)

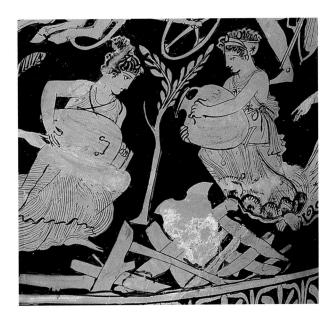
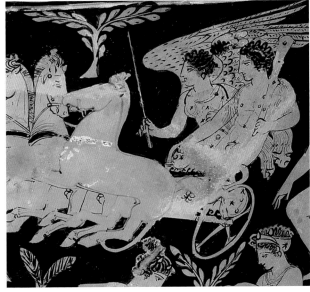

The relation between vase shape and decoration became ever more complex from the mid-fifth through the fourth century B.C. The skyphos No. 29 by and large retains the traditional deployment of figures along a plane parallel to the implied "background" of the vase wall. This is one of the factors producing the effect of thoroughgoing homogeneity among all features of a Greek vase. At the same time, the desire of artists to depict movement in space, which manifested itself in the mid-fifth century (see No. 25), continued to develop. The present calyx-krater is a representative example that for our purposes can also serve as a link to vase-painting in Southern Italy, where the art enjoyed an intense renewal for about a century and a half (see Nos. 32–35).

The large cast of characters on the obverse participates in the final events of the life of Herakles. Herakles' earthly existence ended on a flaming pyre after he put on the cloak that his wife, Deianeira, had smeared with blood of the centaur Nessos. The garment seared Herakles' flesh, and to terminate his agony, he had himself placed on a great pile of wood on Mount Oite, in central Greece. The lower row of figures shows the goddess Athena directing two women as they quench the pyre, emptying their hydriai (water jars) onto a jumble of planks and an empty corselet—the tangible remnant of Herakles. At the center of the zone immediately above, the young and beautiful hero, identifiable by his club, rides to Mount Olympos in a chariot driven by Nike, the personification of victory,

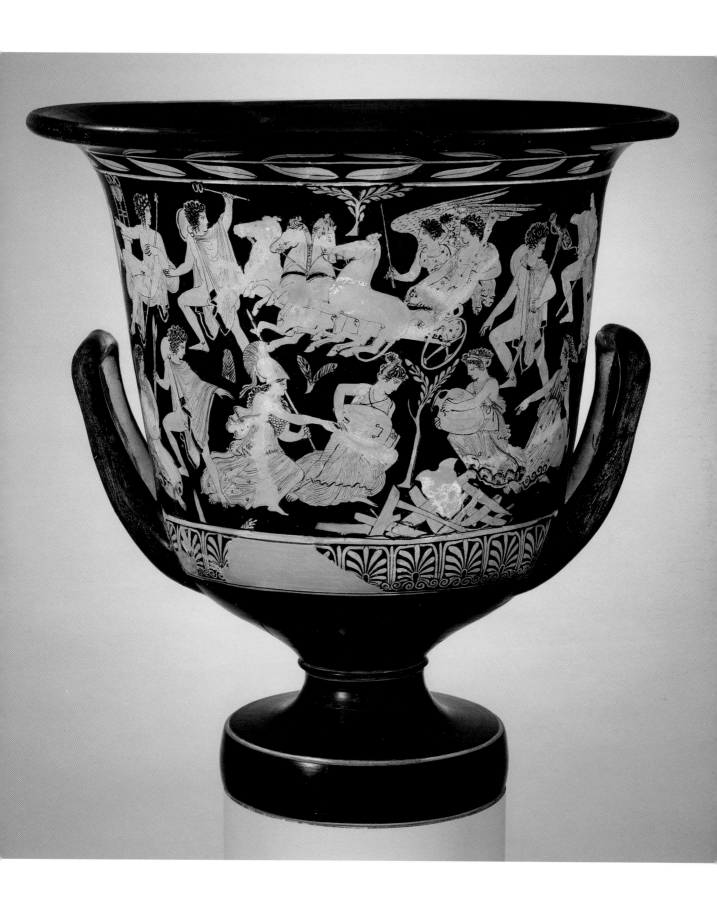

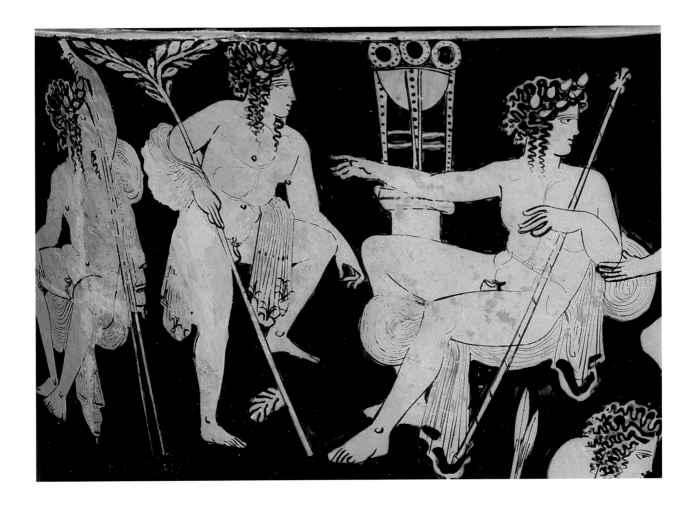

and preceded by the god Hermes (see No. 27), who brandishes his kerykeion (messenger's staff). The other youths are probably Iolaos, Herakles' nephew and faithful companion, and Hyllos, his eldest son. The figure at the upper right, holding a bow and quiver, may be Poias, whom Herakles persuaded to light the pyre in return for his weapons, or Poias' son, Philoktetes. The gods of Mount Olympos are represented at the left by Dionysos with a scepter, Apollo, and Ares, god of war, with two spears. The scene here does not fit the surface comfortably; the figures are densely packed and even spill over the handles.

On the reverse, Amymone, holding a hydria and thyrsos (fennel stalk topped with ivy), is beset by a corps of balletic satyrs. One of the fifty daughters of King Danaos, she was rescued by the sea god Poseidon, who became her lover. The story is the subject of a satyr-play by Aischylos, of which only the scantiest fragments remain, and it began to appear in vase-painting during the first quarter of the fifth century B.C. The question arises as to whether, and to what degree, these images have a theatrical connection. Of note, but perhaps not significant, is the centrifugal composition here contrasting with the irregularly horizontal organization on the other side. Action and demonstrative poses, however, characterize the figures in both scenes. Whether there is also an iconographical connection between the two depictions remains unclear, although rescue and water play a part in both subjects.

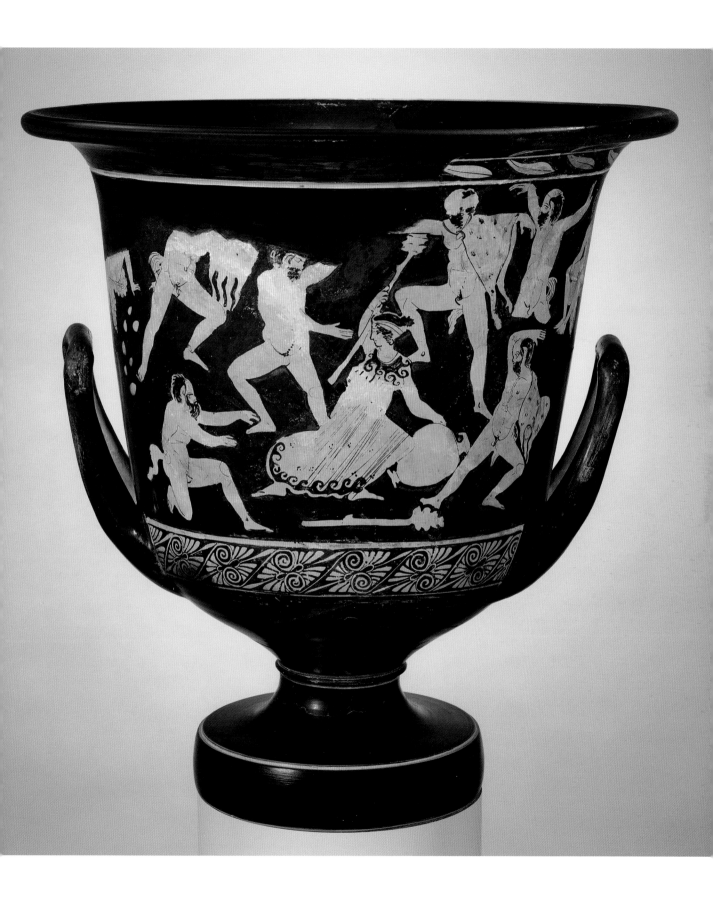

Volute-krater (monumental vase) with Amazonomachy

Greek, South Italian, Apulian, red-figure, ca. 320–310 B.C.
Attributed to the Capodimonte Painter
Terracotta, h. 36 1/16 in. (91.6 cm)
Fletcher Fund, 1956 (56.171.63)

For all the differences in shape and size, this vase shares quite a number of elements with the calyx-krater No. 31. The main scene is organized in two superposed zones, the figures wear recognizably Greek dress, and Nike, the personification of victory, drives a quadriga (four-horse chariot) on the neck, among other features. However, if we scrutinize the image further, with particular attention to detail, we find major innovations.

The first and perhaps most obvious is the greater quantity of everything: filling motifs among the figures,

tightly packed ornament on the shoulder and neck, relief masks of Io in the spirals of the volute handles, small representations of Pan on the lower part of the handles. Io was one of the loves of Zeus whom he transformed into a heifer, and Pan, with the horns, ears, and legs of a goat, was a god of herdsmen. There are also quite a variety of different details, such as the bucrania (bulls' heads) flanked by swags, the large suspended mirrors, and the kidney-shaped shield. The decoration on the reverse points to the magnitude of the change from the mainland

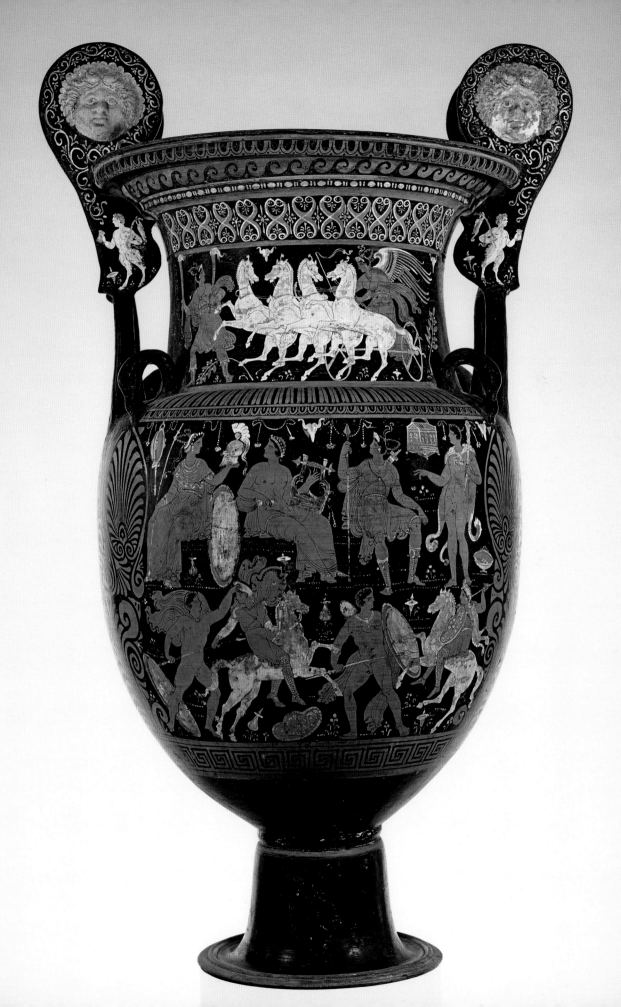

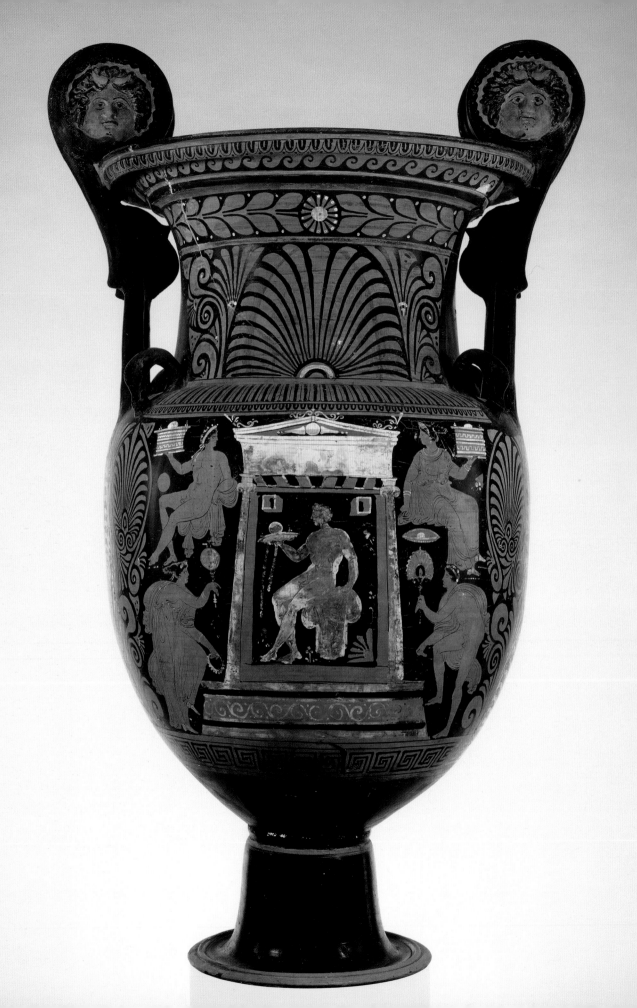

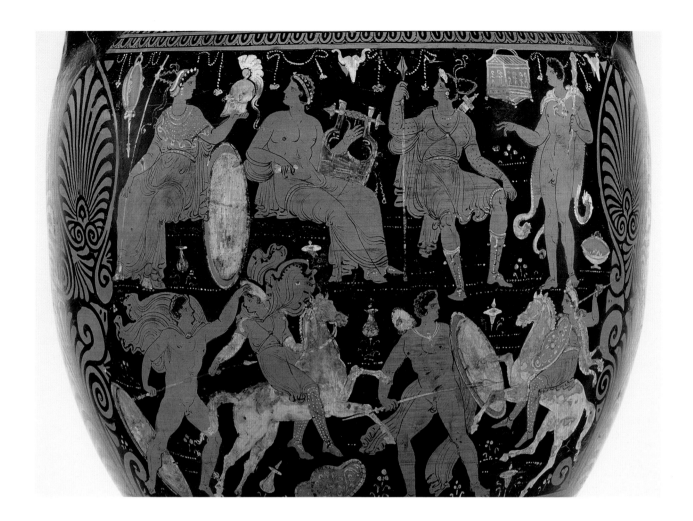

Greek vases we have seen so far. A youth sits within an architectural niche raised on a low podium. Below the pediment of the roof, ceiling beams are rendered to give the illusion of perspectival recession. Figures are implausibly squeezed and stacked to either side. On the neck, foliate motifs have been wholly rigidified. A hard look at the vase as a whole reveals that the elements of the shape and the relation between shape and decoration have lost their compelling symbiosis.

The volute-krater exemplifies a number of points in which red-figure vase-painting transplanted to Southern Italy diverges from its Greek origins. Beginning in the third quarter of the fifth century B.C. (see Introduction, p. 25), red-figure prospered, developed into several regional styles—notably Lucanian, Apulian, Campanian, Paestan, Sicilian—and was adapted to the needs and predilections of the local populations. The function of the pottery was primarily funerary, as is shown by the subject on the reverse. The extraordinary challenge to modern scholars is how to interpret correctly all the visually familiar components of Greek vases—shape, technique, ornament, subject matter—that are now invested with very different meanings. The scene on the body depicts an Amazonomachy (see No. 25) below a gathering of Athena, Apollo, Artemis, and Herakles standing at the far right. On the neck, Hekate with two torches (see No. 27) precedes a chariot driven by Nike. While many mainland Greek vases are difficult to interpret, we are often helped by surviving literary evidence such as the epics of Homer or longstanding traditions in the art of vase-painting. For the pottery of Southern Italy, external evidence is far more scanty and proposed interpretations more tentative.

33

Skyphos (deep drinking cup) with warrior and seated woman

Greek, South Italian, Campanian, red-figure, 3rd quarter of the 4th century B.C.
Attributed to the CA Painter
Terracotta, h. 9¾ in. (24.8 cm)
Edward C. Moore Collection, Bequest of Edward C. Moore, 1891 (91.1.444)

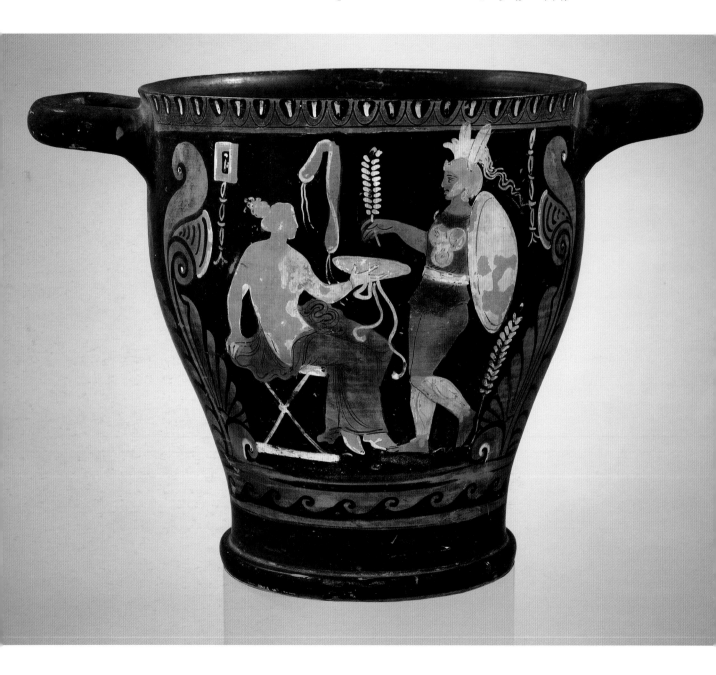

The degree of verisimilitude in ancient scenes of "daily life" is an open question that will never be fully resolved. Moreover, photography has accustomed us to previously unattainable levels of fidelity in the reproduction of a subject. In a broad sense, however, the images of Athenian warriors of the mid-fifth century B.C. (see No. 26) or their Campanian counterparts a century later do reflect certain contemporary realities.

The volute-krater No. 32 depicts a mythological subject on the obverse and a heroized, idealized funerary scene on the reverse. The sturdy skyphos here shows a woman seated on a diphros, a folding stool, wearing her hair pulled up and a red garment around her lower body. Her flesh was painted a beigy white, which has now partly flaked off. She extends a shallow bowl toward the warrior facing her. Shown in full South Italian regalia, he wears a cloth tunic that just covers his torso, cinched with a broad belt (Fig. 53). His chest is covered with a distinctive Italic breastplate composed of three joined circular elements attached to a metal strap that goes over the shoulder (Fig. 54). His legs are protected by greaves. The helmet is topped by two vertical feathers and a crest with a long floating appendage. On his left arm, he holds his shield, and in his right hand, he extends a sprig of foliage. Added white and a golden yellow articulate various details; where they are applied to the woman's bowl and the warrior's armor, we can infer that the objects depicted are of metal.

FIGURE 53. Belt with clasps. Italic, Samnite, late 5th–early 4th century B.C. Bronze, circumference 33 in. (83.8 cm). Rogers Fund, 1908 (08.3 a)

FIGURE 54. Pectoral. South Italian, possibly Apulian, 2nd half of the 4th century B.C. Bronze, h. 12 5/8 in. (32.1 cm). Badisches Landesmuseum Karlsruhe inv. F 453. Photograph courtesy of the Badisches Landesmuseum, Karlsruhe

The warrior in full native gear appears frequently on vases produced in the region of Campania and gives some idea of the clientele for whom these vases were made. Although there was a long and influential Greek presence in this part of Italy, called Magna Graecia already in antiquity, the painted pottery catered to undoubtedly affluent and socially significant members of the indigenous population.

The reverse of the skyphos portrays a coarser variation of the scene on the obverse. A seated bejeweled woman of imposing proportions and heavy features extends a shallow bowl toward a youth wrapped in a himation (overgarment) with a fillet (band) around his head; he holds a branch of vegetation against his body. The phiale (libation bowl) and branch suggest a ceremonial scene. Finally, the vegetal ornament below each handle looms as a solid structure rather than an artistic motif dynamically related to the underlying shape.

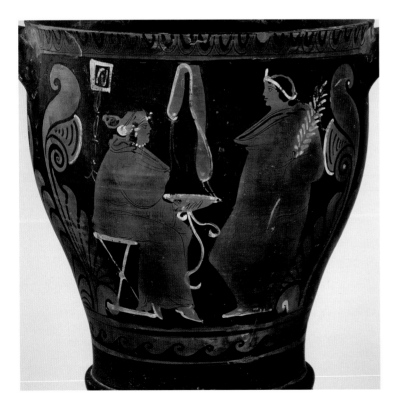

34

Bell-krater (deep bowl) with the fate of Sarpedon

Greek, South Italian, Apulian, red-figure, ca. 400–380 B.C.
Attributed to the Sarpedon Painter
Terracotta, h. 19⅝ in. (49.8 cm)
Rogers Fund, 1916 (16.140)

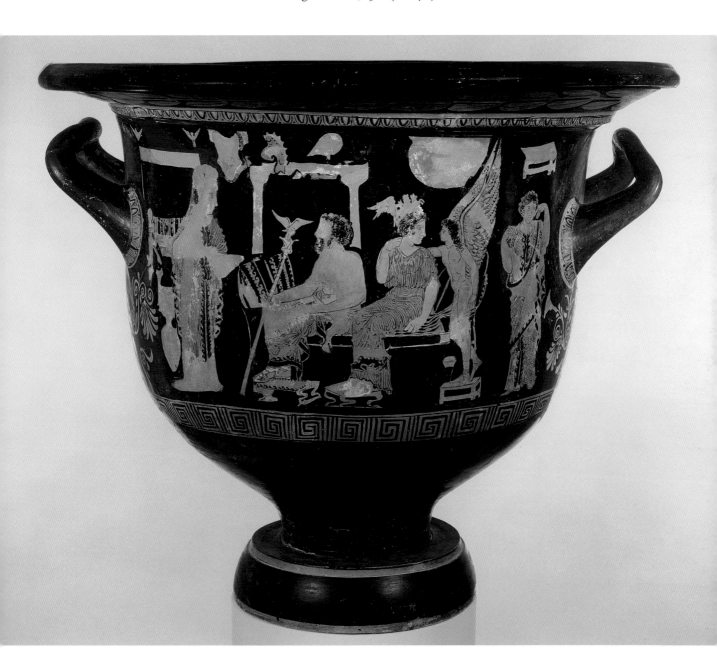

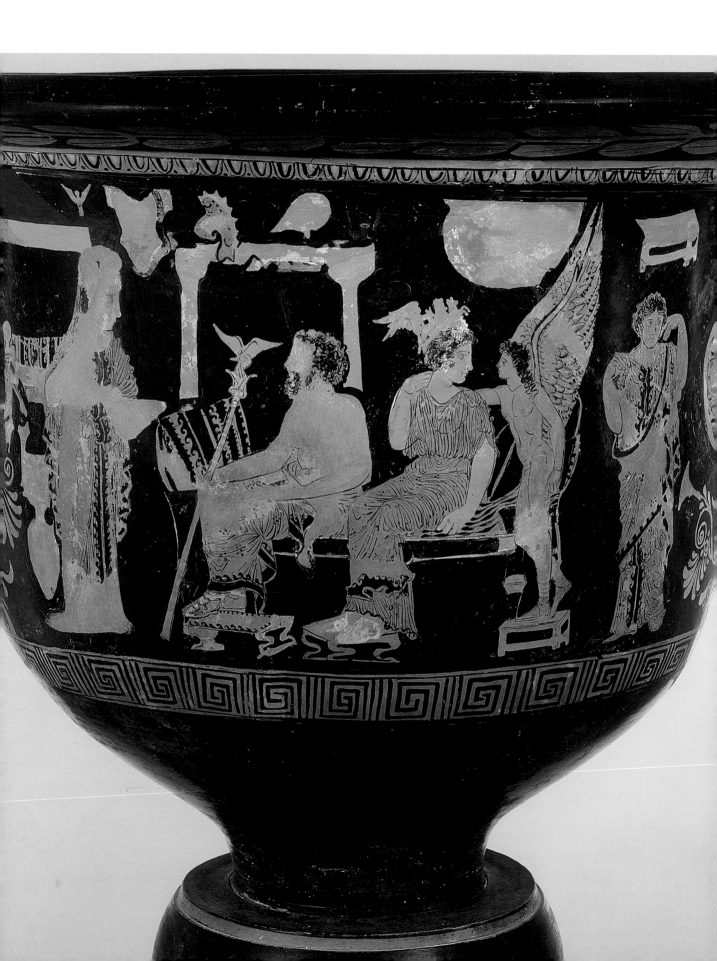

One of the distinctive features of South Italian vase-painting is its predilection for scenes derived from the theater. This art developed most significantly in Athens, and the works of Aischylos, Sophokles, and Euripides—the three outstanding tragedians of the fifth century B.C.—inspired many representations during the fourth century, particularly in Apulia. South Italian vases provide invaluable evidence insofar as they may have been influenced by actual performances, and they include not only the protagonists but occasionally also details of staging.

Although not in perfect condition, the bell-krater by the Sarpedon Painter is a good case in point. Its large size and the rather regular surfaces allow a great deal to be shown on both sides. The source of inspiration seems to have been a play by Aischylos, *The Carians* or *Europa*, of which few fragments survive. While the date of its first performance is not known, similarities to another play of his, *The Persians*, have indicated a date shortly after 472 B.C. Europa was a Phoenician princess abducted to Crete by Zeus in the form of a bull. The children born of this union were Minos, Rhadamanthys, and Sarpedon, the Lycian ruler who fought on the side of the Trojans in the Trojan War and was killed by Achilles' friend Patroklos. On the left, Europa, in an elaborate garment and tall headdress, stands before Zeus to plead for the life of their child Sarpedon. Zeus, distinguished by his scepter, sits on a couch next to Hera, his wife. In Homer's *Iliad*, Zeus and Hera debate Sarpedon's fate, ending in Hera's favor.

> But Queen Hera, her eyes wide, protested strongly:
> "Dread majesty, son of Cronus—what are you saying?
> A man, a mere mortal, his doom sealed long ago?
> You'd set him free from all the pains of death?

> Do as you please, Zeus . . .
> but none of the deathless gods will ever praise you.
> And I tell you this—take it to heart, I urge you—
> if you send Sarpedon home, living still, beware!
> Then surely some other god will want to sweep
> his own son clear of the heavy fighting too. . . .
> But once his soul and the life force have left him,
> send Death to carry him home, send soothing Sleep,
> all the way till they reach the broad land of Lycia.
> There his brothers and countrymen will bury
> the prince
> with full royal rites, with mounded tomb and pillar.
> These are the solemn honors owed the dead.

(Homer, *The Iliad*, Book 16, lines 522–43, trans. Robert Fagles [New York: Viking Penguin, 1990])

On our bell-krater, Hera turns away from Zeus to look at a lithe winged youth who may be Hypnos, the personification of Sleep, with Pasithea, his wife, behind him; her apparent distress may derive from the evident preoccupation of Hypnos and Hera. In its simple but enormously artful composition, the scene presents a lineup of infidelities and adumbrates their consequences. The tall frames behind Zeus and Europa suggest elements of staging, and the armor above them indicates the reason for their dialogue.

On the reverse, Europa occupies a large throne within a structure that, deliberately or not, looks like a simplified version of a funerary naiskos (small pedimental structure; see reverse of No. 32). It may have been a stage prop. She wears a so-called Phrygian cap and an elaborately patterned sleeved garment recalling that of the Amazons

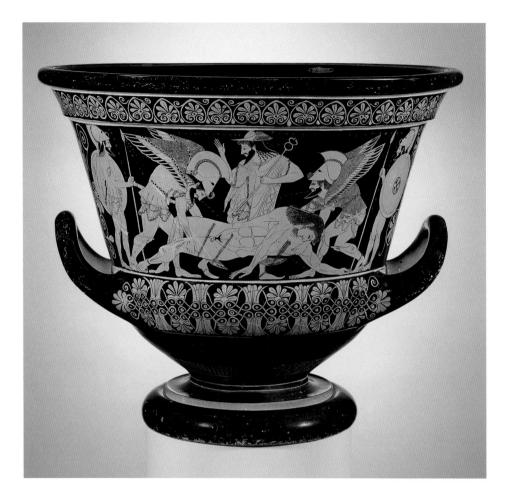

FIGURE 55. Calyx-krater (bowl for mixing wine and water). Greek, Attic, red-figure, ca. 515 B.C. Signed by Euxitheos as potter and Euphronios as painter. Terracotta, h. 18 in. (45.7 cm). Rome, Museo Nazionale di Villa Giulia. Permission courtesy of the Soprintendenza per i Beni Archeologici dell'Etruria Meridionale

(see No. 25) except for the lower part consisting of a skirt rather than trousers. She and the attendants around her respond to the uncanny appearance of the personified Sleep and Death transporting the nude body of her son Sarpedon. Although he was slain, he alone of the casualties at Troy was buried in his native land. This scene must have appeared exotic indeed, in terms not only of the figures and their dress but also of the airborne apparitions. They may, in fact, reflect some form of stage machinery producing special effects, a deus ex machina.

The scene on the reverse is particularly revealing because it can be compared with depictions of Sarpedon with Sleep and Death in Attic vase-painting of the late sixth century B.C., earlier than Aischylos' play (Fig. 55). The Attic representations show the warrior and/or the two personifications still in contact with the ground. They present us with a picture of Sarpedon being raised. We are asked to see it happen right before our eyes. On the bell-krater, the translation of his body is one part of a larger whole that is also indicated to us. We are looking at a picture within a picture. The relation between decoration and vase as well as between viewer and vase has evolved considerably.

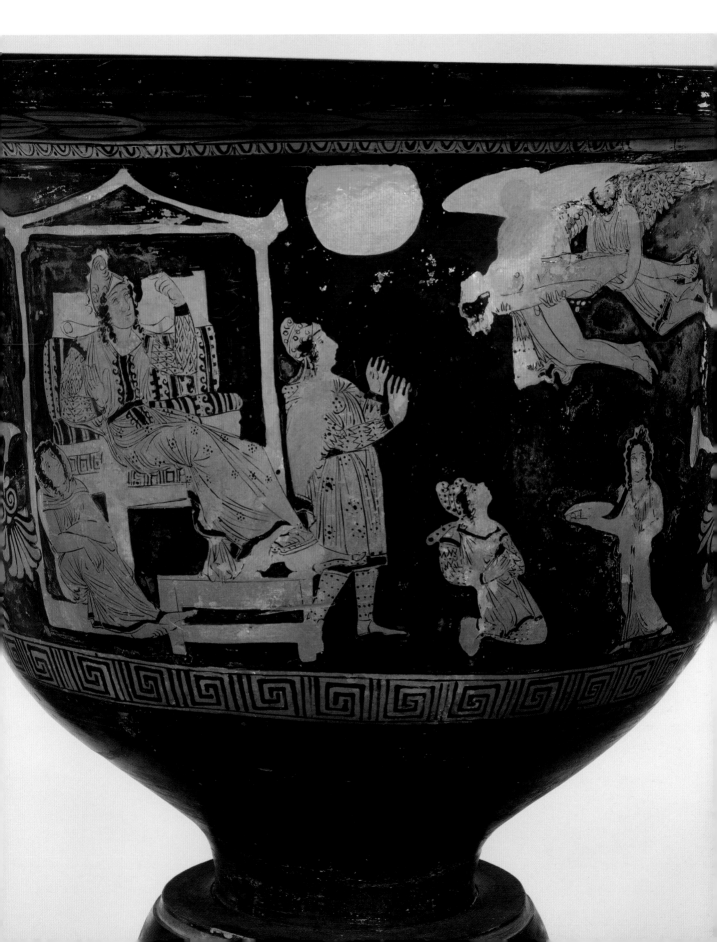

35

Lekanis (dish) with lid and finial

Greek, Sicilian, Centuripe, 2nd half of the 3rd century B.C.
Terracotta, h. 24½ in. (62.2 cm)
Fletcher Fund, 1930 (30.11.4a–c)

To close our look at Greek vases as represented in The Metropolitan Museum of Art, many examples would qualify. This remarkably ornate work looks to both the future and the past. It is the product of a center localized in Centuripe, in northeastern Sicily, active during the third century B.C. The lekanis, a shallow dish with two handles and often a lid, was an old shape that entered the Attic repertoire at the end of the seventh century B.C. It flourished in Attic red-figure from the end of the fifth century on and was adopted in the West, particularly in Sicily and the Lipari Islands. The major surface for figural decoration is the lid, here showing four women at an altar. The extremely fugitive white ground was painted with tempera colors that are poorly preserved. At this late date, all the pigments were applied after firing. The prevailing pastel tonality represents a further step beyond the polychromy of Attic funerary lekythoi of the later fifth century B.C. (see No. 28). The handle zone of the lekanis is richly embellished with detached three-dimensional tendrils incorporating rosettes, birds, and Erotes on either

side of a winged head, possibly of Hermes (see No. 27) or Hypnos (see No. 34), both associated with death. There is a row of applied lions' heads above and akanthos leaves around the base and finial. These plastic elements show abundant remains of gilding.

The lekanis is a virtuosic artistic performance, but it has become a vase in name only. The lid is inseparable from the dish, so that the object has lost its function as a container. The handles survive, but really only as traditional appurtenances of the shape. Their fragility combined with the delicate surface decoration, both painted and applied, makes the piece unsuitable for handling. The work was funerary and intended to be looked at, not to be touched. The dissociation of vases from the rhythms of people's lives, whether routine or ceremonial, marks the very end of Greek vase-painting. The defining aspect of this art was the interaction between user and shape. Perhaps the greatest achievement of Greek pottery was the degree to which size and design were adapted to the human body on the one hand and to a particular function on the other. The vase was the intermediary between the individual and a wide range of activities. The lekanis testifies to the end of that relationship, but it is also a stunning example of a new role as objet d'art.

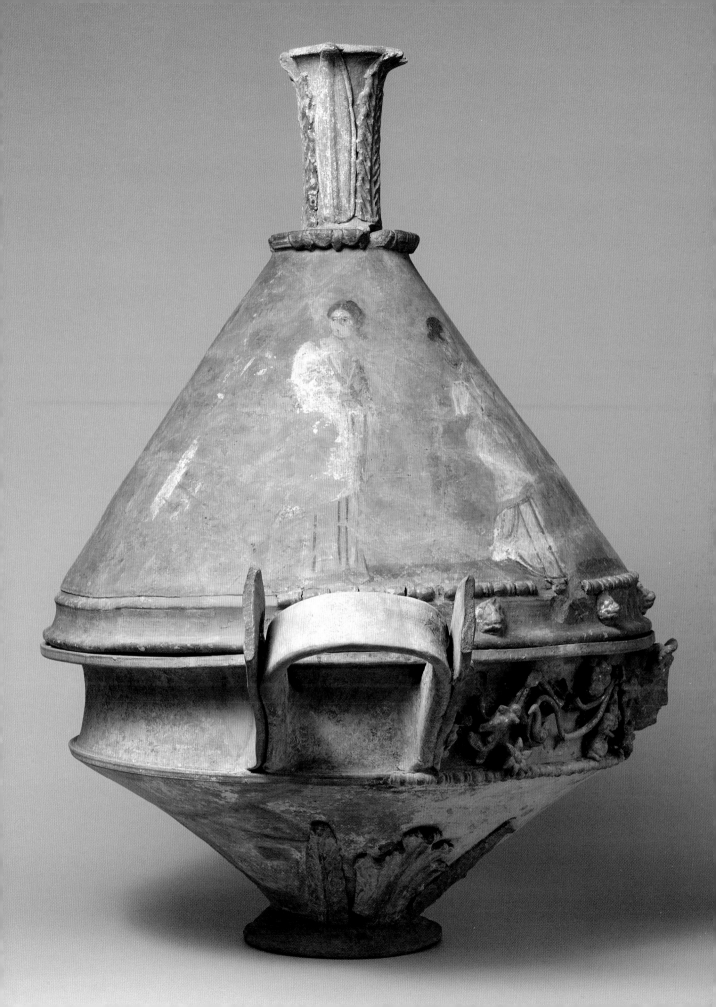

SUGGESTED READING

NOTE: The sources are arranged chronologically by subject in the general list and in order of importance/interest in the sections that follow.

For a useful survey of recent scholarship on Greek vase-painting, see John H. Oakley, "State of the Discipline: Greek Vase Painting," *American Journal of Archaeology* 113, no. 4 (October 2009), pp. 599–627.

GENERAL INTRODUCTIONS

Betancourt, Philip P. *Introduction to Aegean Art.* Philadelphia: INSTAP Academic Press, 2007.

Karageorghis, Vassos. *Early Cyprus: Crossroads of the Mediterranean.* Los Angeles: J. Paul Getty Museum, 2002.

Cook, Robert Manuel. *Greek Painted Pottery.* 3rd ed. London: Routledge, 1997.

Boardman, John. *The History of Greek Vases: Potters, Painters and Pictures.* New York: Thames & Hudson, 2001.

Sparkes, Brian A. *The Red and the Black: Studies in Greek Pottery.* London: Routledge, 1996.

Boardman, John. *Early Greek Vase Painting, 11th–6th Centuries BC: A Handbook.* New York: Thames & Hudson, 1998.

Beazley, John Davidson. *The Development of Attic Black-figure.* Rev. ed. Berkeley: University of California Press, 1986.

Robertson, Martin. *The Art of Vase-painting in Classical Athens.* Cambridge: Cambridge University Press, 1992.

Trendall, Arthur Dale. *Red Figure Vases of South Italy and Sicily: A Handbook.* New York: Thames & Hudson, 1989.

TECHNIQUE

Schreiber, Toby. *Athenian Vase Construction: A Potter's Analysis.* Malibu: J. Paul Getty Museum, 1999.

Cohen, Beth, et al. *The Colors of Clay: Special Techniques in Athenian Vases.* Exh. cat., Getty Villa, Malibu. Los Angeles: J. Paul Getty Museum, 2006.

Lapatin, Kenneth, ed. *Papers on Special Techniques in Athenian Vases.* Proceedings of a symposium held at the Getty Villa, Malibu, June 15–17, 2006. Los Angeles: J. Paul Getty Museum, 2008.

MYTHOLOGY

Gantz, Timothy. *Early Greek Myth: A Guide to Literary and Artistic Sources.* Baltimore: Johns Hopkins University Press, 1993. [Reprint ed., 2 vols., 1996.]

Hard, Robin. *The Routledge Handbook of Greek Mythology, Based on H. J. Rose's "Handbook of Greek Mythology."* London: Routledge, 2004.

Woodford, Susan. *Images of Myths in Classical Antiquity.* Cambridge: Cambridge University Press, 2003.

GREEK VASES IN A CULTURAL CONTEXT

NOTE: The literature is vast and quite Athenocentric; the few works cited are useful points of departure.

Langdon, Susan. *Art and Identity in Dark Age Greece, 1100–700 B.C.E.* Cambridge: Cambridge University Press, 2008.

Boardman, John. *The Greeks Overseas: Their Early Colonies and Trade.* 4th ed. New York: Thames & Hudson, 1999.

Shapiro, Harvey Alan. *Art and Cult under the Tyrants in Athens.* Mainz: Philipp von Zabern, 1989.

Kaltsas, Nikos E., and Harvey Alan Shapiro, eds. *Worshiping Women: Ritual and Reality in Classical Athens.* Exh. cat., Onassis Cultural Center, New York. New York: Alexander S. Onassis Public Benefit Foundation, 2008.

Oakley, John H. *Picturing Death in Classical Athens: The Evidence of the White Lekythoi.* Cambridge: Cambridge University Press, 2004.

Cohen, Beth, ed. *Not the Classical Ideal: Athens and the Construction of the Other in Greek Art.* Leiden: Brill, 2000.

Hart, Mary Louise, et al. *The Art of Ancient Greek Theater.* Exh. cat., Getty Villa, Malibu. Los Angeles: J. Paul Getty Museum, 2010.

Pugliese Carratelli, Giovanni, ed. *The Western Greeks.* Exh. cat., Palazzo Grassi, Venice. Milan: Bompiani, 1996.

HISTORY OF THE REDISCOVERY OF VASES

Rouet, Philippe. *Approaches to the Study of Attic Vases: Beazley and Pottier.* Oxford: Oxford University Press, 2001.

Schnapp, Alain. *The Discovery of the Past: The Origins of Archaeology.* London: British Museum Press, 1993.

Sloan, Kim, ed., with Andrew Burnett. *Enlightenment: Discovering the World in the Eighteenth Century.* London: British Museum Press, 2003.

INDEX